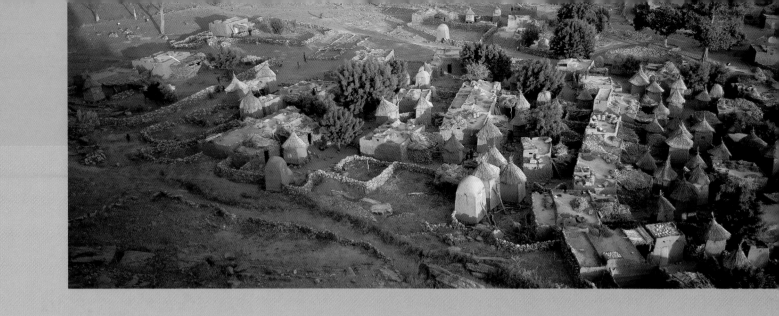

Africa's People of

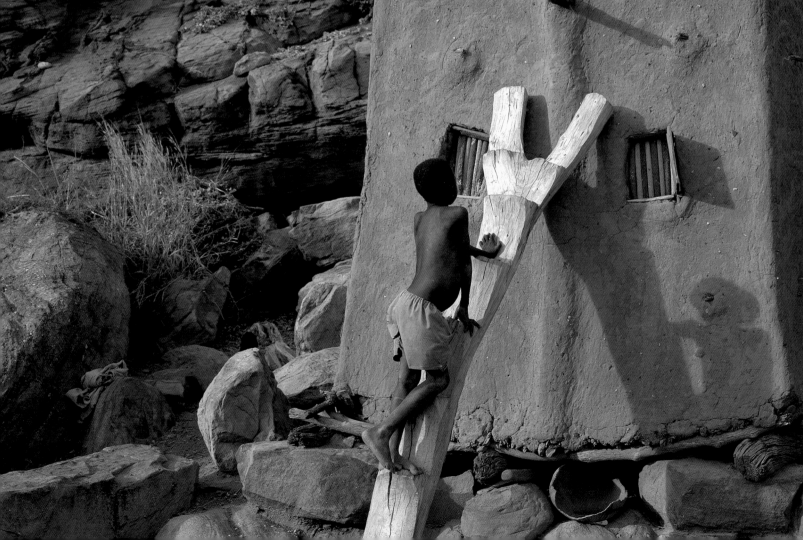

Dogon

the Cliffs

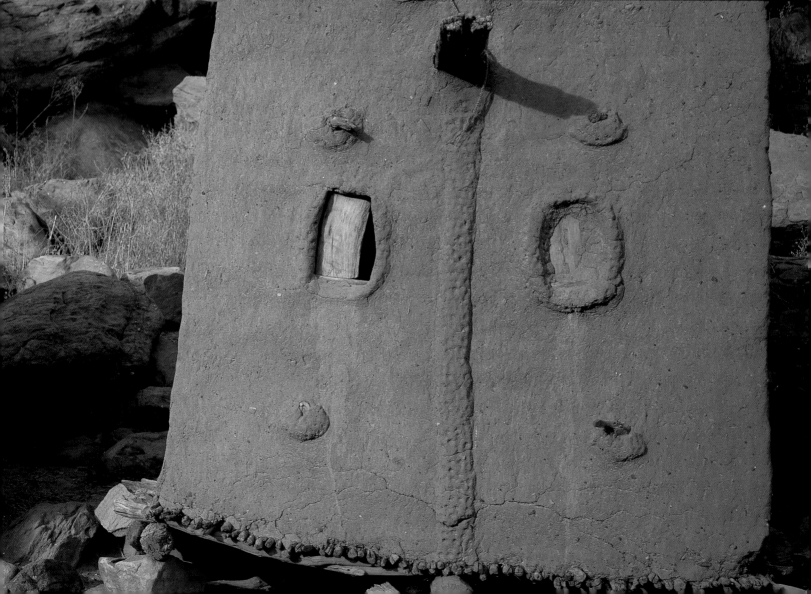

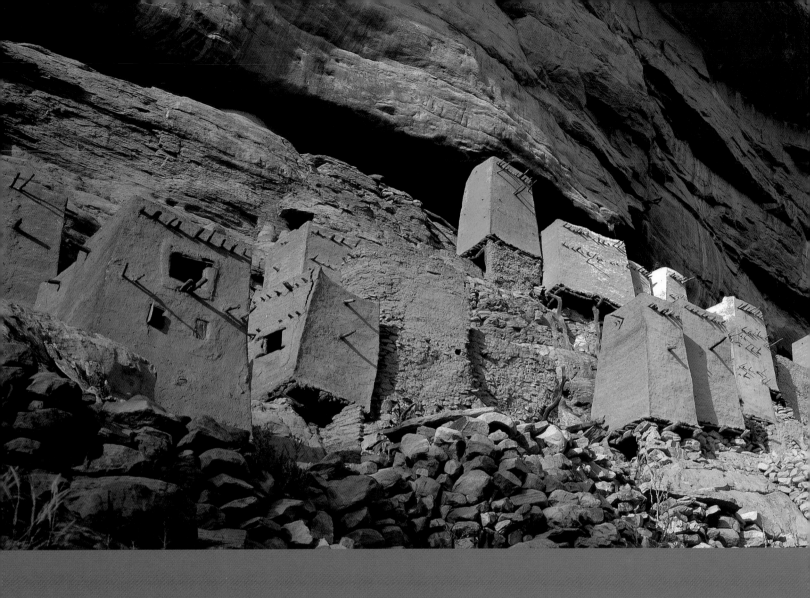

Text by **Walter E. A. van Beek**

Photographs by
Stephenie Hollyman

Harry N. Abrams, Inc., *Publishers*

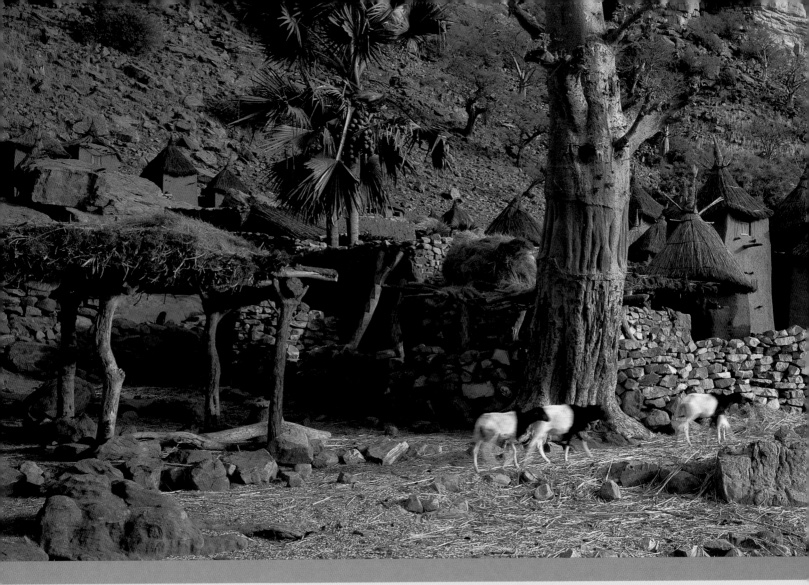

Editor: Robert Morton
Designer: Robert McKee

Library of Congress Cataloging-in-Publication Data

Hollyman, Stephenie, 1952–
 Dogon : Africa's people of the cliffs / photographs by
Stephenie Hollyman ; text by Walter E.A. van Beek.
 p. cm.
 Includes index.
 ISBN 0–8109–4373–5 (hardcover)
 1. Dogon (African people)—History. 2.Dogon (African
People)—Social life and customs. I. Beek, W.E.A. van. II.
Title.

DT551.45.D64 H66 2000
966.23—dc21
 00–063981

Photographs copyright © 2001 Stephenie Hollyman
Text copyright © 2001 Walter E.A. van Beek

Printed and bound in Hong Kong

Page 1:
In Koundou night falls over the village. It is the time for
families to gather in courtyards, to eat millet from a com-
mon bowl. Later the men of Koundou stuff their pipes
with home-grown tobacco as they discuss the day's events
under a star-filled sky.

Page 2 and 3:
Above: A panoramic view of the village of Songho.
Below: In Eli a Dogon boy climbs a ladder to reach into
his family's granary for millet.

Page 4 and 5:
The Bandiagara Escarpment, a sheer sandstone cliff,
stretches in northeast-southwest direction for 125 miles.
Some 250,000 Dogon live in the hundreds of villages
atop and below the cliff.

Page 6 and 7:
From the plain the great cliffs rise several hundred feet
and are filled with thousands of caves and caverns.

Harry N. Abrams, Inc.
100 Fifth Avenue
New York, N.Y. 10011
www.abramsbooks.com

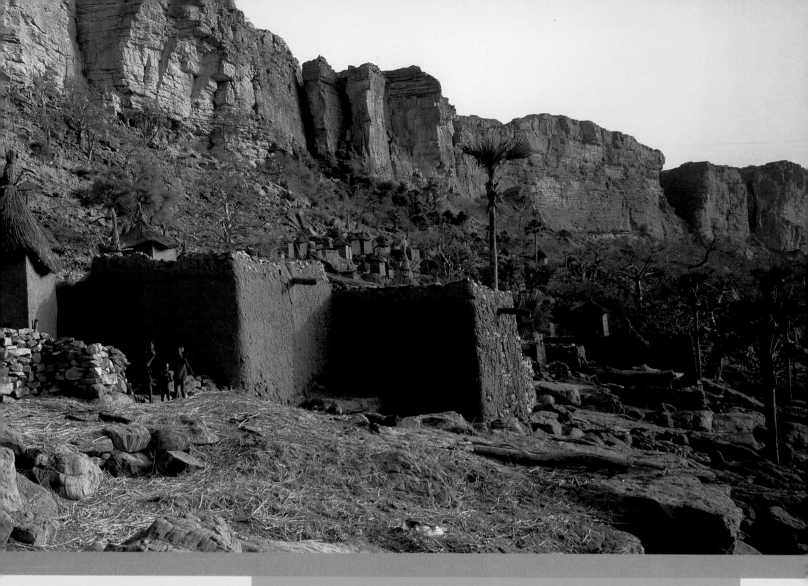

Contents

Dogon Africa's People of the Cliffs

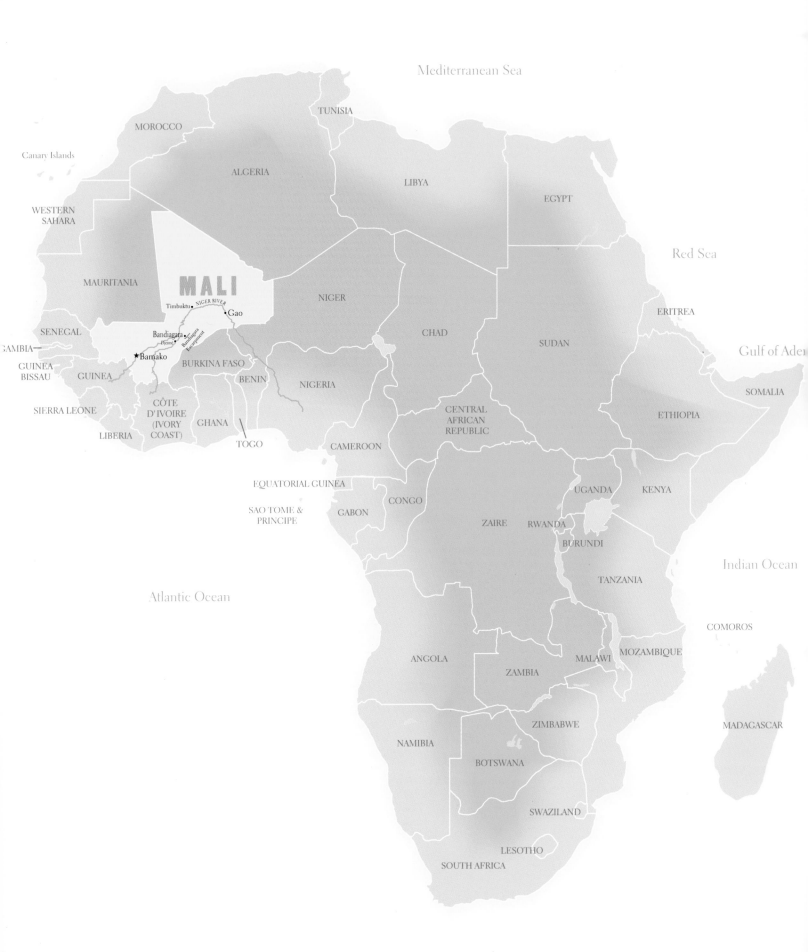

Mediterranean Sea

TUNISIA

MOROCCO

Canary Islands

ALGERIA

LIBYA

EGYPT

Red Sea

WESTERN SAHARA

MAURITANIA

MALI

Timbuktu NIGER RIVER

Gao

NIGER

CHAD

SUDAN

ERITREA

SENEGAL

GAMBIA

Bandiagata
Djenné Bandiagara
Bankass
Bandiagara Escarpment

Bamako

Gulf of Aden

GUINEA BISSAU

GUINEA

BURKINA FASO

BENIN

NIGERIA

CENTRAL AFRICAN REPUBLIC

ETHIOPIA

SOMALIA

SIERRA LEONE

CÔTE D'IVOIRE (IVORY COAST)

GHANA

TOGO

CAMEROON

LIBERIA

EQUATORIAL GUINEA

SAO TOME & PRINCIPE

GABON

CONGO

UGANDA

KENYA

ZAIRE

RWANDA

BURUNDI

Indian Ocean

TANZANIA

COMOROS

Atlantic Ocean

ANGOLA

ZAMBIA

MALAWI

MOZAMBIQUE

ZIMBABWE

MADAGASCAR

NAMIBIA

BOTSWANA

SWAZILAND

LESOTHO

SOUTH AFRICA

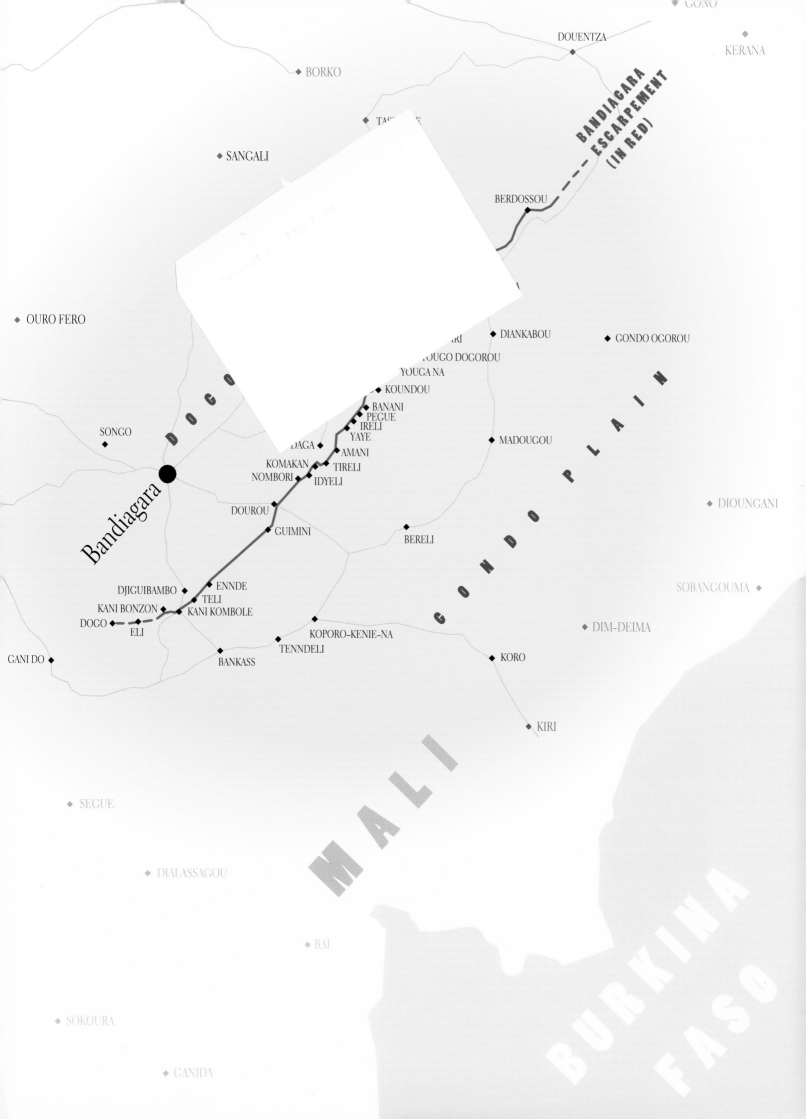

Many visitors to

IN DOGON VILLAGES the pointed straw roofs of granaries rise above the flat-topped huts of the people. Despite the many changes in Mali, Dogon culture has retained its essential characteristics, and the lives of men and women have changed little.

Mali wonder how

the Dogon manage to survive in such a seemingly inhospitable environment and why they chose such a site—their villages huddled on the heights of the majestic Bandiagara escarpment or on the scree at the foot of the cliffs below. Two factors—historical and geographical—have shaped the Dogon choice. The first was slave raiding. The bend in the river Niger, roughly where the Dogon area lies, has been scourged for centuries by powerful outside forces coming in to abduct locals as slaves. Emperors of Ghana, Mali, and Sonrai and the chiefs and kings of the Mossi, Sao, and Fulani peoples have long had a hunger for slaves. For them, all non-Muslims were potential booty. The raiding itself was usually carried out by small bands of men using a hit-and-run technique to overpower campsites or villages. Captives were then sold to tribal leaders elsewhere. Local oral histories recount numerous slave raids on a large or a small scale, skirmishes in which the bows and arrows of the cultivators were matched against the lances, shields, and sometimes guns of a mounted cavalry.

Against these threats the high, 125-mile-long Bandiagara escarpment offered a fair defense. For safety's sake, the Dogon built their houses only on defendable spots, and cleared their fields in the immediate vicinity, cultivating primarily those in view from the plateau rim. On top of the plateau the villages were built beside steep-walled gorges accessible only by foot. At the base of the cliff face, the fallen boulders and loose rock offered some protection against a mounted attack as well as an opportunity to spot raider parties from afar. If the pressure became too great, the Dogon could flee into the caverns inside the sandstone cliffs.

This situation changed dramatically with the coming of colonization. When the French came into Mali just after 1890 they pacified the region and put an end to the slave raiding and tribal wars. The Dogon still remember the "war of Kasa" (just north of Sanga) as the decisive

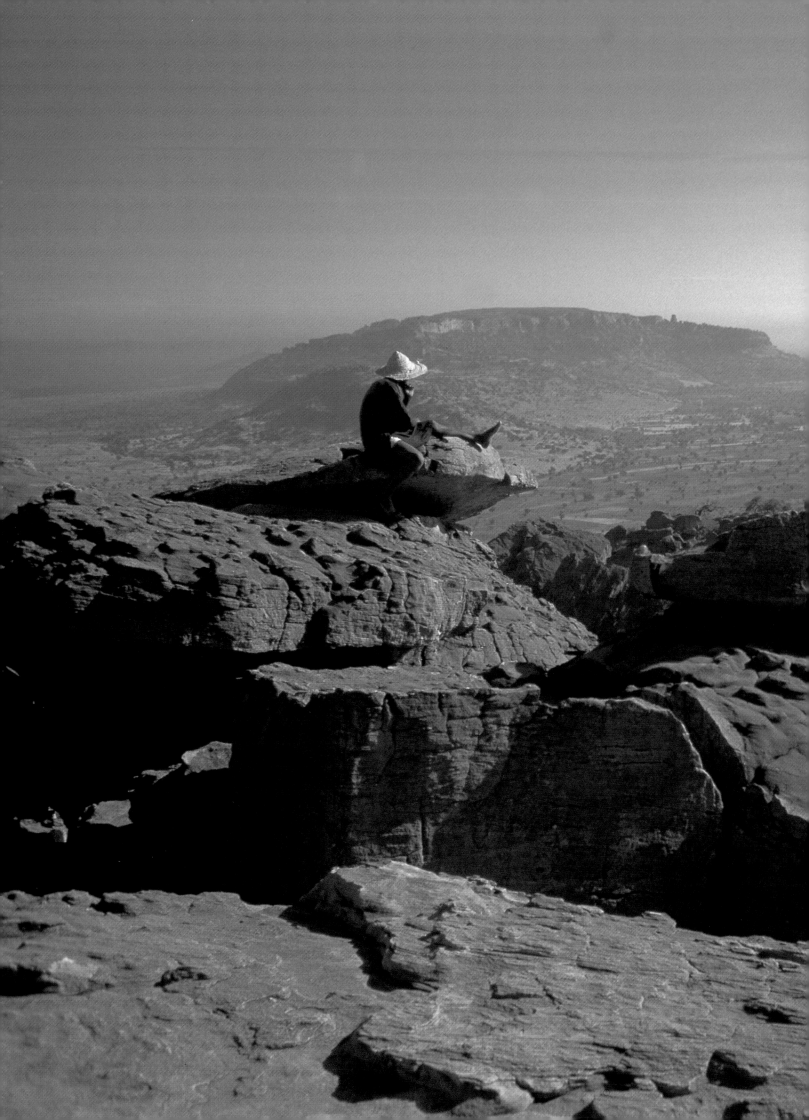

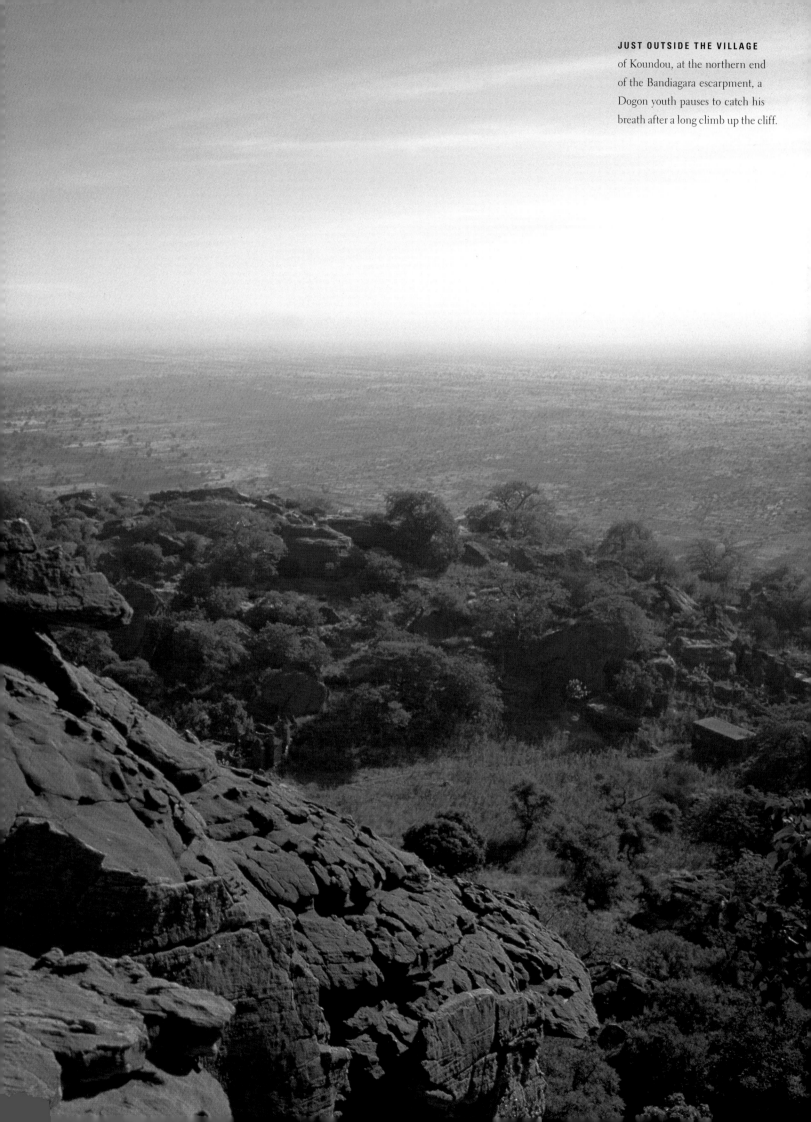

JUST OUTSIDE THE VILLAGE
of Koundou, at the northern end
of the Bandiagara escarpment, a
Dogon youth pauses to catch his
breath after a long climb up the cliff.

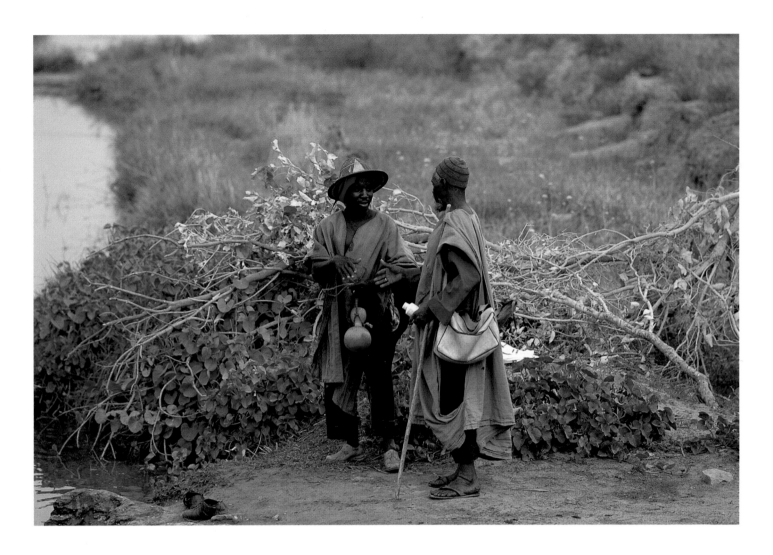

A VISIT WITH A NEIGHBOR
breaks up work beside the onion
fields of Ogosogo.

moment when the French established their hegemony in the area. Though this was a military defeat for the Dogon, the reign of peace meant that the plains and plateau could be safely opened up as a cultivation area. This resulted in a rapid dispersal of population over the formerly danger-ous outlying fields, quickly expanding into the newly available territory.

S T R I V I N G F O R H A R M O N Y

Perhaps as a result of having lived under threat for so long, the Dogon have a strong orientation toward harmony and communion among members of clan and village. Conflicts are largely avoided and differences of opinion are seldom raised. Not only are the people very much aware of their mutual interdependency but they also cherish it, accentuating personal relationships wherever they can. A Dogon individual easily gives expression to his or her dependency on and membership in the larger group. Thus, during one of the Dogon's central rituals, the old thank the young and vice versa; groups of men praise the women and vice versa.

Communal labor, collective action, and group responsibility are characteristic of Dogon village life. Hospitality and openness are essential values: each Dogon, it is felt, should be accessible at all times for anyone. In the Dogon language there are many ways of welcoming a stranger. Whereas for numerous other African groups strangers are enemies without any right to respect, the Dogon consider strangers as guests, from whom "new words" may be heard and information from the out-side world may be gleaned.

This quest for harmony is expressed, for instance, in the elaborate greetings when one adult meets another. This crucial ritual is repeated over and over again and never avoided. The rules of

Dogon greeting are complex: the person who "enters" the contact, whether he or she is coming into the dwelling compound of another or into a marketplace where the other already is, waits to be greeted by the "resident" and then answers. The greeting consists of a series of inquiries about the health of the other person's whole family. Brief fixed replies are given. Here is a sample greeting at a market between two male friends, Irekana and Dogolu:

(Irekana)	(Dogolu)
Iwè po, iwè po *(greeting at the market)*	Dige po *(greeting in the afternoon)*
How is your health?	Very good (sèwa).
Are you strong?	I am strong.
How is your mother?	Very good.
How is your sister Yana?	Very good.
How is Yasaa?	Very good.
How is Berewadya?	Very good.
How is the white man in your house?	Very good.
How is your whole family?	Very good.
Tare *(thank you)*	

Then it is Dogolu's turn:

	How is your health?
Very good (sèwa).	*How is Ago, your father?*
Very good.	*How is your mother's sister?*
Very good.	*How is Munyuire (younger brother)*
Very good.	*How is Yaga (sister)*
Very good.	*How is Yalewa (wife)*
Very good.	*How is Atimè, your son?*
Very good.	*How is the whole family?*
Very good.	Tare *(thank you)*
Greetings, thank you.	Greetings, thank you.

Everything is fine, just fine. Dogolu, however, knows that Ago, Irekana's father, has been severely ill. Rumor has it that he was on the threshold of death. Yet, in greetings nothing of this knowledge surfaces, that is reserved for later conversation. During the salutation the pretense is that everything is fine, in Dogon *sèwa*. Neighboring people dub the Dogon the *sèwa* people, after the interminable repetition of *sèwa*. In the early morning the loud *sèwa* answers sound through each sleepy village when women meet each other on the way to the well. Throughout the day people keep greeting each other—neighbors, family, visitors, anyone. The greeting machine shuts down only after sunset, when people settle down for dinner and sleep.

The greeting ceremony communicates little concrete information but remains extremely important. All further communication stems from this salutation, for it is felt that to greet is to be human, to greet like a Dogon is to be a Dogon. Greeting in Dogon language means for the Dogon almost complete mastery of the language: "You greet like a Dogon, so you speak Dogon." It might be said of someone who had long resided in Mali: "She could not even greet properly."

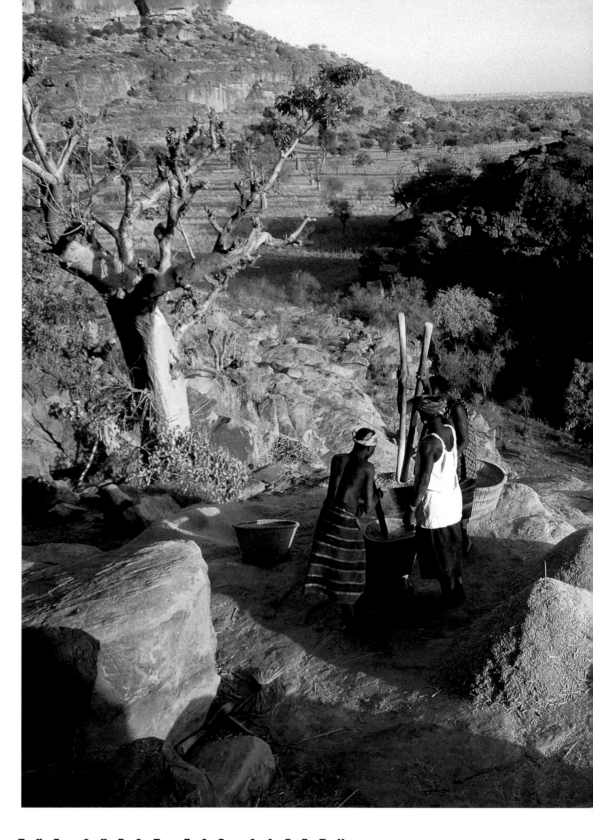

THE QUEST FOR SAFETY

The second factor that led the Dogon to settle along the Bandiagara escarpment was water. The availability of water at the rim of the plateau or in the sandy dunes of the plains below, away from the foot of the escarpment, is slightly greater than elsewhere. The sandstone rock holds a considerable amount of water throughout the dry season, and the floor of the cliff face lies at the lowest part of the area, where a rivulet runs in the wet season.

For people who cultivated by hoe only, having no beasts of burden to pull plows, the rim and foot of the plateau offered a fair prospect for agriculture. The Dogon were by no means the first to settle the area. Older groups known as the Tellem and the Toloy preceded them. Their ecological

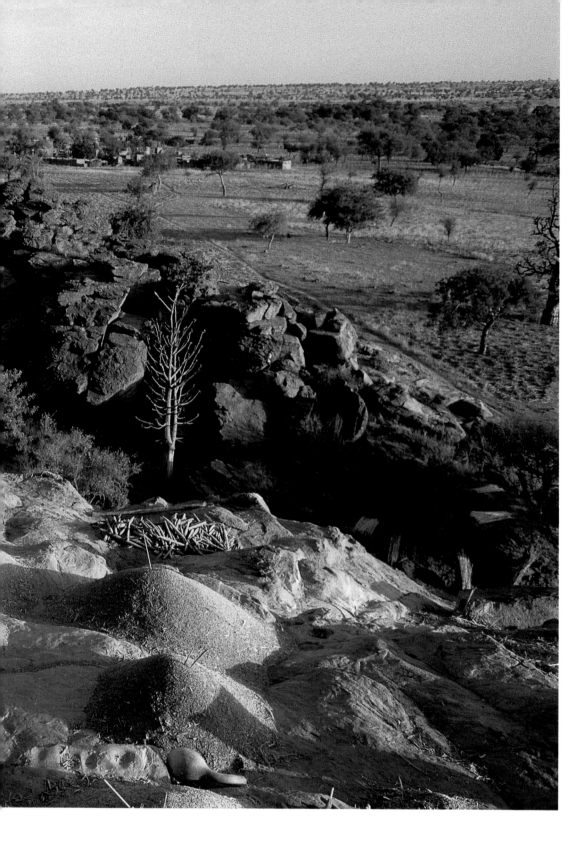

MANY RESIDENTS OF YOUGO
Na, especially the young men, have abandoned their village in search of seasonal labor in Burkina Faso and the Côte d'Ivoire.

Overleaf left:
A DOGON BOY CLIMBS UP A notched Dogon ladder that bridges a cleft in the limestone cliff to reach the village of Koundou.

Overleaf right:
THE DOGON WHO LIVE in the isolated village of Yougo Na store their grain in granaries that they say once belonged to their predecessors at the cliffs, the Tellem.

situation, as far as can be learned from the scant data, must have been quite similar. The Dogon arrived at the escarpment during the waning of the Mali Empire, sometime around the fifteenth century. It is believed that they drove the Tellem away and settled in their niche, cultivating millet and sorghum. Periodic droughts must have been experienced, but the Dogon persisted and stayed on. The sixteenth through eighteenth centuries saw at least three drought periods each, while the nineteenth century seems to have been more generous with rain. The Dogon still practice some rituals associated with drought that may have been generated during these periods, but oral tradition does not reach back to before the nineteenth century, so confirmation remains impossible.

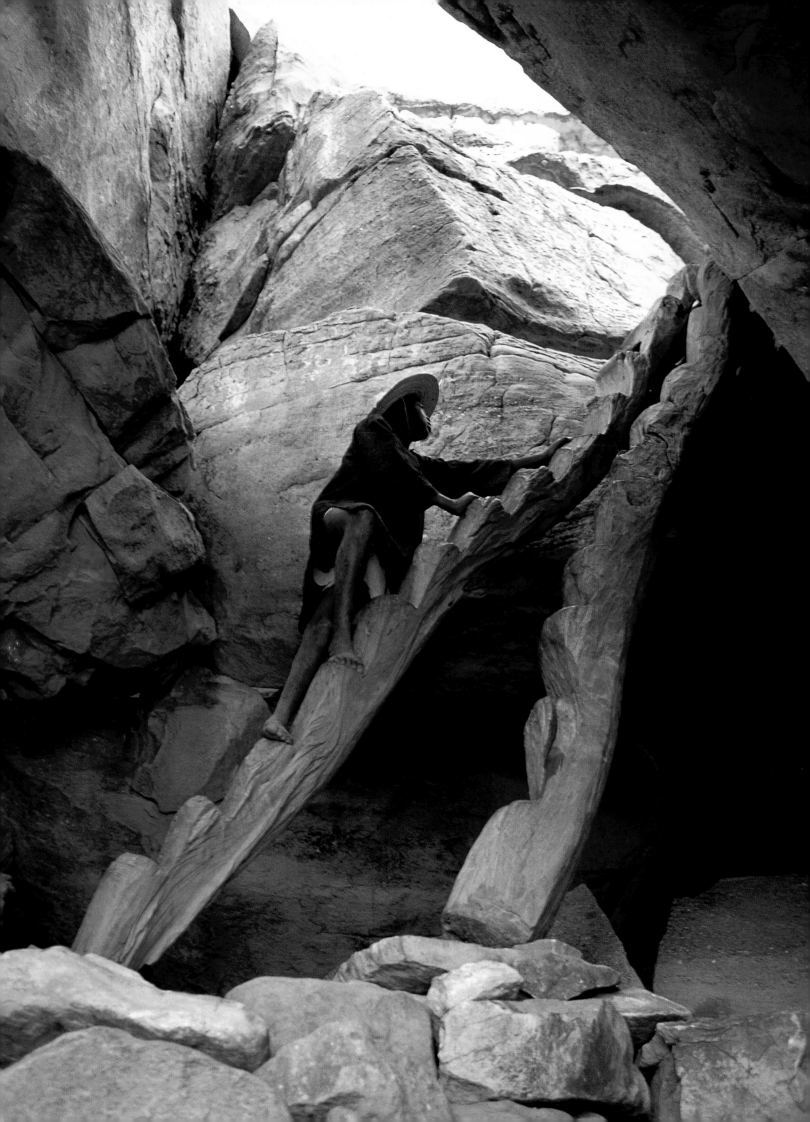

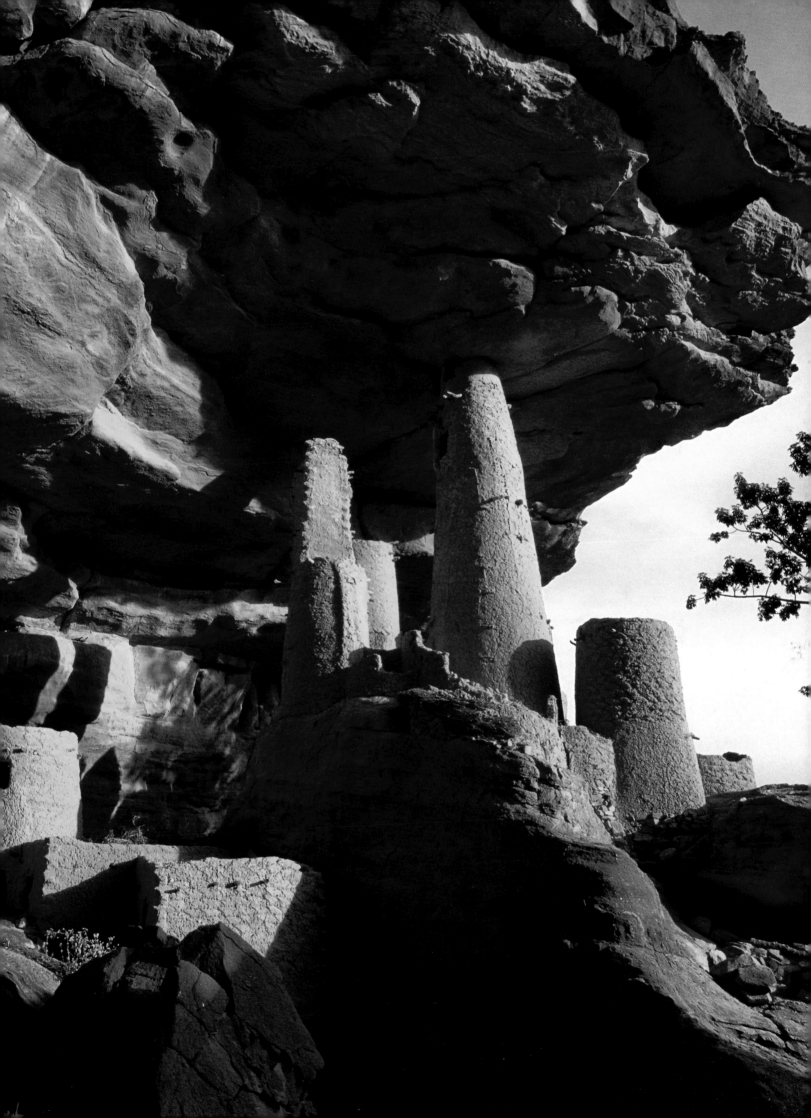

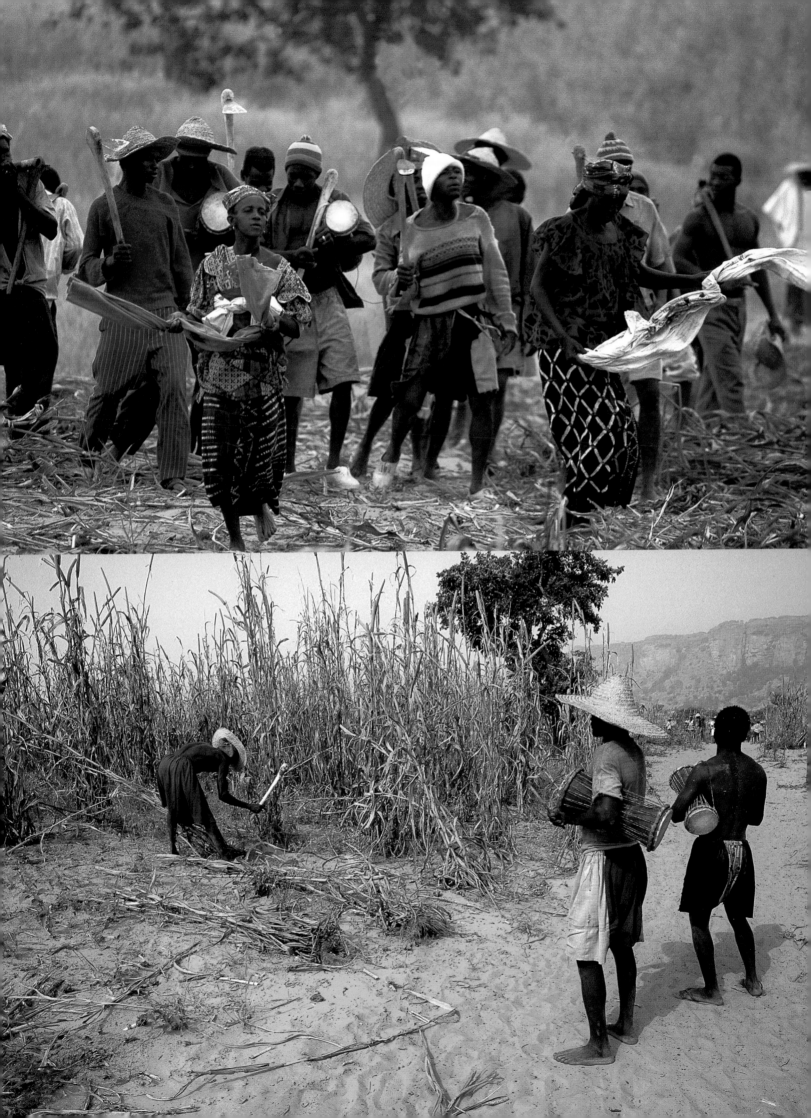

The slave-raiding pressure on the Dogon probably increased before the nineteenth century, as centers of settlement in West Africa, with their increased social and political activity, moved closer to the Bandiagara region. Neighboring tribal groups took up the roles of slave merchants, as both the intensification of war and the growth of cities increased the demand for slaves across the whole of West Africa. Further, beginning at the end of the eighteenth century, a series of *jihads*, or holy wars, triggered by a resurgence of Islam, put a larger premium on slaves for warfare. Over the next century, the relatively benign climatic conditions allowed for large cavalries, for which great numbers of slaves and craftsmen had to be recruited to insure the smooth functioning of the larger armies. Thus, insecurity among the Dogon was at a peak, and the pressure on the escarpment gradually increased until Europeans arrived on the scene.

The safety of the escarpment was a relative one for the Dogon: it offered a possibility for defense but by no means a guarantee of safety. The Dogon lost many to the slave raiders, though the number remains unknown. The people coped with the perennial threat in several ways. First of all, they cultivated fields as close to the village and the cliffs as possible, using a system of intensive horticulture at viewing distance from the village. The cultivated crops, millet and sorghum, were rotated with beans and fonio (*Digitaria exilis*), a highly nutritious cereal grain: the latter crop may have been more important formerly than in recent times, as evidenced by its preeminence in ritual. Well suited for growing in difficult areas, fonio can be easily and efficiently sown by broadcasting the seed, as the French say, "*à la volée*"; weeding requires little work and the Dogon like to harvest it collectively. It is the first crop after the rainy season, just when hunger sets in. In more modern times, in addition to these main crops, peanuts and tobacco were cultivated; peanuts serving as an alternating crop with millet (like beans), and tobacco being grown in the riverbed in the dry season.

WORKING TOGETHER

Among the Dogon, the combined need for numbers of people to work together at food production and mutual defense led to a great sense of communality. The size of villages traditionally varied between 500 to 1,000 inhabitants. Smaller villages were hard put to mobilize enough able-bodied young men for defense, and in larger villages the pressure on the land to produce enough food forced cultivation far from the protecting cliff face. As a result, work came to be organized as often as possible in large groups, able to defend against the slave-raiders that once roamed the countryside.

Work parties of from ten to twenty men were usually considered large enough for self-defense, but the fields farther from the villages required larger groups to be sent out. Recruitment of these groups followed two lines: first, that of the extended families, and secondly, that of the age classes. For the nearby fields an extended family usually was able to furnish enough men for a working party that could defend itself. Sometimes a combination of two to four extended families formed a working unit. The older men of the families coordinated the work, either having their people work together on one large field, or arranging for related families to work on adjoining fields. The old men served as lookouts from the *toguna*, the men's hut, built high up against the mountain and with an unrestricted view of the plains or plateau. Drums served as their means of communication with the workers.

For the fields farther removed from the village, a larger group of workers was recruited from among various Dogon age groups, or *kadaga*. The age class system of the Dogon had (and has) the

Opposite: above and below:
THE RHYTHM OF DRUMS
accompanies many Dogon village activities. As men of Tireli village arrive to harvest millet in fields belonging to their neighbor, Dogolu, they sweep along in a line, accompanied by some women. At work, they wield sickles and short knives to cut the cobs of millet from the stalks.

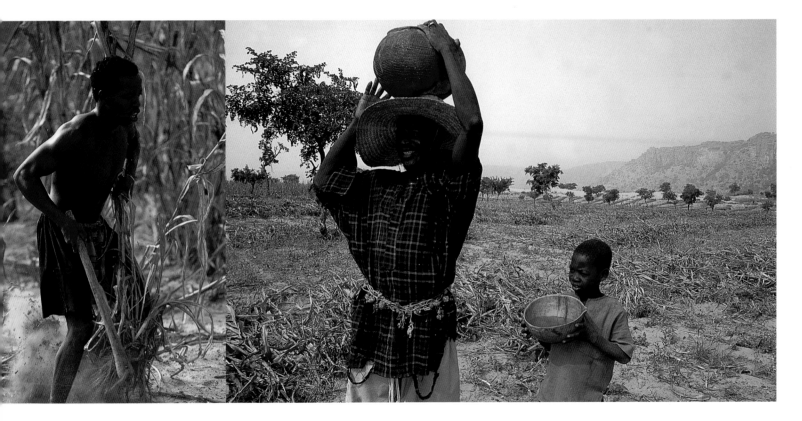

MEMBERS OF THE LINEAGE of Dogolu Say help harvest millet cobs during the annual harvest in the fields on the plain near Tireli.

DOGOLU SERVES BEER TO the villagers who are helping him to harvest his fields. The smile on his face indicates that the crop is plentiful.

regulation of labor as its main goal. An age class of a typical Dogon village consisted of a fixed number of able-bodied males, around fifty in many cases, who were summoned whenever communal work, such as clearing and weeding fields in the bush, in other words away from the cliff face, needed to be done. That age class was formed when the young men were between seventeen and twenty-two years old, marriageable age. Thus, their communal labors also served as bride service, an important aspect of the marriage proceedings. This type of age group still functions in the cliff-side villages.

Dogon age groups still regulate most public labor today. To repair a *toguna* (men's house) roof, to plaster the women's menstruation hut, to fix a road in the village, to restore the steps leading up the cliffside, or to dig a well—any public endeavor—calls for work by the *kadaga*. When a job needs doing, the old men meet in the *toguna* to decide how many *kadaga* should be involved. That evening the village crier calls out the task and identifies which *kadaga* are to show up, beginning with the youngest group; the next oldest group being responsible to supply the beer that must be shared at the work's completion. The next morning the workers turn out, perform the job, get praised and blessed by the old, and drink the beer. Of course, some are more eager to work than others, but loafers are dressed down severely, both by the town crier ("nobody should hide in his house") and by the old men after the work ("let the lazy whither in their huts"). Most importantly, labor creates public esteem and secures social position. Whoever works hard will easily command laborers for any job that he needs done. All this embodies central Dogon values: harmony with the fellow villagers, respect for the old men, earned respect from age-mates.

One of the more spectacular examples of *kadaga* in action occurred when the men in Tireli had to deepen the main well of the village, after many complaints by the women who had been having more and more trouble getting water each morning.

The first day of work began early. Each of the men carried a long-handled flat shovel made by the blacksmiths, who all had worked night and day for a week. Each age group furnished a musi-

cian, many with a drum or *gangana*, the iron bell that leads most of the collective ritual dances, to keep up the rhythm of the work. The women came, carrying their babies on their backs, to greet and admire the men coming for the work. Some merchants set up shop, selling cola nuts, tobacco, sweets, and other delicacies.

The youngest *kadaga* went first. They were the ones whose wives had just moved in with them; they had just become adult in the full Dogon sense of the word. Determined to show themselves as good workers as anyone else, they struck a very fast rhythm, pitching the sand over the high wall of the well pit with a great show of force. One of their younger brothers beat the drum, while clan elder Yengulu, whose son was among the workers, led with the bell. After about twenty minutes in this furious work they called for relief. The second youngest *kadaga* then went in, with a change of musicians. The new men in the pit underscored their dedication by singing one of the many songs the Dogon use to accompany work. Another twenty minutes later, the next group of men, eight years older than the last one, hopped into the well and had a go, drums beating, bell clanging, and the women at the side ululating in admiration.

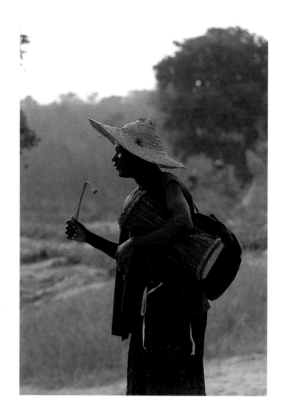

No woman went into the well; this was men's work. After it was finished, the well would belong to the women, with no man ever allowed to set foot in it, but now the men were in charge. All *kadaga* of able-bodied men, up to about the age of fifty-five, went in and showed their strength, the oldest group working considerably slower than the first. The cycle then started all over again, but by then most of the women had left, to cook and tend to their beer brewing. At about four in the afternoon, the men called it a day.

ATIME SAY, DOGOLU'S SON beats an hour-glass drum to set the pace for the harvest on his father's fields. Pulling the sinew cords tight and then letting them go he can vary the pitch of the drum.

The next day the *kadaga* returned in strict order of age, while the women cooked and finished making the beer. At noon the well was deep enough, and the youngest *kadaga* slowly began tunneling into the nearby mountainside, looking for water. It was dangerous work, and the older men shouted down advice. But they did find water, without any cave-in. Now the women returned, carrying large wooden bowls with millet mush and sauce on their heads. The dusty men ate quickly and went home to wash and dress for the real feast—beer.

Row after row, the women of the two youngest *kadaga* came with pots of beer. The men had installed some huge jars to hold the beer near the well. Gradually, they were all filled to the brim. This beer was about half of the total brew: the rest was kept in the homes on the scree for later consumption. The old men of the village arrived in full regalia, wearing their large indigo *boubous* and crowned with splendid broad-brimmed hats. At the start of the party, Adomo, the son of the Tireli priest, Amono, thanked all men of Tireli for their splendid work; everybody had shown himself *sagatara*, strong and able-bodied. Then drinking began, age group by age group. Though unfiltered (there was too much to filter), the beer was good. The elder Dogolu commented: "This is the real life: work hard with women watching, then drink in your best clothes."

Although people had come from Amani and the plains to help their neighbors with the digging, the beer was plentiful and the party lasted until sunrise. Later, strolling up to his house with some difficulty, Dogolu happily remarked that there was still beer in the houses. So the whole next day, Dogolu, as the head of his *kadaga*, kept washing the fatigue away, from calabash to calabash, from

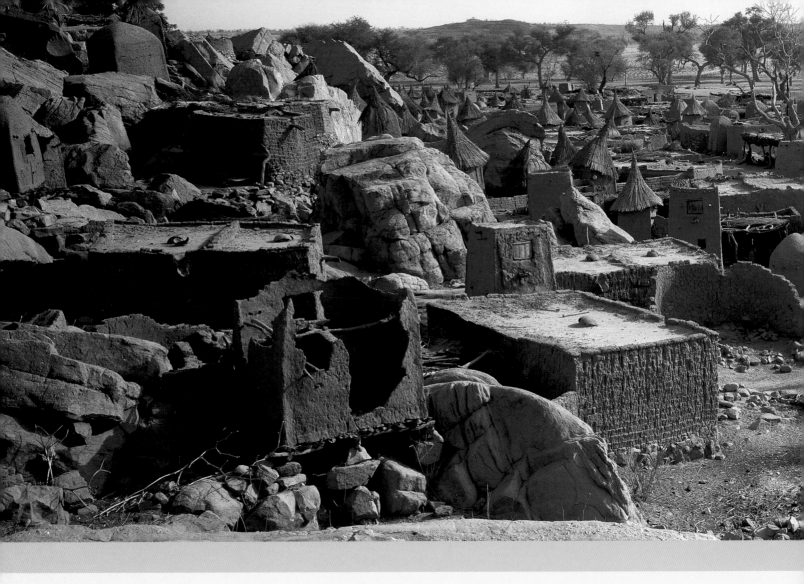

pot to pot, from song to song. Each of the *kadaga* had earned distinction in the digging, and they
kept celebrating their unity. For three days life had been as it should be—work, women, food, and
beer, lots of beer.

In this huge work, the old men coordinated the many tasks by virtue of their authority in the com-
munity. They always occupy a key position by control of the infields, those fields within view of the
scree. All fields where permanent cultivation was possible—close enough to bring manure—were
assigned to the oldest men, whether of the village, ward, clan, or lineages. The complicated system
of land rotation involved a specific set of fields being assigned to the oldest of the village, another
set to the next in line and so on, for each section of the village as well as for the whole community.
So the old men were in a position to coordinate the cultivation of their fields and had a definite
interest in them. These men usually belonged to the same age group and could base their work on
a long-standing tradition of cooperation. In precolonial times the old men seem to have decided as
a group which fields were going to be cultivated, what crops would be sown, and how many of
which age groups were going to participate. Latterly the task fell to individuals. Calling out loud in
front of the sound-deflecting cliff, they had the village in reach of their voices each evening. And
conforming with Dogon standards of interpersonal communication, they downplayed their own
role, extolled the virtues of those who turned out on previous occasions, shamed the lazy ones, and
always stressed the reciprocal dependency of old and young, men and women.

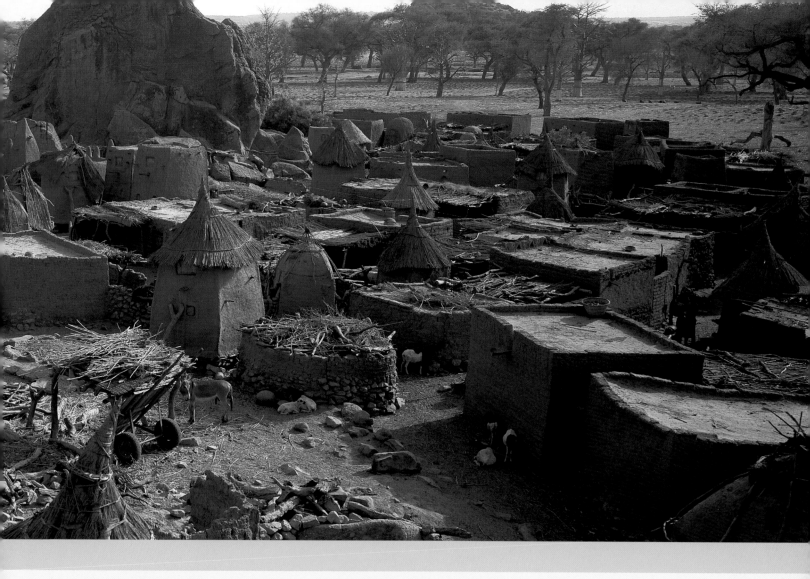

OPENING UP TO THE WORLD

European colonization in West Africa brought about some fundamental changes that increasingly transformed Dogon life. The arrival of French colonial administrators ended slave raiding in the area and the few skirmishes that had taken place between Dogon settlements themselves. The result of this was that a much larger area of the plateau and the plains became available for cultivation. At an ever-increasing pace the Dogon swarmed out into the newly opened resources, building farms and founding villages. Plains and plateau were not exactly empty, as some villages had been established already on the plains. Still, in the first decades of the twentieth century, the Dogon quickly filled in the empty spots on the map, first against the present border with Burkina Faso with its better soils, and then in the sandy plains closer to the escarpment. On the plateau the Dogon drifted in a northwesterly direction. For the villages at the cliff face, which this book concentrates upon, this caused a diminishing population pressure at first, owing both to the emigration and to the cultivation of new but more distant fields that were still considered to be village territory. In the cliffside villages fields from three to six miles from the rim were brought into cultivation. The control of those fields fell to the families that ventured out, first collectively as male-based lineages but also individually. So, in contrast to the old structure of infield control, which was in the hands of the elders, these outfields were owned by the lineages.

New crops came into the area, and a dry season cultivation developed, in which onions (and tobacco) were cultivated in the riverbed, irrigated with hand-carried pots and calabashes. Water

holes were dug at several places in the river bed, to follow the receding water table during the three months of onion cultivation (December through February). Villages on the plateau cultivated the borders of places where water remained for that duration. The onions were the first real cash crop for the Dogon, triggered by the need for money (taxation and the purchase of commodities) and the presence and development of food markets. They found a ready market in the region.

Between the two world wars, the French "pacified" the area and the Dogon were, to some extent, dispersed. Socially it was a period of moderate fragmentation. The traditional survival strategy of communal labor lost most of its rationale, though it did not disappear. Individual property became more important, though this was not new for the Dogon. The influence of the old men as a body diminished somewhat, as their collective coordinating role in agriculture dwindled. Yet they remained important in village matters and regulated large communal tasks for the whole village. The importance of elders within the extended family was strengthened, as they gained control over the outfields through the lineage structure. Production in the onion gardens was in the hands of individuals or nuclear families, and as this production complemented millet cultivation but did not affect it, the position of the old men was largely untouched. The extended families themselves gained in importance as they grew less dependent on cooperation with other extended families. Finally, the labor services mandated by the colonial authorities and recruitment for the army were demands that extended families could cope with very well.

A decrease in small-scale and an increase in large-scale migration characterized the second colonial period, from the late 1940s up to the 1970s. While the plains gradually filled up and the people began to settle in the dune areas closest to the villages, labor migration, after a slow start before World War II, began to be quite important. Young men were first allowed by their families and later expected to work a stint in the large cities of the West African Coast, such as Accra (Ghana) or Abidjan (Côte d'Ivoire). Dogon laborers gained a reputation for energy and resourcefulness, and easily found employment. After a work period lasting between one dry season and several years, most of them returned to their villages, laden with modern commodities such as radios, bicycles, European-style clothing and of course, cash money. Monetarily, the villages grew dependent on this labor migration, a phenomenon well known in many parts of Africa as a "remittance economy".

Onion farming became more important, especially on the plateau. After a successful start in 1938 an increasing number of small manmade lakes were built. Dozens of these water sources enabled the plateau Dogon to concentrate on onion farming in an environment where formerly no cultivation—not even grazing—had been possible, a point to which we shall return later.

This is when the desertification of the plains began. The sandy dunes adjoining the escarpment began to be cultivated beyond their carrying capacity. The shifting cycle of the outfields was gradually foreshortened, and the supply of wood for fire and construction became ever more scarce. Dogon agriculture intensified, concentrating on three focal points: the plateau rim and the outfields in the wet season and the water holes in the dry season. This intensification, combined with the filling up of all ecological niches in the area, put the ecosystem under an increasingly severe strain. As the resources were diminishing, new kinds of limitations appeared. Fertilization of the soils became more problematic, as the onion and tobacco farming demanded ever more manure. The traditional ways of fertilizing relied on the residue of subsistence farming on the one hand and on animal husbandry on the other. As more cattle were introduced in this period, the ecology

of the area as a whole came under pressure, endangering the natural recovery of the soil by the old fallow system of the outfields.

Demographic pressure became an important factor. The Dogon population rose from an estimated 100,000 at the turn of the twentieth century to at least 300,000 in the early 1970s, and about 450.000 at the end of the century. Emigration became increasingly important, using the strongholds established by the migrant workers in the cities.

Dogon family structure, however, proved very flexible. The extended family shifted from a patriarchal one to a flexible cooperation of related nuclear families, a community of interests in which the second generation took precedence. During the wet season, when labor was very much in demand, the whole family lived and worked together, cultivating their joint millet fields. The dry season onion cultivation split the family into nuclear units on a basis of restricted profit sharing. When the outfields were too far away from the village, or when one of the sons had settled in a plains village, the extended family remained a single financial unit: both the plains and the escarpment parts of the family contributed to its common fund. This kind of extended family, in which members do not live together, proved to be very flexible in both arranging labor and meeting expenses as well as profiting from the varied resources of the region. Spreading out the families enhanced the chances for survival in an ecological system that proved over the years to be less and less dependable.

The old men did lose some of their importance, although they retained control over the infields, over the finances of their families, and over the performance of ritual. As onion farming, for example, gave rise to new cooperating groups (such as the groups of people using the same water hole) the network of relations in the villages grew more diffuse. Still, as kinsmen tend to live close together and peers tend to cultivate together, the warp and woof of lineages and age groups remained dominant in the cliffside villages.

Villages in Dogon

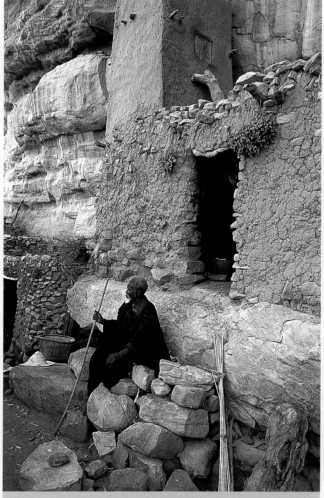

THE GUARDIAN OF THE SACRED cave above the village of Teli is also the Hogon, the village or regional priest. He serves as the head of the cult of Lèwè, the Dogon "god of the earth" represented as a snake. The Hogon resides in this little house high on the cliff, whose back wall is the escarpment itself.

VILLAGE

country along the

escarpment are composed in clear-cut social units. A village like Tireli, one of the larger ones along the cliffs, comprises two halves: Teri Ku ("head of Tireli") in the south and Sodanga in the north, both roughly equal in size. Each of these halves consists of three wards, one large one and two small ones. Each ward includes a few clans, usually two, called *gina*, meaning literally "big house." The larger clans are divided into what anthropologists call lineages, kinship lines that can be traced directly and in which all living and dead members are known by name. Basic units are the extended families. Dogon trace their clans and lineages along the father's heritage, patrilineally. Thus, everyone belongs to one's father's lineage and clan.

In Tireli as elsewhere, some special buildings mark the wards and clans. Each ward has its dancing square, *tei,* a small flat area on the village slope where the public dances and festivals are held. A heap of stones in the middle marks the ritual center, a sacred place where no one should ever sit. Overlooking the *tei* is the major *toguna,* the men's house, one of the four or five in each village. A striking, open-sided structure, the *toguna's* enormous thick roof rests on stone pillars just high enough to enable men to sit inside. Here, men of all ages discuss important ward matters, chew tobacco, or doze in the heat of the afternoon.

In each ward or village half a special building is reserved for menstruating women: a round hut where the women cook and sleep during the week of their period. Usually this *yapunu ginu* is near the center of the ward, in view of the men in the *toguna.*

In the village's wards, each clan and lineage has a central house, usually a very old structures, the ancestral abode, called *gina,* like the word for clan. On the cliffside these usually are simple; on the plateau they are decorated with rows and rows of small holes. Inside this building, some altars and a small shrine form the focus of the clan cult. In addition, most wards have one major shrine, standing apart, that is used by the ward shaman.

Each village ward houses two or three clans, large family groupings that trace descent through male ancestors only. A Dogon clan typically numbers between twenty and eighty households restricted to a village. The larger clans are subdivided into lineages, two or three per clan. In the large clans people know they are related and stem from a common ancestor, but do not know exactly how. In the lineages and the small clans, people can trace their kinship precisely and know all the names of the linking ancestors. Kinsmen tend to live close to each other; brothers and "cousins" are often next-door neighbors. The farther away, the more remote the clansmen are. Thus, people live with large families, among kinsmen: they work with their kin, converse and relax with kinsmen, dance, drink, and feast with their kinsmen. Often they marry kinswomen (but not clan members), and in fact all of a village half consider themselves children of the same "father." The other village half constitutes the preferred "in-laws," where the wives often come from.

Among the Dogon chronological age holds considerable weight, showing itself in social interactions, as well as in things as simple as where one lives in the village. The oldest men live in the lineage or family compounds in the center of the village, high up against the scree. A young man who builds his own house for the first time seeks a spot, usually at the low end of the village, close to the rivulet. There he finds his peers, often his cousins, building at a nearby site. When he grows

IN MOST DOGON VILLAGES
such as Ogosogo (seen here) the head of a clan lives in a *gina*, considered to have been built by the clan's founder. The present clan head, the oldest man, will live here until his death. Here, a visiting boy climbs down from the high door.

older he gradually moves to the older houses uphill, first of his father, later perhaps of his grandfather, and if he lives long enough, to the clan house uphill.

The old men not only occupy the old cult houses and command the village altars, they also are in charge of the best fields. All fields within view of the village belong to the oldest men in town, as part and parcel of their position as elders of a lineage. Of course, by that time they are no longer able to cultivate these fields, so their young descendants profit, and the old men receive food. So for a young man it is imperative to have an old relative alive: he can then cultivate close to the village. An "orphan" without an old parent has to go way out into the bush and cultivate more hostile, barren, and formerly dangerous fields.

The oldest man in the village holds a special place: he is the Hogon, the village priest. In many villages he may not wash himself nor leave his compound. Once, a Hogon did not even walk, he

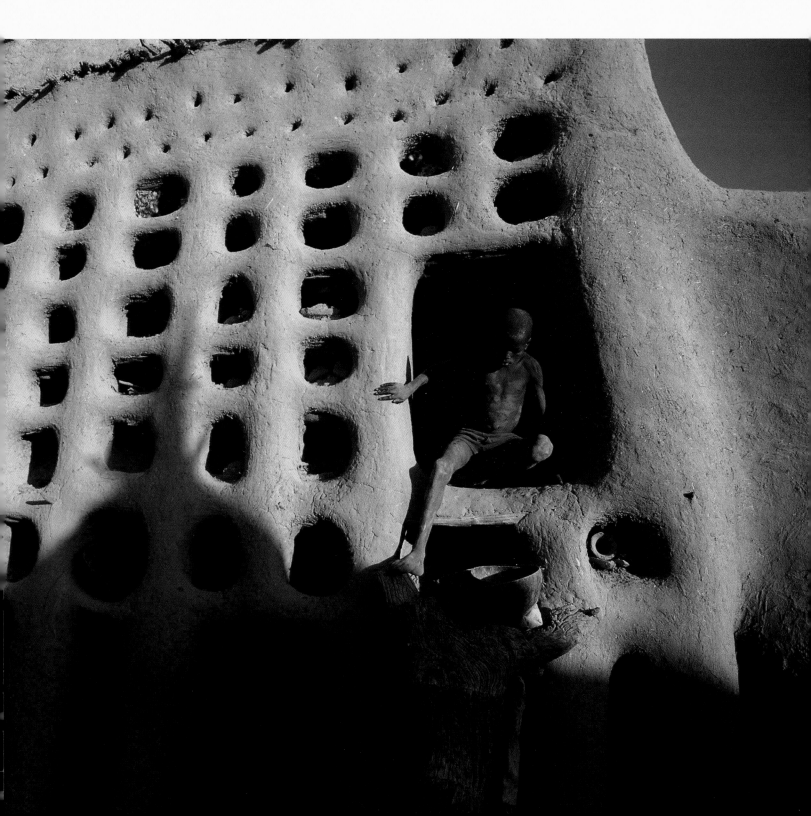

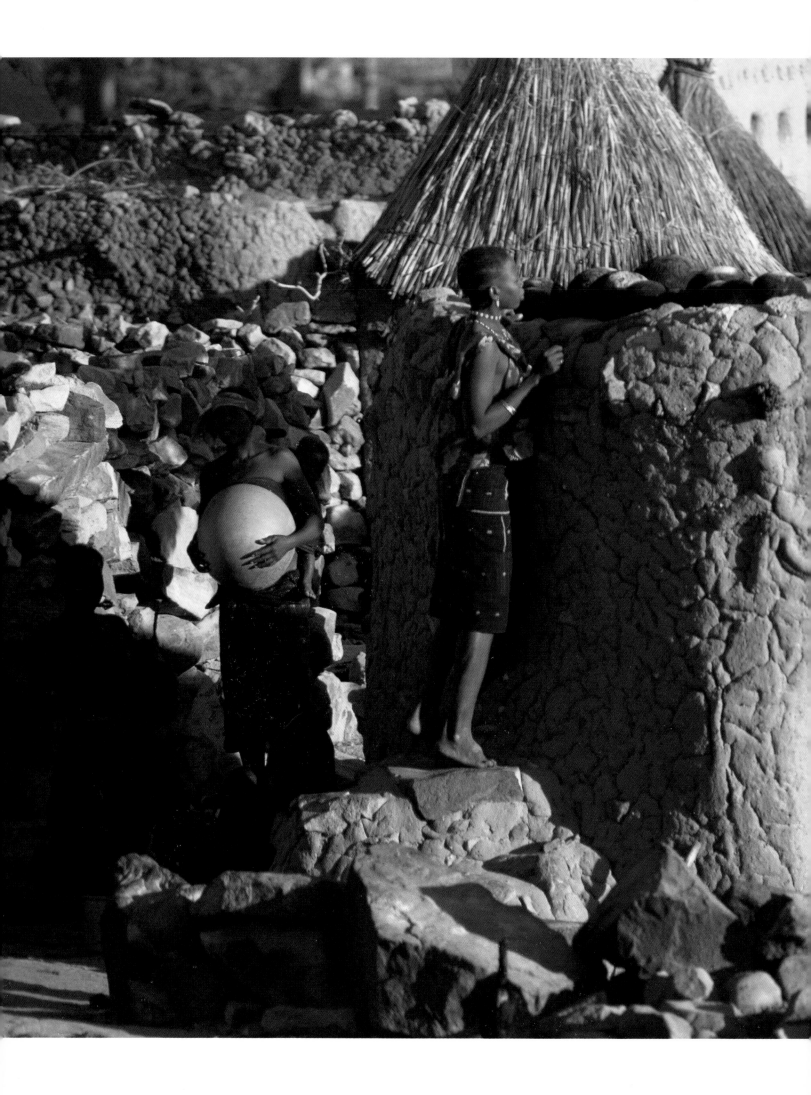

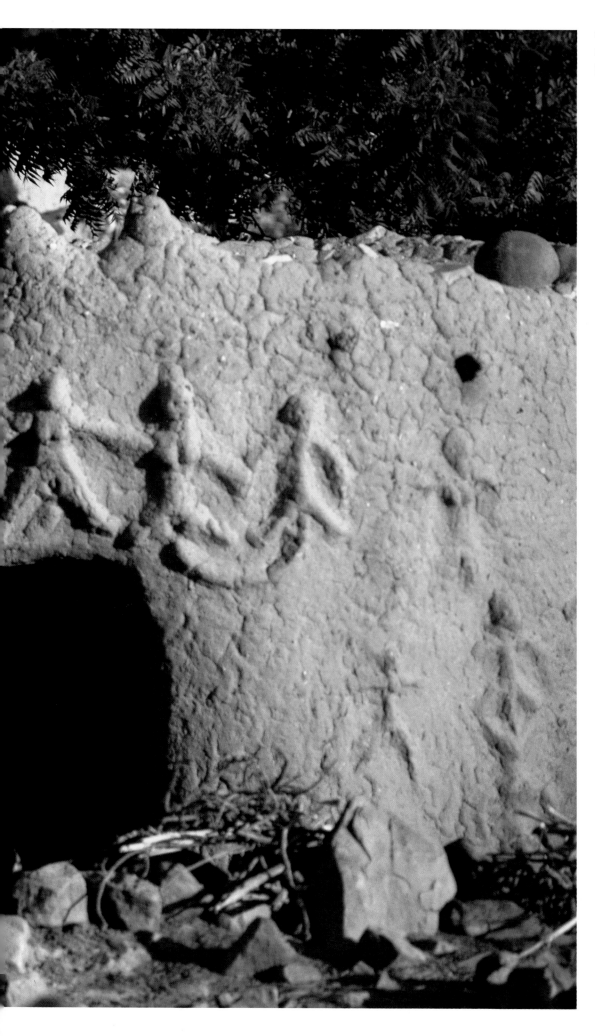

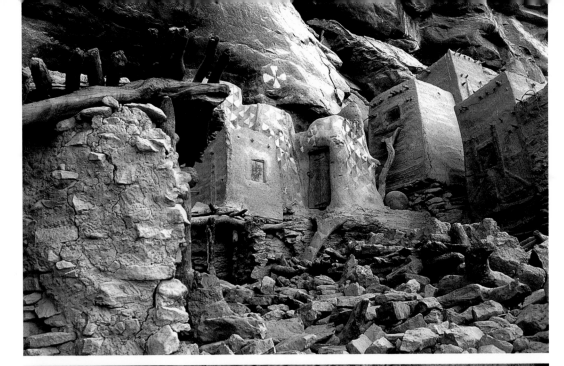

Right:

IN A CAVE HIGH ABOVE

Teli, the burial crypt for previous Hogons nestles between boulders. The walls of the crypt are shaped from clay and painted in traditional geometrical patterns with mineral and vegetable pigments.

Lower right:

BABOON SKULLS ADORN

a wall high up on the cliff in the sacred cave of Teli, which was also formerly a Tellem burial cave. Baboons are almost extinct in Dogon country now, where wildlife of all kinds once abounded. An expanding population, with few taboos against any kind of meat eating, has taken its toll.

Opposite:

IN THE VILLAGE OF YOUGO

Dogorou, a sculpted door marks the entrance to the sacred house of the Hogon, nestled high in the cliff. Doors such as this one, with a woman's breasts carved on double planks of wood, have become extremely rare and can be found in only the most isolated of Dogon villages. The female breasts represent fertility and kinship.

Overleaf:

EVERY TEN YEARS OR SO

the men gather to rethatch the millet stalk roof of their *toguna*, according to a date set by the elders. Many reasons are offered for the low height of the toguna roof. The most common is that it inhibits quarreling, as angry speakers cannot stand up to make their points.

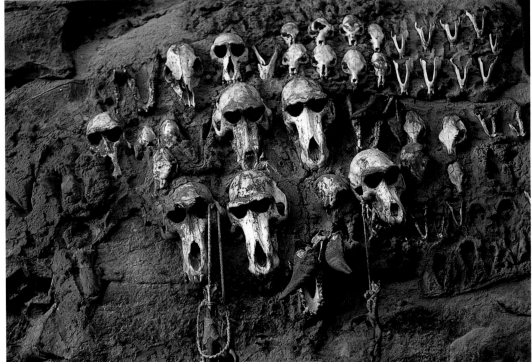

was carried on the shoulders of kinsmen. He performs all sacrifices, leads ceremonies, and must excel in benedictions to his descendants. Also, he will name the babies of his clan and purify those who have transgressed against the taboos. In Tireli, the village mostly pictured in this book, the oldest man of the village functions as a Hogon, though he does not carry the name and is less restricted in his behavior and mobility than a Hogon would be. Tireli and the village of Pegue fall under the influence of the mightiest of all local priests in Dogon country, the Hogon of the relatively small village of Aru. His function and his importance go way beyond the relative unimportance of the village of Aru itself: he is the central figure for the Dogon heartland.

WHAT'S IN A NAME?

Dogon people have many names, and the first of those is given at the end of the birth period. After thirty-five days (seven Dogon weeks) the mother may leave the family compound and eat and drink together with other people. On the fortieth day she presents the baby to the oldest man of

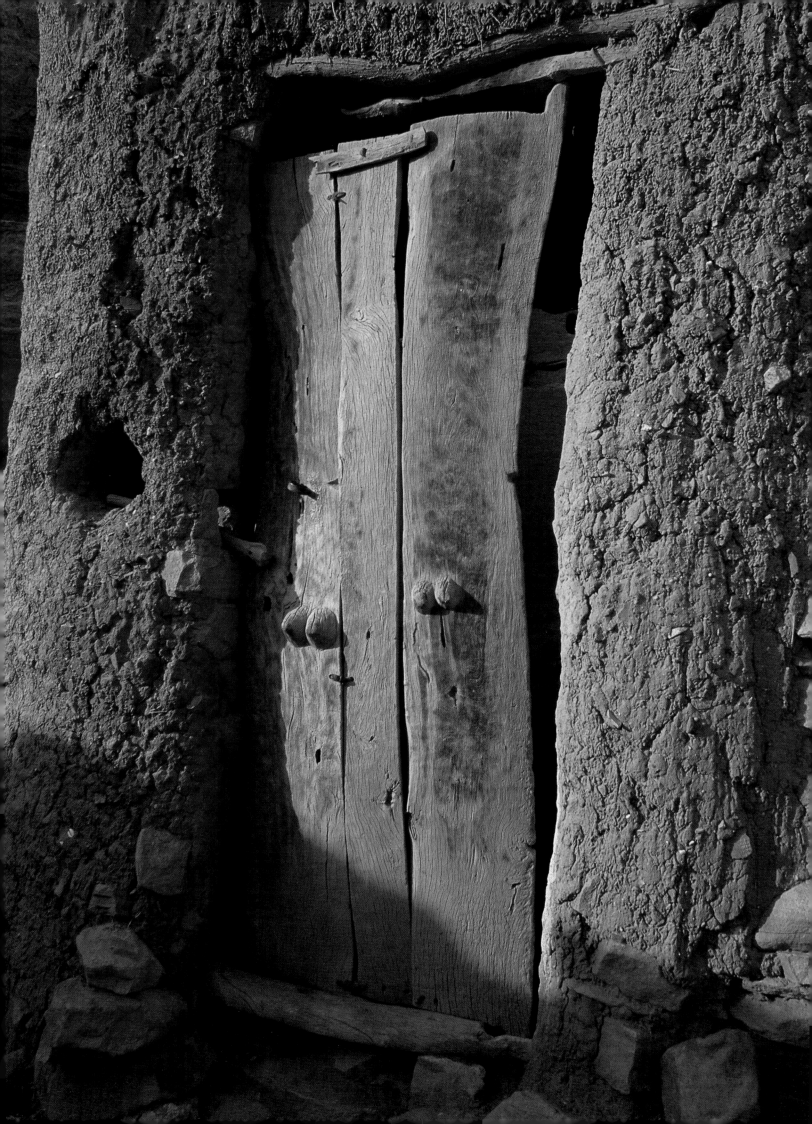

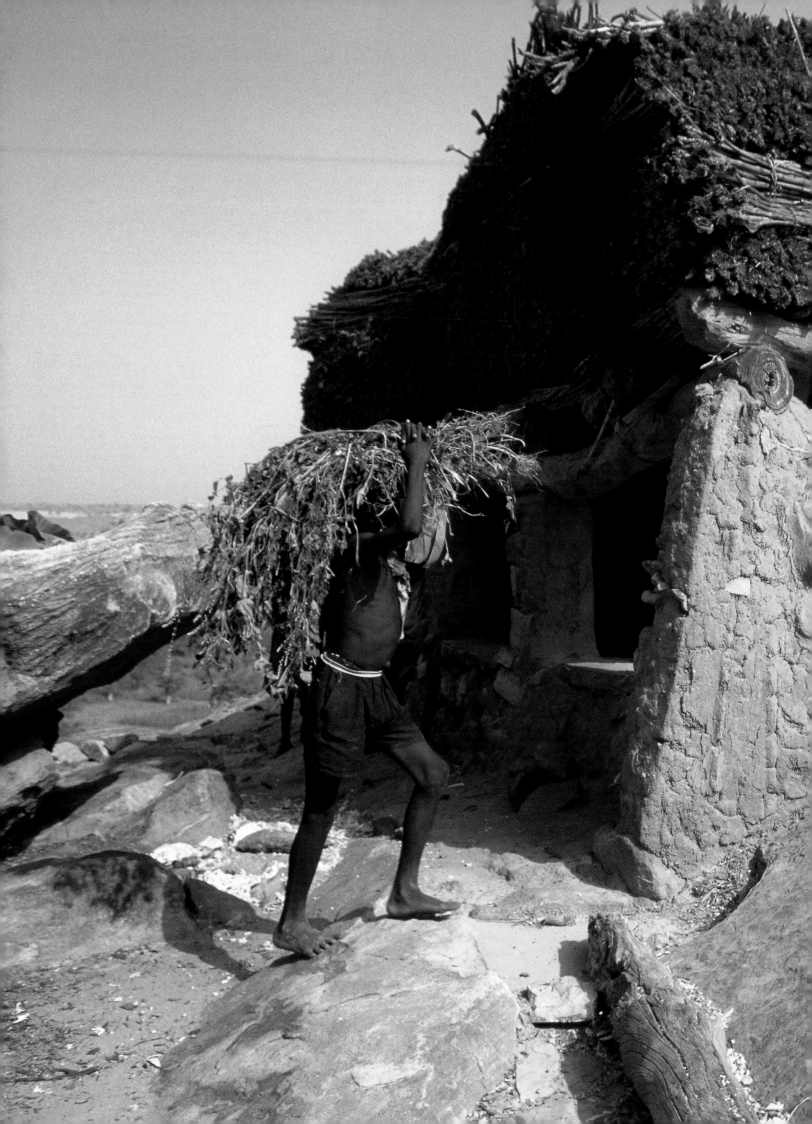

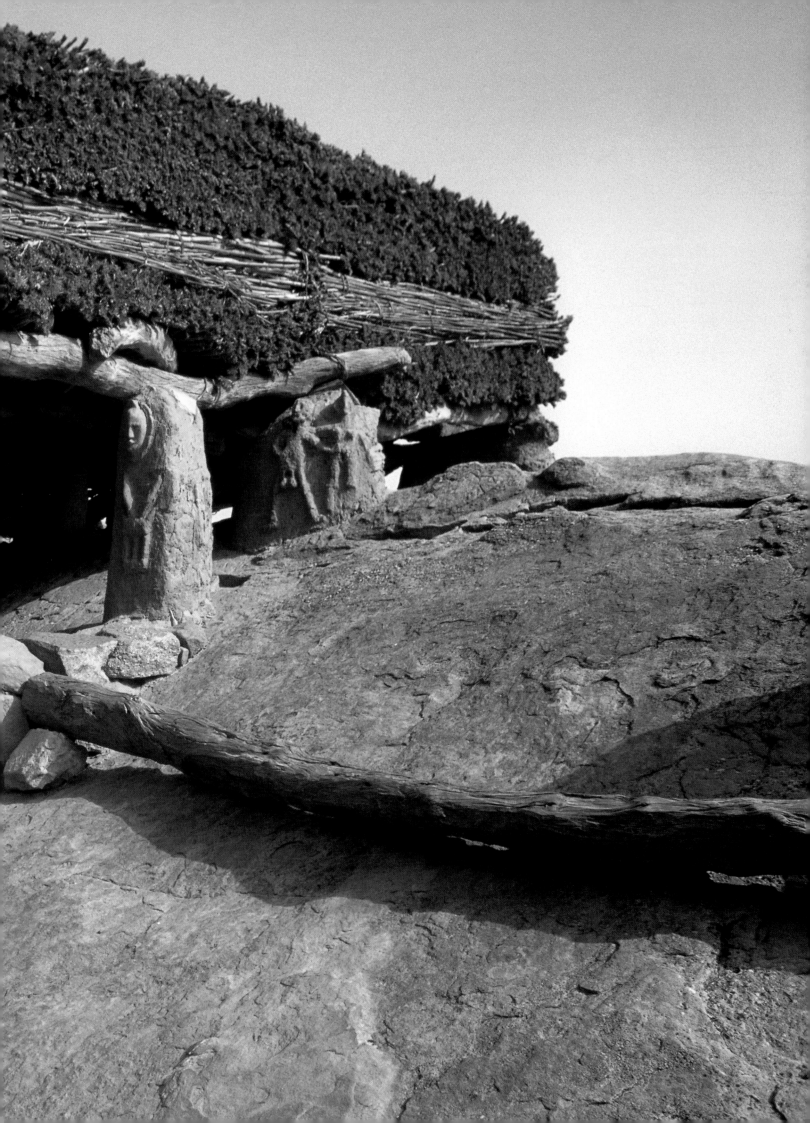

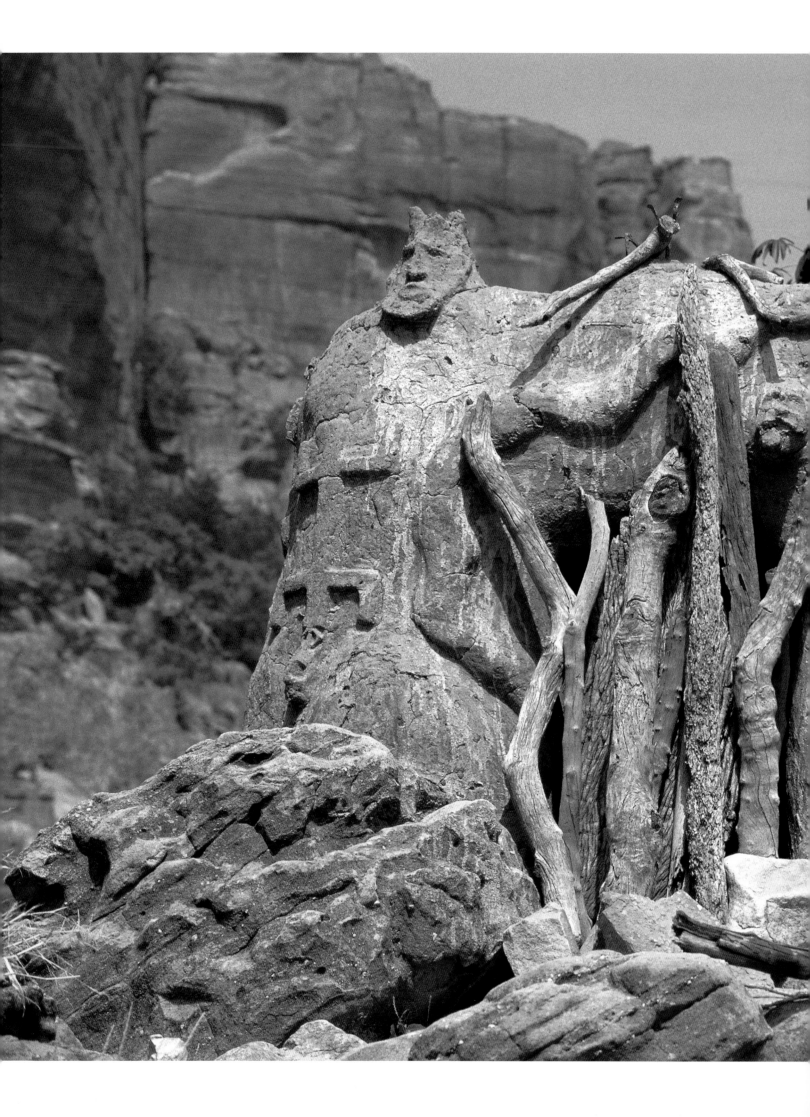

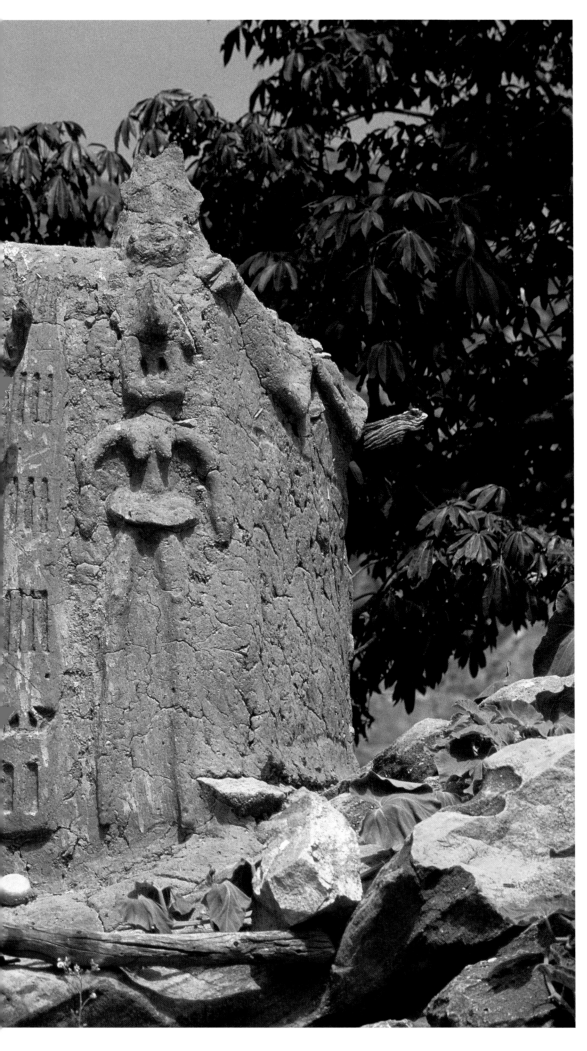

THIS *BINU GINU*, a shamanistic shrine in Komakan, serves the *binu kèju* (shaman), who makes sacrifices on behalf of the whole village. The *binu* are spirits belonging to the place and they are so powerful that they may take possession of the shaman and put him in a trance, from which he may have difficulty recovering.

the lineage, the one who inhabits the *gina*, the lineage house. She gives the old man a small gift and shows him the child. Seated next to the altar of the lineage, the old man gives the child its *gina*, or lineage, name and performs one of the many blessings that fill Dogon social life. Invoking the name of Ama, the high god, the elder wishes the child and the family peace, asks for another day for it to live, and orders its obedience to the elders. Curiously, on this happy occasion, the name the elder chooses often implies some criticism of the child's family. Names such as "The wealth has not found me," "Respect is no longer," or "Forgotten," say nothing about the child but bring the message of the old man's feelings home to the parents. The name "Dogolu," for example, means, "Shame has not left me," indicating that the old man felt a lack of attention from Dogolu's parents. He then presents the baby with a few coins. If the mother has some meat, she will give it to the elder. Five days later, the baby is presented to the father's parents and receives their names, one from his grandfather and sometimes another from its grandmother.

These are only some of the many names that a child receives: any close relative may give his or her own name to the newly born. The father gives his name, the mother hers, as do the grandparents. But the basic name of any baby is based on its birth order in relation to its mother: a woman's first male child is called Ato, or Yato if it is a girl. Her next child is Atime or Yatime, meaning "second child": the third one becomes Atanu or Yatanu (literally "the third one") and so on. Thus, a name carries a lot of information. Dogolu's oldest surviving son, Atime, is his wife Yasaa's second. The first son, Ato, died in infancy. These birth-order names are often used by the mother: "her Ato, her Yatime", and they often stick. As there are many Atos in a village, however, this birth-order name forms only part of one's identity: one may not be called Ato but still be an Ato.

Who gave birth to a firstborn child, and which characteristics mark them, are indicated by other names. Different people may employ different names for one person: one's identity varies according to the network of relations and the relevant reference group in question. Finally, specific circumstances in Dogon life call for a special name: for instance, children begotten without menses between them and the preceding sibling are called Akunyu or Yakunyu. More rare still, girls born or conceived during the *sigi* festival carry the name Yasigi. The same holds for twins, whose birth calls for specific rituals. Though many are addressed with these "structural names," many others are not.

Finally, when people become older, they may choose their own name, which may stick. Thus, when a child grows up some consensus may prevail about the name, although in many instances people are called different names by different persons. For example, Dogolu called Domo, a cook who worked for the authors, Madu, a name that the cook had chosen for himself. He was known as Domo, the name his old grandfather had given him, to his neighbors in Tireli, and he was referred to as Anu (meaning "fifth child") by the people from Sangha. Occasionally, Dogolu's nephew called him Jauire ("better than a leatherworker"), a name his age-mates had given him. But nobody mistook who he was; people knew all his names.

In the complex Dogon network of relations, many feel a need to stress some individuality in a special name, the *tige*, which resembles a motto. Each *tige* has a story behind it, and one's *tige* may be used in ritual contexts, in comradely beer talk, in singing. In teasing, people always use each other's *tige*. Most young people choose a personal *tige* when reaching the age of marriage in order to describe their own view of themselves. The above mentioned Domo had as his *tige* the motto *joũ girè*, hare's eyes: he liked to look without comment, be cunning without harming people.

Thus, the Dogon kinship system expresses the way of life in the village. Any Dogon can call half of his ward with a kinship name. The Dogon kin terms are used very broadly: any clan member in principle is family. All people from the same *gina* are either father/mother, brother/sister or child. So children from a pair of sisters or from a pair of brothers call each other "brother" and "sister," children from a brother and a sister call each other with another term, like "cousin." This system is not unusual in kin-based societies and is called Iroquois by anthropologists. Special among the Dogon is the attention paid to age in these names. In fact, no single term for "brother" exists: one has to distinguish "younger brother" and "older brother" (*sungunu, dere*). The same holds true for the brothers and sisters of one's parents. For example, one's father's brother may be either a "big father" or a "small father," depending on his age relative to one's genetic parent. The same holds true for a mother's sisters.

So when speaking to a kinsman, a Dogon always indicates the lineage and age of the relative. An important pair of terms relates to the mother's side of the family: here, too, the terms apply widely. For example, all men from one's mother's lineage are called "mother's brother" (*ninyu*): all women are either "big mother" or "small mother" depending on whether they are older or younger than one's "real" mother. And all these women would address one as "sister's son" or "sister's daughter," *lèdyu*. Similarly, if one's mother has moved from Amani to Tireli, one is called *lèdyu* by all people of Amani.

ROLLING A GOATSKIN around under his feet, an artisan in Ogosogo softens the leather before beginning to make a bag.

JOKING PARTNERS

As usual in patrilineal societies, the father's line commands the most respect. A son should respect his father and father's father very much, showing deference and obedience. He will never use proper names, but always the kinship term. For the mother's side, however, a lot of affection and easy humor passes between relatives. Between *ninyu* and *lèdyu* jokes are allowed.

Here is an exchange I witnessed in a market in Teri Ku: Dogolu came across a young woman, who after greeting immediately began to scold him, saying that he was a worthless bum, no good to anyone, and that he should die on the spot. Dogolu responded in kind: he was glad she did not have a husband yet as she would render anyone miserable, smelling as badly as she did. After a jolly five minutes of give and take, he happily explained to me: "She is my *lèdyu*!"

This kind of joking between certain relatives, called *gara* in Dogon, occurs commonly in Africa and forms part of most patrilineal systems. Some villages are *gara* to each other: Guimini and Tireli, for instance, have such a joking relationship. Living some twelve miles apart, the villagers

do not cross paths too often, but whenever they do some gentle joking takes place. Sometimes during funerals in Tireli distant relatives from Guimini may turn up. Then they become the clowns of the burial festival, mimicking the dead, making fun of the mourners. At the last funeral dance a Guimini woman started to prance around with a wooden stick, mimicking the horse the deceased had owned for a time. All of this was borne with good-natured acceptance.

Dogon society includes one or two special castes or classes of people, the blacksmiths, the leatherworkers, and their kin. In Dogon country, as in most of savanna West Africa, these special groups operate with certain special restraints and controls. For instance, a blacksmith may only marry a woman from the same blacksmith group and has to stick to his trade. Each village should have one or two blacksmith families, for their work is essential. Blacksmiths make and repair metal utensils, make guns, and carve wood. Their workshops also serve as a ritual center. For instance, when a new anvil is installed in the village, the whole village gathers to feast and sing, to offer sacrifices, and to chant. That anvil may never be removed, even when the blacksmith decides to move his shop or dies. The spikelike anvil indeed is considered the foundation, the root of the village. If it becomes loosened, the village may drift.

THE SON OF BLACKSMITH
Bryma Say pumps the goatskin bellows for his father's forge. Among the Dogon the blacksmith caste is powerful, respected, and feared. Formerly the ones who changed "earth" into iron, they still are indispensable in agriculture, and have a specific ritual position as intermediaries between man and the supernatural world.

FOR BLACKSMITHS,
new iron is often taken from derelict automobiles. This supply has replaced the old iron produced in Africa's traditional smelting ovens. Though smelting is no longer done in the Dogon area, the old iron remains available in the form of tools or bars. It is highly prized. According to Dawuda, one of Tireli's blacksmiths, it withstands reheating and reshaping much better than new iron, it lasts longer, and it rusts less. Why this is so is not quite clear, but it may be that the locally smelted old iron had a high proportion of elements such as nickel.

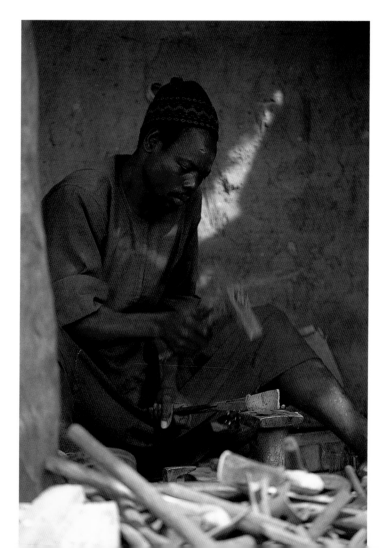

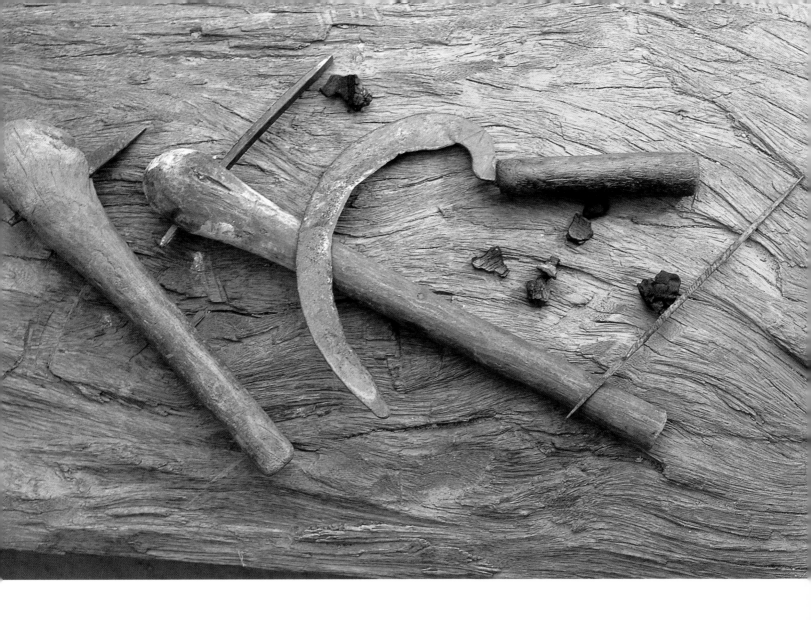

SOME OF THE TOOLS FORGED
by Bryma Say, a blacksmith in Tireli, include an adze, hoe, sickle, and piercing iron.

Leatherworkers, another castelike group, are less dispersed: they are the tanners of the goatskins and cattle hides, and their women dye the indigo cloth that all Dogon women wear. Increasingly they serve as the intermediaries for the tourist trade: most of the commerce in statues and masks today falls in their hands. Leatherworkers are not found in every village but live in easy reach of the most important markets.

Between these groups joking exchanges also occur: blacksmiths tease leatherworkers and vice versa. The easy interaction of their relationships may in part be bolstered by the fact that the two groups are not allowed to intermarry. It is not the profession, though, that counts here, but the group identification. Everyone born into the blacksmith or leatherworker group will always remain a member of that group. The term *caste* has been used for this system, and with some reason.

A famous case of interethnic joking occurs between the Dogon and the Bozo, a people who practice fishing in the inland Niger delta around Djenne. A strict taboo on marriage reigns here as well: no Dogon man may ever marry or have sexual intercourse with a Bozo woman and vice versa. The reason for this taboo, as for the one between blacksmiths and the leatherworkers, is hard to discover. A number of stories circulate to explain the matter. Most of them begin at a time when both groups lived together and a problem arose. One example:

In the days of old, a Bozo man in Djenne had two wives, a Bozo and a Dogon wife. Famine struck the city, and the family became hungry. When all supplies were gone, and it was the Dogon wife's turn to feed the family, she cut a piece out of her thigh to feed them. At first husband, co-

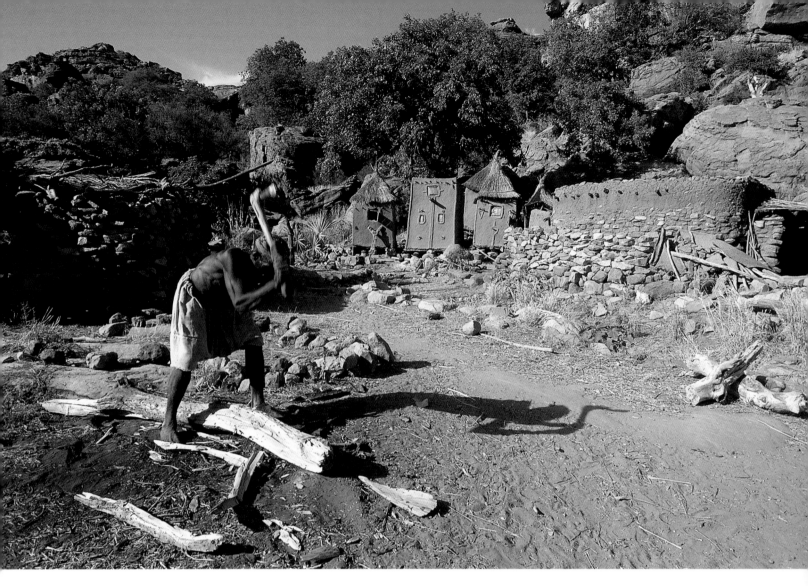

IN THE VILLAGE OF ELI ONLY
the women, children, and the eld-
erly men have remained behind:
as the lack of rain in the region has
forced able-bodied men to strike
out in search of work elsewhere
after a poor harvest. This pattern
began with the extreme droughts
of the 1970s and continues today.

Right:
BUILDING A NEW GRANARY,
the chief of Teli mixes mud with
straw to form walls. Once this
newest layer has hardened in the
sun, another layer of adobe will be
applied.

Opposite:
IN AMANI, WEAVER
Wasserou Poudiougo fashions
a basket from various grasses,
cane, and reed.

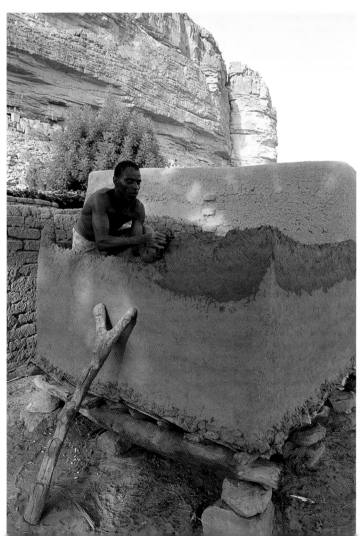

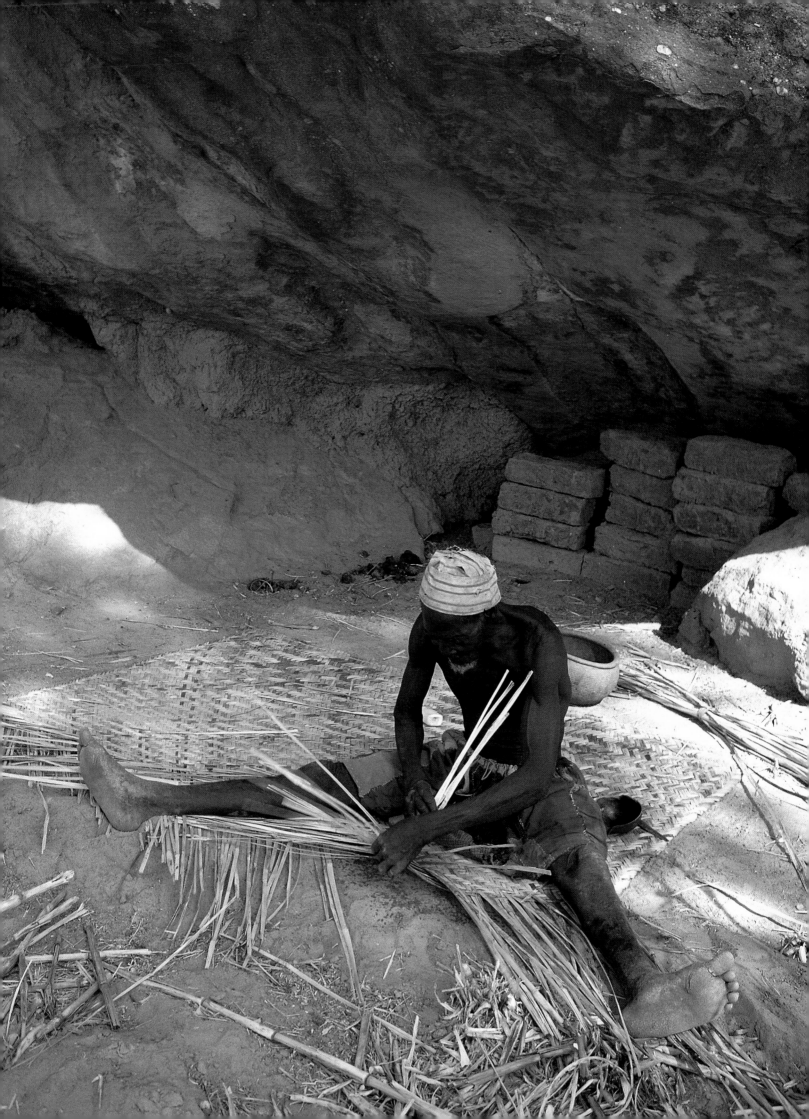

VINTAGE DOGON GRANARY doors are much sought after by foreign collectors. The Dogon believe that figures carved in the doors, such as the lizard and Nomo figures, give the owners status, but in times of hardship and famine they have been prepared to sell the doors as art objects. In the village of Djiguibumbo on the plateau above the Bandiagara escarpment the chief displayed these doors, which he hoped to sell to Japanese collectors to pay for millet for the village. The doors were sold the next day.

wife, and children did not notice anything, but the next day the husband saw something was missing from his second wife. "What have you done?" The Dogon wife explained that she had fed him and his children with her own body. Then the Bozo man decided that this should never happen again and that such a sacrifice must never be asked. So, henceforth, no Bozo could marry a Dogon.

THE FAMILY COMPOUND

The extended, polygynous family forms the basic unit in Dogon social life, and usually consists of a man, his wives, and children, and, if they are alive, his mother and father. The word *ginu* stands for the house and the compound surrounding it—sleeping huts, granaries, a stable—all set in a kind of circle around a courtyard. Walled in with a simple, low stone fence that marks the limit but allows neighbors and passersby to look in, a Dogon house lies open to the rest of the world. A typical family compound has a hut for the man, a hut for each of his wives (not often more than two), and a fair number of granaries. An altar, tucked away in a corner of the compound, and if possible situated under an overhanging rock, serves for worship and sacrifices.

The flat-topped personal huts contrast sharply with the pointed straw roofs of the granaries. The Dogon build four types of granaries: two for the men, and two for the women. Both types of female granaries have a door in the middle of the structure and small compartments inside. The most common type is the square *guyo ya* (female) granary. There the wife keeps her personal belongings and the baobab leaves and beans that she uses for the daily sauce. No husband will ever

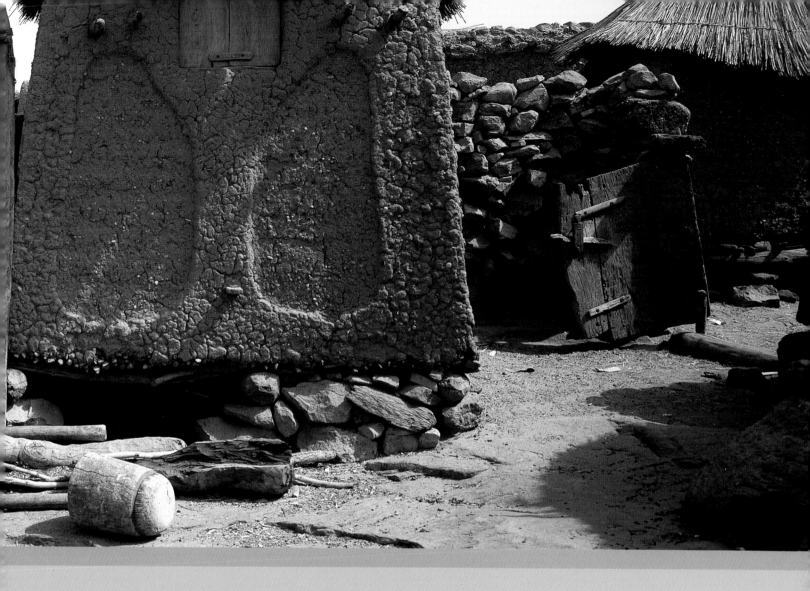

enter his wife's granary: it is her private territory, like a woman's handbag in Western culture. For some special harvest of baobab leaves or beans, the women use a less common round granary (*guyo totori*), also divided into small compartments. In addition to these personal spaces—the hut and granaries—each woman has her own cooking place in front of her hut and a washing spot behind it.

The man of the compound has at least one high granary, the *guyo ana* (male), with two levels inside and two small doors, one above the other, for storage of millet and sorghum. Though these staple foods are for the whole family, the men control their storage and bring the grains out for the daily meal. The second male type of granary, the *guyo togu* (shelter) is quite special: it serves as a dwelling for a very old man. The squat structure has a little door at ground level, just large enough to crawl through. The old man sleeps in the low part and uses other small compartments inside for storage. Very old men live in such granaries and usually are quite proud that they do so. After all, only old men are allowed to do so, and old age is a considerable achievement and carries a great deal of status and respect.

Although the functional parts of each compound are clearly demarcated, family living is more complex. If the old father of the principal man of a family still lives, his daughters-in-law go to his house to cook the daily meal in his compound. In that case, the whole family of the old man—his wife, his sons, daughters-in-law, and grandchildren—eats every evening in his compound. He still is the center of family life. Any old widow with a son usually lives in a small compound next to her

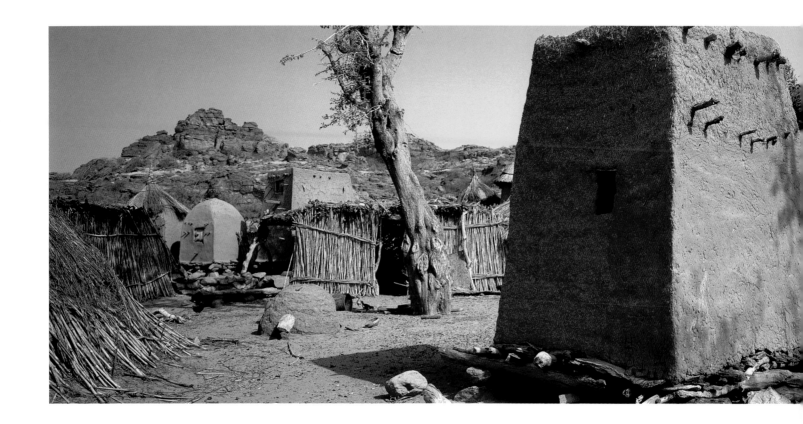

IN DOGON CLIFFSIDE
villages, granaries often out-
number dwellings. Some
residents have abandoned
their homes under the cliff to
form settlements on the plain
closer to arable land.

son's place. She helps her daughters-in-law with the preparation of the evening meal at her son's compound. A widow without a resident son has a problem. She will have to rely on her late husband's family to house and feed her.

The older daughters of a man help their mothers with the preparation of the food and eat at the family compound. However, if they are past puberty, they sleep together with some age-mates in the compound of an old, widowed kinswoman, who acts as their chaperone. Sometimes, however, they often do not sleep there at all, but at their boyfriend's house.

The older boys share a sleeping house with their peers, often their cousins. Such a house is built by all the boys but nominally acts as the residence of one of them. The boys sleep there and receive their girlfriends there, often on a rotational basis: each night the girlfriend of one of them sneaks in. The boys eat at their fathers' compounds, however. A boys' house can be easily recognized as it contains virtually nothing: no utensils, no objects of various kinds, barely a fireplace, just some sleeping mats.

So how is a Dogon family different from others? It consists of all those who *eat* together, not who *sleep* together. This is not unusual, in fact, in Africa, where a shared cooking fire is what defines the basic unit in society.

Men and women not only have their own huts and granaries, they also have specific tasks in the household. Dogon men take on the bulk of agricultural work, build the houses, repair the granaries, plait the straw for the roofs, and make utensils. The women fetch water, cook, weed the fields, harvest certain crops—mainly for the daily sauce—and make pottery. They also brew beer, which in modern times has been their chief opportunity to make money. The women of Tireli are renowned brewers and earn quite an important income from it.

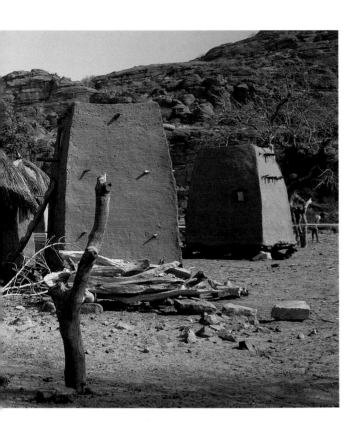

MARKET DAY

Thus, the structure of life in a Dogon village is quite complicated, divided as it is into halves, wards, lineage houses, and individual houses on the one hand, and into age groups on the other. Sometimes, during daily life and during rituals, those groups confront one another, and the dividing lines between them are quite clear. There is one instance, however, when all the divisions in the village give way to equality, at least an equality of social contact, in a massive interaction that includes everyone from the village and beyond—the market.

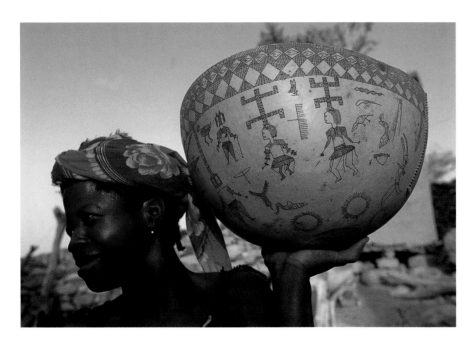

A DOGON WOMAN displays a calabash gourd carved with the designs of the *kanaga* (bird-of-the-wild) mask and other figures. The carving enhances the market value of the gourd, which she has brought to market to sell.

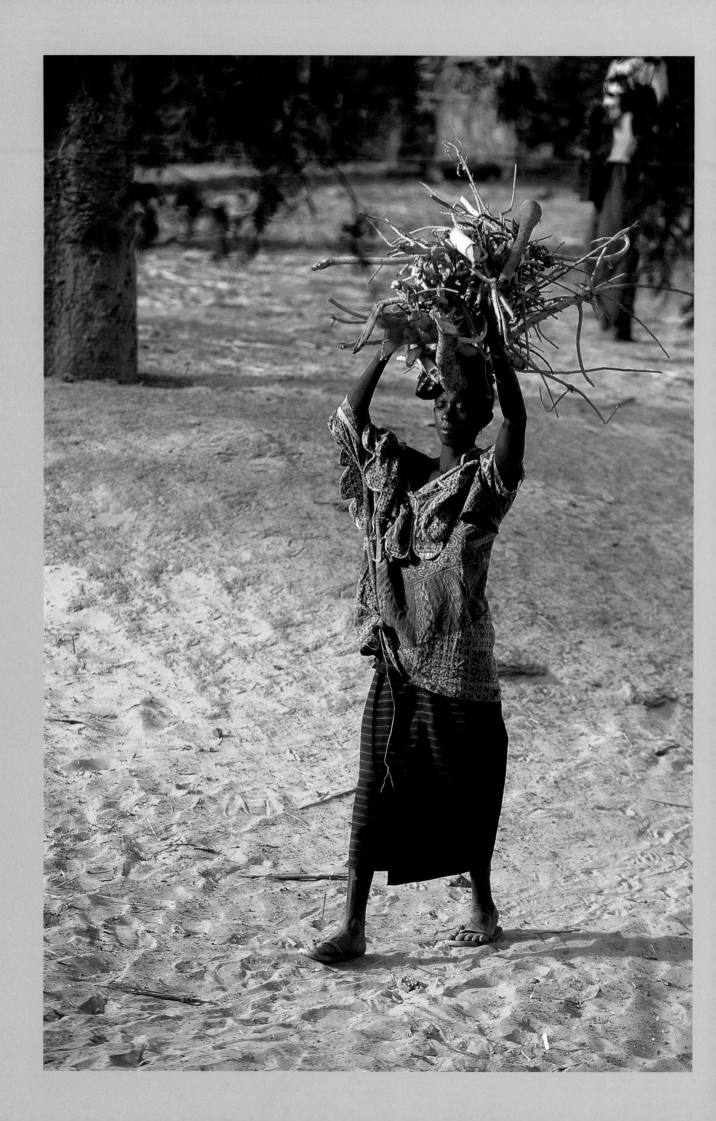

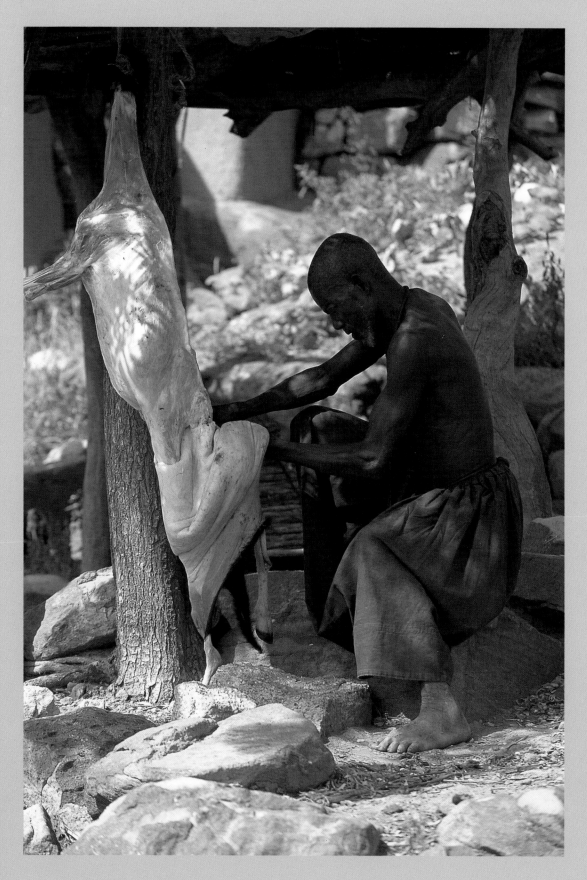

Opposite:

A DOGON WOMAN RETURNS from the bush with firewood she has gathered. The supply of wood needed to fuel cooking fires has diminished rapidly as the swelling population pressures the fragile environment. As desertification sets in along the Sahel, the Dogon women must travel ever farther in their quest for firewood.

A TIRELI RESIDENT butchers a sheep for sale at the market. Fresh meat is sold by a few Dogon butchers who buy a goat, sheep, or cow, slaughter it at the marketplace, and sell it. Virtually everything is used.

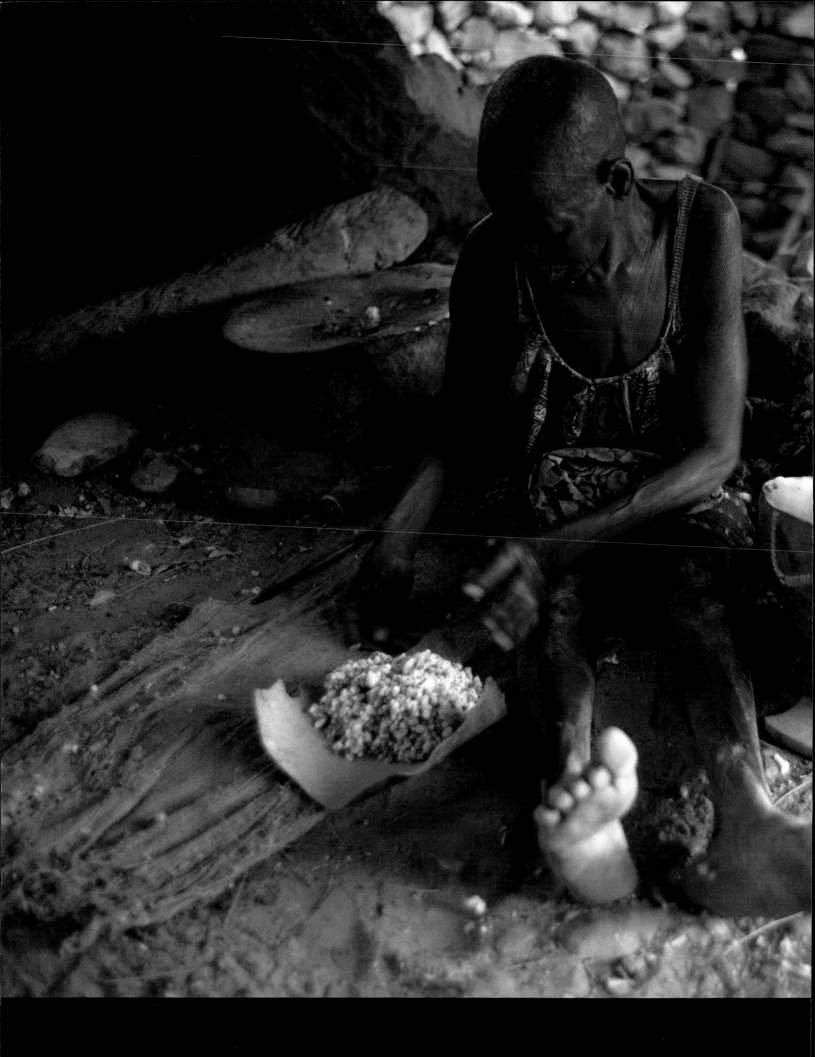

A WOMAN CARDS LOCAL cotton to prepare it for spinning and weaving.

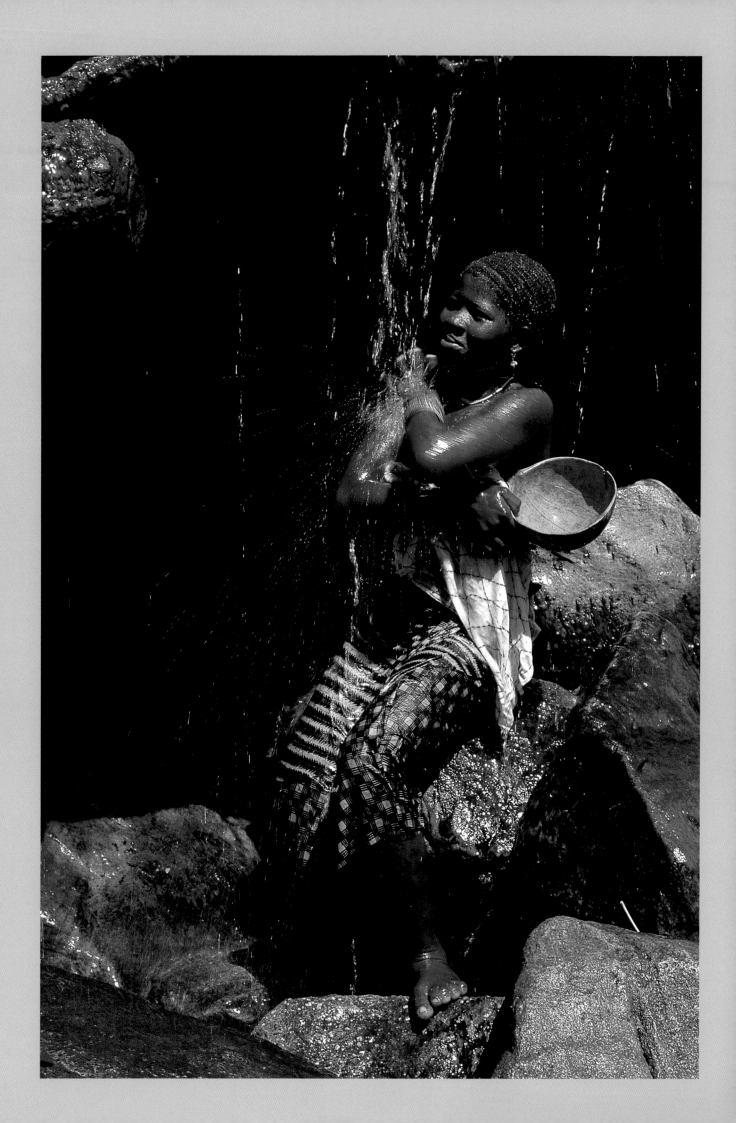

On an average market day, the women go about their usual tasks, fetching water, cutting firewood, pounding millet in the morning. A few women in the ward are busy with their beer; the other women know exactly who plans on selling today, and they let the word go around if they intend to brew next week. (A week in the Dogon calendar is, of course, five days long. The seven-day week of the European may operate in the rest of Mali, and in Dogon country it regulates the schools and the official calendar. But at the cliffside the Dogon still cling to their cherished five-day week.)

On market day, at about noon, the women and men prepare themselves, stopping whatever other work they were engaged in. The husbands and their wives wash themselves behind their personal huts, and dress up. The women put on their best indigo *pagnes* (wraparound skirts), with a cotton print bodice. The men don their most colorful long flowing gowns, with the characteristic Dogon baggy breeches. The younger men sport elegant straw hats that define them as adults but show that they are still young and up-to-date. The wives gather the things they want to sell; perhaps some vegetables, some grilled peanuts, or a calabash with peanut or millet-paste balls. Usually, they set off for the market before their husbands are ready.

Market at Tireli takes place at the foot of the cliff, near the rivulet. Approaching, the low roar of voices becomes clearer and louder. A veritable torrent of human speech spills over the small dunes, revealing a mass of people, crowded under the large trees or in full sun. Voices everywhere, speaking, cajoling but above all greeting. Just a few steps into the marketplace, one is greeted by people who are known, and by many who are totally unknown as well. This is the Dogon way. The market is full of greeting. Sometimes groups greet a newcomer, a half dozen men question-

Right:

THE BRIGHT RED LOCAL
clay, rich in iron and dug from
the base of the cliffs, is non-plas-
tic. Pots are made, therefore, as the
potter forces the clay into shape
by pounding it with a stone or a
special pestle rather than turning
it on a wheel or modeling it.

Opposite:

REMOVING BAKED POTTERY
from the fire pit, a Dogon elder
dusts off the ash from the vessel
that is still warm. Some twenty
villages get their pots from Tireli,
and the pots can be found as far
away as Bandiagara, about twelve
miles away.

Overleaf:

TWO TIRELI POTTERS,
wives of Dogolu, leave their wares
to dry on the roof of their hut, well
exposed to the sun. By the end of
April, each has about three dozen
pots of various shapes and sizes
ready for firing. Early one morn-
ing, they load the pots in nets and
carry them down the slope to the
kiln of the ward, a wide shallow pit
lined with stones. Gray-black from
repeated firings and with heaps of
white ash around them, Dogon
kilns are landmarks in the yellow-
brown of the villages. Dark heaps
of firewood to be used in firing are
strewn around.

The women line their season's
production of pots on the floor
of the pit, then cover them with
straw and firewood, bark, and
dried dung. Mixing dung with the
firewood serves both to slow the
fire and to produce decorative
black spots on the bowls and jars.
A girl must light the fire: it is
believed that if an adult woman
fires it, it burns too quickly.

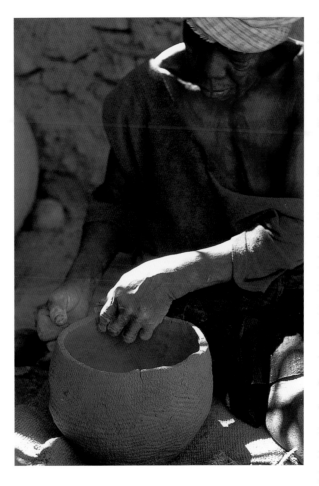

ing and responding in strict unison.
Especially at the start of the market,
greetings take up the bulk of the conver-
sation, gradually giving way to more
general trade talk, and finally to beer talk.

People come to the market not only to
greet. Market serves for talking and drink-
ing, buying and selling, showing and look-
ing. It becomes a meeting point for the
two halves of Tireli, which are almost vil-
lages in their own right, and is also a meet-
ing point for people from other villages.
Some traders bring in goods from beyond
the Dogon area. Coming from Sangha on
the plateau or Koporo in the plains on
donkey cart or by bicycle or motor scooter,
enterprising men sell dried fish (from the
inland Niger delta), cloth, clothing, cof-
fee, sweets, sugar, batteries, and more.
Millet comes in from the plains villages,
and vegetables arrive from neighboring Dogon villages (their specialty), but the bulk of the mar-
ket's fare is home-produced. A few Dogon "butchers" who buy a goat, sheep, or cow, slaughter it on
the spot, and sell it retail, offering it as fresh meat or boiled in a salty stew over a slow fire. Men
bring in tobacco for sale, often in the form of snuff. Almost all women sell and buy at the market,
offering anything they can produce: all the many kinds of ingredients for millet sauce, beans,
peanuts, and flour balls, often with the penetrating smell of almost-rotting hibiscus leaves that
lingers long after the market has ended.

Beer, of course, figures prominently. Each ward has its proper place at the market, one to sell
produce, and one to sell beer. Most women start fermenting the beer just before noon. At noon the
market is still quiet, with only a few people butchering animals, heating the fires, laying out trade
goods on the flat boulders of the hillside. Between three and five, the pitch of activity at the market
is at its height and a steady roar of human voices echoes off the cliffface.

The contrast between the colorful cotton bodices and gowns and the dark indigo *pagnes* of the
women captivate the eye; the tobacco-dyed brown of old men's outfits offer a warm visual counter-
point. All women wear scarves of various bright colors and fabrics around their heads. At first sight,
the market at this time looks like a colorful throng moving at random, without structure or organi-
zation. But the opposite is true. The geometry of the market is quite regular: though only simple
stones mark the sellers' places, three narrow lanes form the core of the market, divided into sec-
tions for men and women, and for each of the village's wards. The same holds true for the neigh-
boring villages, which occupy the fringes of the market. Thus, the Tireli market in its geometry
mirrors the geography of the area: to the north the people from Ireli and Amani, to the south
Komakan, and at the side of the mountain the people from Nandoli, the village on the plateau. As

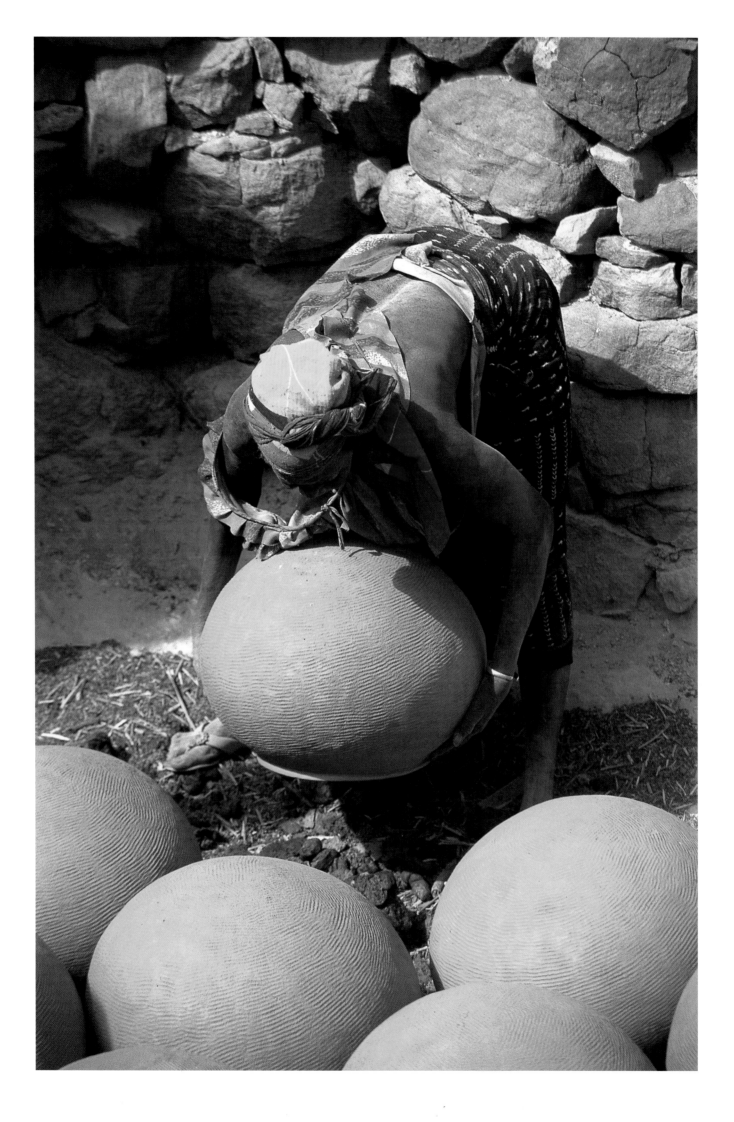

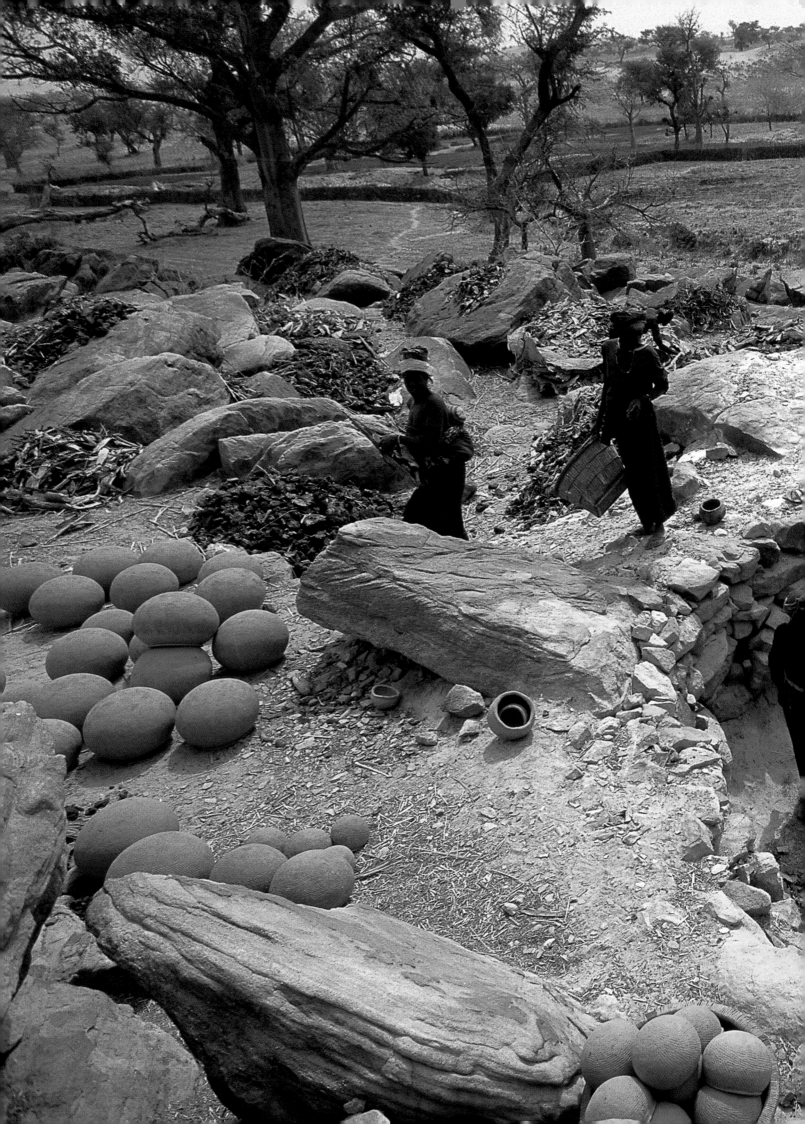

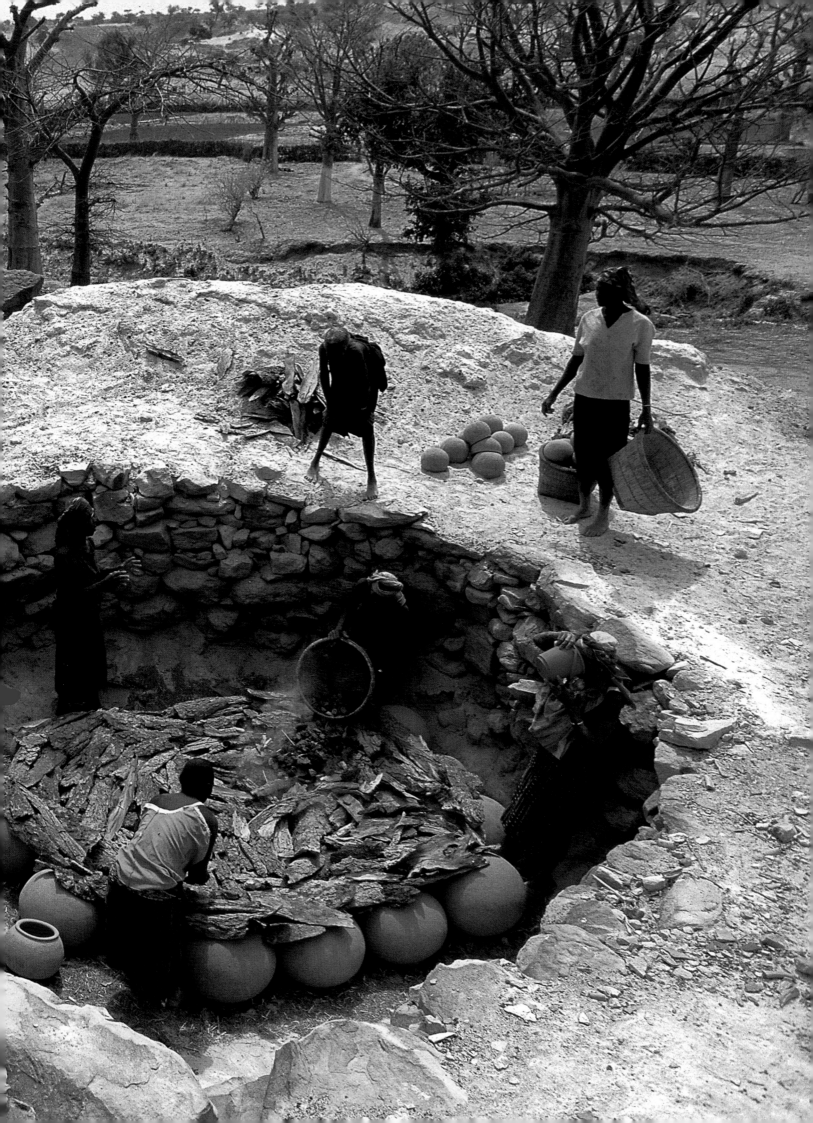

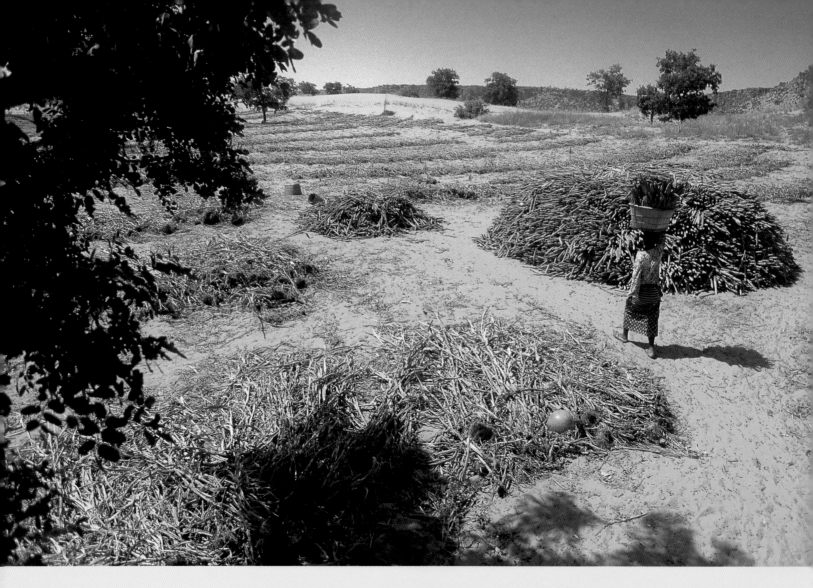

DURING THE HARVEST OF Dogolu's fields, the women stack millet cobs into tidy piles along the sandy plain.

AT DAY'S END THE WOMEN OF Tireli return from Dogolu's out-fields carrying baskets brimming with millet balanced on top of their heads.

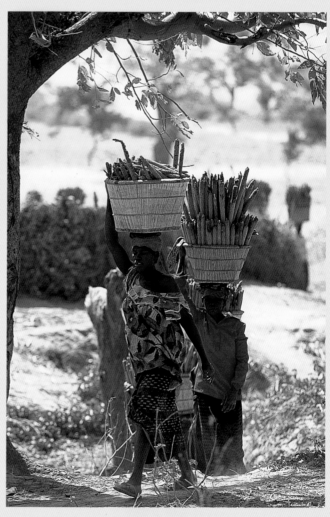

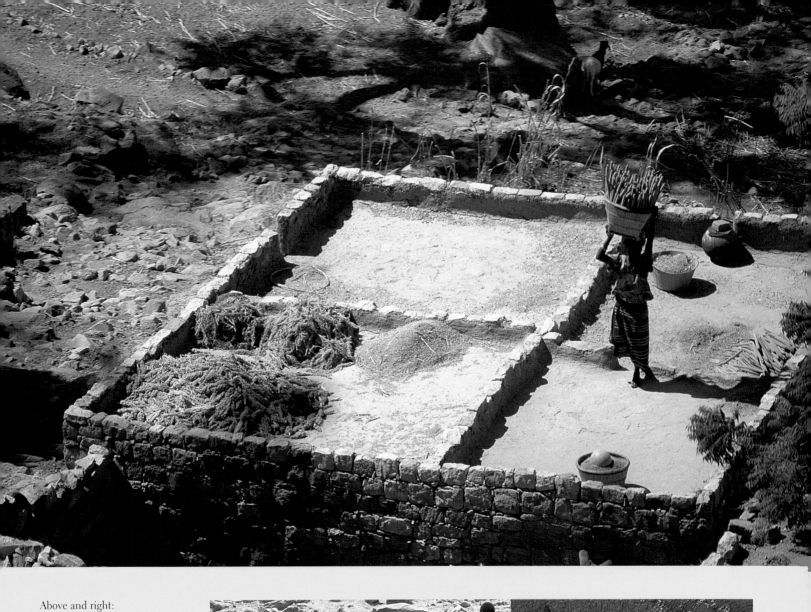

Above and right:
HARVESTED MILLET COBS
are spread out to dry in the sun
on rooftops before being stored
in granaries.

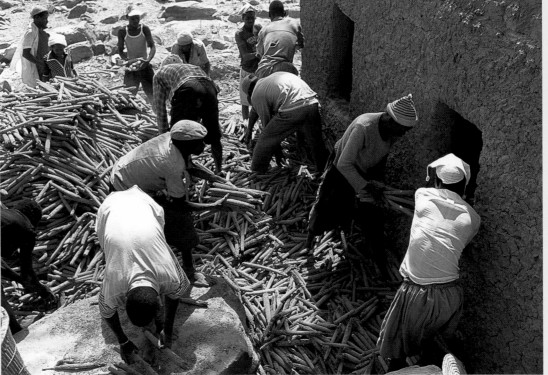

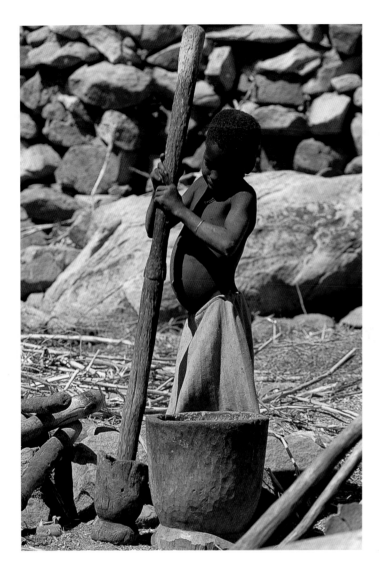
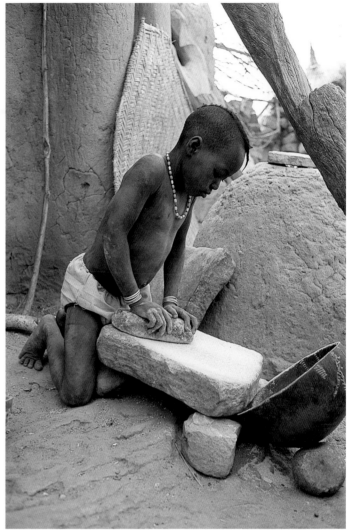

DOGON WOMEN SPEND countless hours pounding millet, hefting their heavy wooden poles with dexterity. They remove the hulls and later crunch the kernels of grain in another bout of pounding. Girls learn at an early age, practicing in small mortars.

AT OGOSOGO, A SMALL village on the plateau, the chief's daughter grinds millet on a stone to prepare a cooked porridge called *punu*.

Oppposite:

SOME DOGON VILLAGERS climb to their flat rooftops at night to sleep under the stars on straw mats. It is too hot to sleep indoors except during December and January.

most villages have their particular specialty to sell, this organizes the content of the market as well: millet at the southern dune side, eggplant-like vegetables in the south, lemons beside the mountain.

Beer is everywhere in the inner circle of wards. At the Tireli market no foreign woman ever comes to sell beer; the reputation and production of the Tireli brewers are too high. At the market in this dry season, beer production is slightly lower than usual, but still some 80 jars are available for the 600-odd people, more than half a gallon for each. The men gather in little groups to drink together.

A group of old friends, all members of the same clan and thus each others' "brothers," habitually gather money at each market and buy a jar of beer. They settle in their own spot at the market, while Ani, the oldest, scouts for the best beer. Tasting a sip here, another there, at those brewers he knows well, he finally decides on that week's delight. The woman brings the jar to the seven old men, gets paid, and takes the first sip of the beer to prove that no poison has been added. Staring at the pot, Ani directs Yoru, the youngest, to ladle the red brew, the yeast billowing from the bottom. Drinking follows etiquette; the oldest, Orisi, gets the first calabash, takes a long draught, and hands it to his right. The calabash should always move in one direction, till the end of the line, and then return through the same hands. No one should down one calabash: every measure must be shared. In the first hour, etiquette is strictly followed, but it erodes with the diminishing level in the jar as more and more beer is enjoyed.

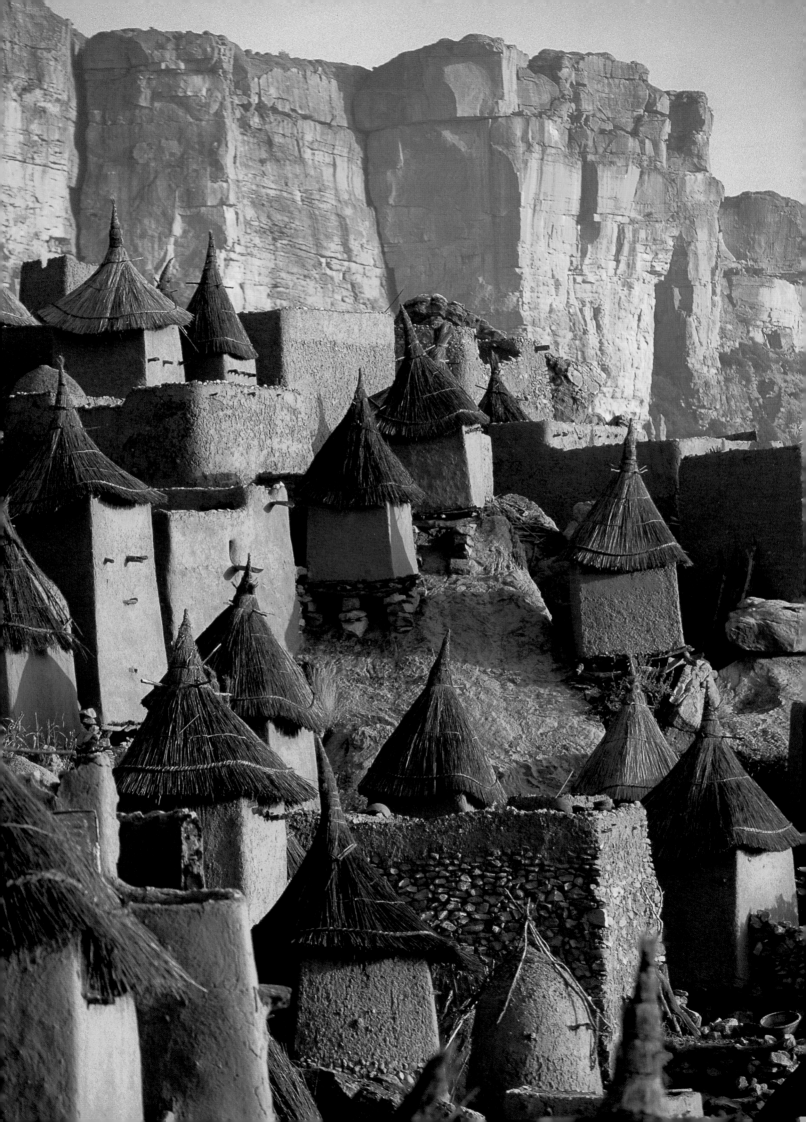

Friends of the group walking by are invariably called in to have a sip. Refusing such an invitation is not impolite. Similar invitations to join in a meal are standard: any passerby may be called to *werè kaya* ("come and eat"), a polite invitation that is just as politely refused, respecting the scarcity of the food. Beer, however, is different and should be shared. So, Atime, who has been invited, greets his friends and sits down on an empty stone. Ani takes a sip, as he should, and hands over the calabash. As a guest, though relishing the warm beer, Atime takes care not to drink too much and leaves quickly.

A flurry of movement at the north entrance catches the eye. In a long single file a dozen boys march into the market, immaculately dressed in white trousers, white shirts, and shining white caps with long tassels dancing around their dark faces. It is just one month after their circumcision

WOMEN COOK THEIR millet beer in jars.

and they still drink together at market. The three weeks of their ordeal have been spent together, chatting, resting, eating, and especially singing at roadsides to the beat of their calabash rattles, to beg some money from adults. Now, every fifth day they dress up, gather at the well, and with one of them beating a little hour-glass drum, they show their new status at market. The oldest boy buys the beer, usually from one of his female relatives, and they all sit down, just like the adults, just like the grand old men, to chat, to drink, and to be seen. They take quite a time to finish one jar and invite bystanders to join them. Just like grownups. The circle of white-clad boys, their earnest dark faces in contrast with the shining white, is a delight to the eye, especially for the Dogon, who love the display of the spunky young. Some men offer them the throat-clearing sweets found all over West Africa, others offer them kola nuts to chew, just as the old men do. Self conscious, they stay together, hardly moving through the market as most men do, but they thoroughly enjoy the attention given to them.

Any market lasts as long as the beer does. Between five o'clock and sunset at about six-thirty, most women leave the market. They collect their things, put the items bought in a basket or an enamel bowl, and with their belongings on their heads, they walk to their wards. The women from other villages leave earlier, wait for each other at the edge of the market, and in a long procession go on their long way home. At the market the beer stalls are still active. Most ready cash has been used up with their first purchase, and now the men try to find some money for a second fill. The next hours will see the number of brewers and drinkers gradually diminish. The men remaining at the market, their money gone, try to borrow from one another or from anyone who enters the marketplace that late. Throughout the night the loud voices of singing and shouting men are heard. Brawls are rare, fights almost nonexistent, but the normal quiet of the village only returns long after midnight.

Dogon family

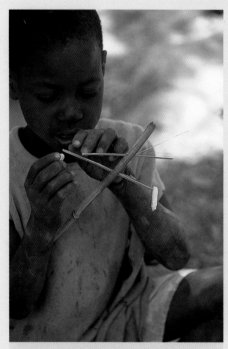

ONE OF DOGOLU'S SONS,
Matiũ, ties together straw and string
to construct a toy.

structure is patrilineal;

that is, authority and clan membership pass through the male line. Men are permitted to have more than one wife, although most have only one, and few have more than two. Their system fosters stable marriages, characterized by a long, easygoing initial phase, during which partner switching is still possible. The tendency toward marriages within a village structure, called endogamy, is strong, so husband and wife usually have numerous kin relations with each other.

Elsewhere in Africa, a substantial bride price must be paid for a wife, often in cattle. Not so among the Dogon. They distinguish two kinds of brides: *yanu birè* and *yanu kèdyè*. To make a marriage with the first type of bride, Dogon men work in the fields of their future father-in-law, often with other members of their own age group. They may present some minor gifts—kola nuts, some jewelry for the girl's mother, and, of course, gifts for the bride. Yasaa, Dogolu's first bride and now mother of seven children, was his *yanu birè* (work wife). Being assured of Dogolu's good working habits, the old man gave his consent: Yasaa could move into Dogolu's house with him. In fact, everyone knew that the couple had already been "married" for four years. Yasaa had been visiting Dogolu in the young men's house during that time and had also borne a child that was weaned by now. As is customary, she left the baby with her parents and moved in with Dogolu.

Dogolu's other wife, Berewadya, is a *yanu kèdyè*, a so-called "cut wife," in other words, someone who has been wooed away (stolen or cut) from another man. (The notion of being stolen is a male conceit, the woman decides herself whether she will leave her husband.) But Berewadya did not like her first husband, and she did not have a child by him. So, after two years, she left the man for Dogolu, who, as custom dictates, made her father a present of some money, a nominal sum.

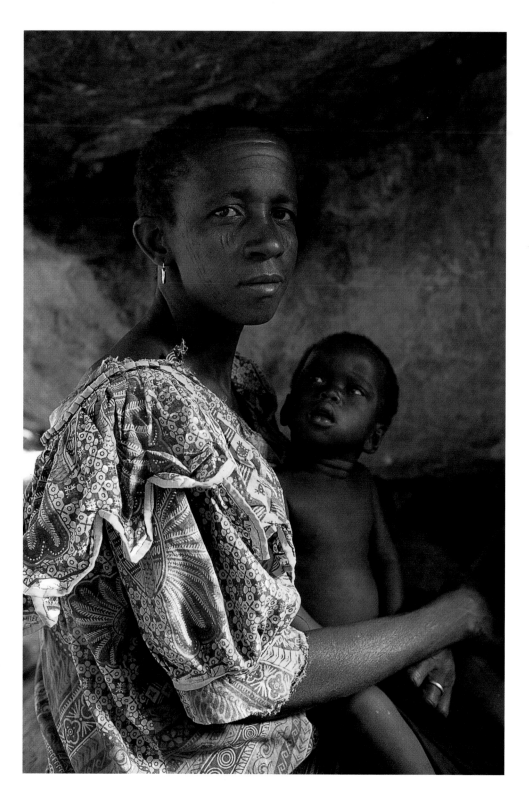

YATIMÈ SAY, THE WIFE OF Mabudu Say, Tireli's maskmaker, sits in the cavern to which the village's menstruating women retreat once a month, until they are considered "clean." Yatimè wears decorative scars that were incised on her face, probably at puberty, as a mark of adulthood.

Other social forms come into play here. Dogolu, for instance, felt free to go wherever he wanted in Tireli, but was not comfortable in the area called Teriku Sabo, where Berewadya's first husband lived. He avoided it as much as possible. If he had to go there, he entered the ward extremely circumspectly, spoke softly, and was quick to enter a friendly compound. His fear was to encounter the other man on his own ground. As the second husband, he would be shamed by the others' presence. Out of the area, however, as at the market, there was no problem: he could meet anyone on that neutral ground.

As stated earlier, boys and girls sleep in separate bachelors' quarters; girls visit the boys on their own initiative. This can continue for years, up to the time that one or two children are born. Then the young man builds his own house, often after a stint of work in a city far away from his home-

land, such as Abidjan in Côte d'Ivoire. He then returns to his home village, works in the fields of the girl's parents, demonstrates his reliability, and gets permission for her to join him in his new house. Her parents keep one or two of the children, their grandchildren, in their house.

No ceremony marks the beginning of a Dogon marriage. A new wife may be accompanied by a friend to her husband's house, but more often than not only those directly involved know anything of it. The only public ceremony occurs during a yearly rite when all the new husbands publicly thank their fathers-in-law for their wives in a festival called *buro*.

For an African group, this marriage system is somewhat exceptional. The absence of a bride-price payment, the minimal involvement of the girl's parents, and the small amount of wealth transferred are striking, compared to the large sums that change hands in other parts of Africa. In Dogon society, however, a daughter may leave her parental home if it seems that she will be well cared for. She is expected to leave a child behind, however, so the loss of a daughter is reciprocated with a new child. Grandparents relate very well to their grandchildren, and the grandfather-grandson relationship is a most intimate one. Also, in the life of a village, older Dogon couples like to have some children around, and they find it useful to have a child around the house to run errands, relay messages, and help with household tasks. These children usually join their mothers after the deaths of their grandparents, although they sometimes stay on in the ward where they have grown up if their mother moves to another village.

On the whole, Dogon marriage is very stable, compared to other African groups. Though the *yanu kèdyè* institution seems to be similar to divorce, a woman can leave a husband only at the very beginning of her married life. Once she has children, divorce is very rare and problematic; if it occurs, it concerns the whole village.

THE MALE SCARE

Though males in Dogon society wield most of the authority in the community, women are held to possess the most fundamental power of all, the ability to create new life through childbirth. This awesome capability earns considerable respect from the men, although quite a lot is done to deny it.

Male recognition of women's power is clearest during the female menstrual cycle, when women are said to be *yapunu*. Most women are then expected to confine themselves for up to five days in a communal menstrual hut, called *yapunu ginu*. Few health problems occupy the thoughts of the Dogon of Mali as much as prolonged menses. A large range of medicines aims at restoring the normal order. One such remedy is invoked when a menstruating woman loses blood for more than five days. At that point a healer will grind the dried liver of a special bird, mix it in water with the bark of a tree that "walks at night," preferably a tamarind, and have the woman drink it and wash herself with it. Then the flowing should stop.

Dogon men are strongly prohibited from seeing, touching, or smelling anything relating to menstrual flow, and many even refuse to speak with women during their periods. During this time the women may not cook for others, and their washing has to be done separately. Most women, therefore, remain in the menstrual hut or keep to their own personal huts, hidden from the rest of the family. One key to all this is that men believe that they risk losing their virility through contact with *yapunu* and will have to undergo elaborate purification rituals if it should happen. Also, their status as participants in ritual sacrifices would be in jeopardy. So when the *yapunu ginu* has to be replastered, the old men perform this delicate task: their sexuality being deemed less threatened than that of the younger men.

birds with pebbles flung from his slingshot. If he is successful, the youthful hunter will roast his prey over a fire and share it with friends.

For the Dogon, menstruation signals fertility for womanhood. They are perfectly aware that menstruation marks a cessation of actual fertility, but a menstruating woman nevertheless represents a fertile one who can (and should) become pregnant. Prolonged menses thus presents a double problem, a negation of both male and female fertile powers. So restoration to the normal sequence is considered extremely urgent.

Dogon believe that the women are fertile one *dyugo* (a five-day week) after the menstruation, just after the end of their seclusion. Thus, when a pregnancy occurs, the child is considered to be fathered by the first man a woman has had sexual relations with after the menses. Women who have moved in with their husbands are very careful about their contacts just after menstruation; if a woman first sleeps with a lover, then that man may claim the child, even four or five years after the birth of the child. The woman's husband in such a case has no claim on the child and cannot dispute his rival. On the other hand, if a wife has intercourse with a lover at a later point in the month, few problems arise; at least no claim on any child can be leveled. On the whole, problems over paternity are rare in Dogon society. Of course, relations between men who are rivals for a woman's affection will be acrimonious, but standards of harmony are vitally important in Dogon social life.

For Dogon men and women clothing underscores this focus on a woman's openness to fertility in an indirect way. Under her *pagne* (loose robe) a Dogon woman may not wear anything resembling a slip, underpants, or any other undergarment. A husband's reaction to such a thing would be a severe beating, although physical violence is extremely rare in Dogon society. The female genitalia should be out of sight, of course, but not shut off from the world. The contrast with traditional male attire is striking: Dogon *ponu* (male trousers) vary in length but are all very broad, as much as two yards wide, and as closed as possible, with only two openings at the ends for the legs in what would otherwise be a large sack. Characteristically, the central symbol for maleness is the *ponu sungu*, the cord tying the extremely wide trousers safely around the loins. The length of a man's *ponu* indicates his status: old men wear indigo or white *ponu laga* down to the ankles; mature men wear the *ponu tubalugu* just under the knee; young men walk in knee-length *ponu tubo*; and youngsters cavort in white shorts, *ponu petogo*, which are just as wide as any of the larger ones. Anyone who appears at the market in a new *ponu* hears hearty salutations: "Greetings, congratulations. May you wear it to shreds." Like the female *pagne*, the trousers are in fact worn to shreds, never discarded. Both types of clothing may end up in the small bundle of rags used as carrying cushions on women's heads. Clothing is so valued among the Dogon that when someone dies, their clothes are inherited by the next of kin, and worn by them, however old and ragged the trousers or *pagnes* may be. Refusal to wear these clothes would imply a denial of kinship.

PREGNANCY AND BIRTH

For a Dogon woman, pregnancy entails a number of proscriptions, and few prescriptions. The Dogon cater to the changed food preferences of pregnant women, and families see to it that the women feed themselves well. They may prefer sharp-tasting foodstuffs occasionally, such as kola nuts, but coffee is deemed bad. No eating taboos apply, except for economizing on salt (a scarce commodity anyway), because it is believed that too much salt will render a child hairless. For the rest, a woman has to pay careful attention to the totemic food taboos of both her own lineage and especially her husband's, but neither of these usually implies any major restrictions in her diet, except that she may not be allowed to eat donkey meat, turtle, or chameleon.

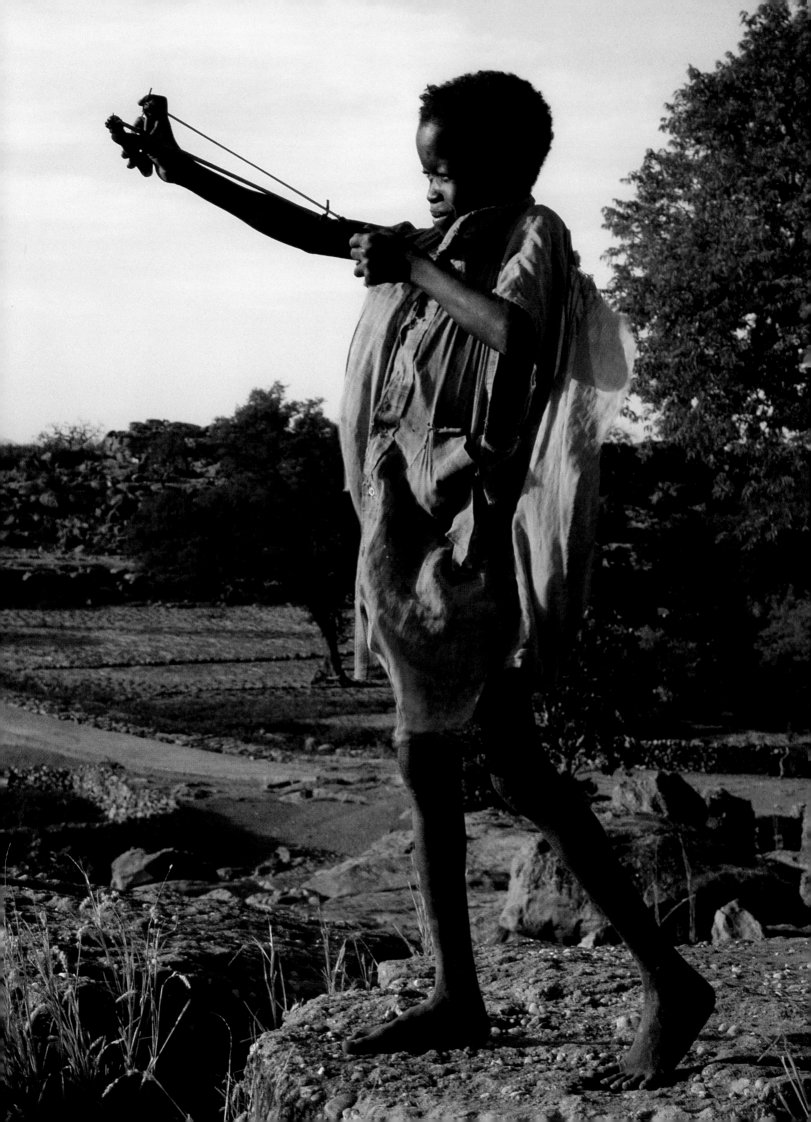

IN A VILLAGE ON
the rocky plateau above the
Bandiagara escarpment,
Dogon boys practice dancing
in front of the village mosque.

During a pregnancy, the husband's responsibility is not to take another wife, as that might upset the pregnant wife, who needs as much attention—including sexual activity—as she can get. On her side, the pregnant woman has to be careful with her child-to-be. Her main worry is that the baby may be stolen or exchanged by one of the many spirits that inhabit the bush. (The bush holds even more dangers for her than for other people.) Bush spirits are thought to be jealous of humans and will change a baby into one of their own, resulting in a child that looks human but in distinct and often fatal ways resembles the spirits.

THE YEAR

The hot late afternoon

sun has fallen just behind the cliff when the old diviner Aninyu takes off his shoes and cautiously walks into the divination field, way out into the dunes. At a small flat altar stone, close to the entrance, he squats down and intones an invocation:

> Yurugu *(fox) good evening,* Yurugu, *greetings in the evening*
> *Greetings in coming, greetings in going*
> *Give me the traces of your feet, do not cover anything*
> *Remove your bad things, your spoiled things.*
> *Tell me the truth.*

Aninyu then makes a series of panels in the sand in which to put the questions to the fox. He starts, as always, with his own panel, and then makes them for each of his clients. Each client gets a panel of six narrow rectangles, in which symbols represent the main partners in life: the client, the family, the village, God, death, and peace:

Tiny sticks placed in the panels represent God, the client and the family. T- and I-shaped tracings in the sand symbolize peace and the tomb, and small heaps of sand with a hole or pockmarks stand for specific issues such as illness, threat, harvest, the next year, or a foreign country.

On this day, Aninyu puts in seven panels. One is for Amaza, a young Dogon who wants to build a proper altar in his new compound. Sometimes clients accompany the diviner to the divining field, but Aninyu never reveals one client's questions to another. When he puts the symbols for the client in the sand, Aninyu's soft voice tells the fox what is expected for each of them:

Tell me please, fox

Is there a corpse, a death blanket, in the next three years?

Something evil? Will there be shame the next year?

Some clients ask questions about the harvest: will there be enough millet, beans, maize? Will the granaries be full? A few have already asked specifically which field they should work first. But most have inquired about the coming *buro* festival, whether their sacrifice should contain something special, or as in the case of Amaza, how they should build their new altar. A few have no specific question, but only want to know if a peaceful time would be their lot. One question may focus on the arrival of a new wife. In other sessions Aninyu has had women asking about their pregnancy: what to do to become pregnant, the reasons for infertility, and the ways to avoid stillbirths.

Today, the sun has set when Aninyu shells some peanuts and throws the nuts among the panels, at the far corners of the dividing lines: these are bait for the fox. Before leaving he again exhorts the fox at the altar stone:

Fox, better a good friend than a bad kinsman:

Speak clearly, a good voice.

Let the people coming to this field stand eye to eye

Throw your traces, give me your nails, and do not close your footprints.

If a simple soul does not hear that his mother will die,

And she falls ill, he would not understand.

Be clear, very clear. Whatever you see, tell me. Give me your footprints.

That night the desert fox (*Vulpes pallida*) came. No wind disturbed the sand beds, so Aninyu got what he asked for: footprints of the fox. The little animal had eaten all the peanuts, meandering through the panels in the sand. Some birds and ants have also made their traces, but these do not count. The rising sun bursts red through the fence, dappling spots on the cool sand. Together with a fellow diviner who uses an adjoining bed, Aninyu interprets the traces in the sand. This is not easy, and a second opinion is welcome. Most of the signs get a positive interpretation despite the evident presence of death and evil. In fact, when a fox predicts sickness and death the traces should lead straight over the symbol for the "death blanket" to the "grave," without coming close to the sign for "peace." In most cases the fox may just hint at evil. The direction of the fox's traces is also important: when the animal walks away from the "grave" toward "illness," the sign is read positively. A stroll in the other direction, however, is very ominous, but a slight bent toward "peace" makes the problem solvable. The usual advice to the client then is to make an extra sacrifice, solicit some extra oral blessings from the old men, and then perform divination again.

The early morning sun has begun to build up heat on the hillside when Aninyu enters the compound of Amaza to report his findings. After elaborate greetings, he tells the young man that the

buro (year rites) will go well, provided that his altar is constructed in the right fashion and the sacrifice done in a specific way. He offers instruction on how to perform both tasks. Amaza then pays him some hundred francs and thanks him for this message.

For the construction of the new altar, following the instructions of the fox, Amaza has invited the respected lineage elders Meninyu and Yengulu to assist him. With care they select a protected spot on the high ground of the compound, on a boulder next to his neighbor's house. On some grasses that have survived a recent bush fire, they put a stone. With mud they fill out an altar cone. Though most of the mud comes simply from the riverside below, in it is mixed a small piece of mud from an old altar of Amaza's. The wives have already prepared the wherewithal of the sacrifice, as the inaugural offering will be made immediately: some rice mush, millet beignets (a kind of doughnut), a mix of sesame and fonio, and some sesame oil. Beer is bought at a neighbor's compound, as none of Amaza's wives have brewed recently. Then Amaza brings out his proudest new possession.

A week before the new altar was constructed, Amaza has ordered a statue to be made that will be put next to the altar. A smith's job, carving sculpture, but not for any smith. Yangau, a young blacksmith from Komakan is the specialist in the area. Amaza has been over to his compound, where statues, large and small lay scattered about, objects ranging from crooked thieves' sticks to sitting stools, statues of various kinds, and a *sigi* stool or two. (Made of a forked branch, a *sigi* stool resembles an English shooting stick.) Yangau greeted his visitor but kept on hacking the log he had just started with. The squat figure of the carver contrasted with some of the long, slender figurines he just finished. When Amaza explained that he wanted his own statue made, Yangau put down his work and cast his expert eye over Amaza's face and stature. From the bits of wood lying around in his com-

Below and overleaf:

AT DUSK IN THE PLAIN at the base of a cliff, shaman Aninyu Anidzu draws a grid in sand as he maps out a fortune that will be told in the morning. The Dogon believe that all the animals of the bush know the future. To attract a fox, a particularly propitious fortune-telling animal, Aninyu scatters peanuts among the drawings that he has etched in the sand with his finger. If the fox or another animal passes by in the night, it will leave footprints here and the shaman can then read the marks and predict the future for his client.

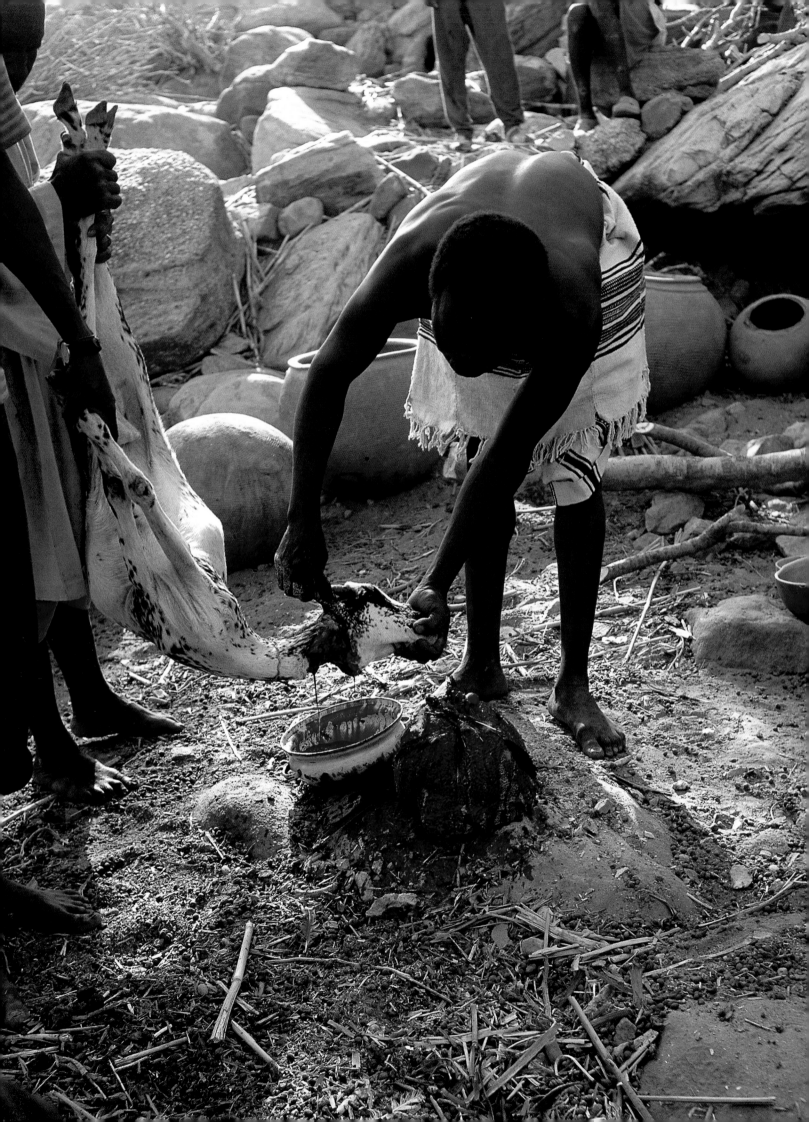

pound, he selected a suitable piece and immediately began carving. After his first glance he needed no further model. While discussing the price, he got the statue under way, using three different chisels. As Yangau hacked away, occasionally commenting on the hardness of the wood and the problems finding appropriate carving blocks, his son was busy smearing mud on other statues to make them look older. These were sculptures for the tourist market, people who like to think that they are getting old pieces. Everywhere in Africa the business of artificially aging new carvings has become an art in itself. But Amaza's statue had to be new and to look new, as Dogon like their objects that way.

The statue was finished in two hours' work. It looked more like all other statues than like Amaza, though in fact it represents him. Dogon statues, as a rule, function that way: they are figurines of living people, often indicating even in their form the wishes of the owner. A barren woman may depict herself with a child in her arms, often sitting on a stool held up by children. A man may ask that his carving depict him as a rich man, or as a notable person. Some statues depict illnesses, pointing out to Ama (god) that becoming well is wished for. Amaza's statue depicts him with a full round beard, which contrasts clearly with his clean-shaven countenance; it was the idea of the blacksmith, who guessed correctly that his client would like to look like (and eventually become) a respected old man.

Statues such as this remain at home altars as reminders of the purpose of the sacrifices that are made there. In a way, they function as mnemonic devices, for it is believed that the supernatural world has a short memory and is capricious, always changing. The statues aim to be constant reminders of the sacrifices and their goals. They serve to enhance ritual, to render it more potent and permanent.

Back at Amaza's house, Meninyu and Yengulu admire the statue and begin the sacrifice, which Amaza has arranged to consist of a goat and two chickens. Yengulu has changed from his daily attire into a *soy piru*, a white loin cloth that an officiator should wear. Meninyu begins the *toro*, the long incantation that accompanies each sacrifice and all burials, gently tapping an old piece of iron on the rock:

> *Greeted in the evening, greeted, from all of us, greeted* Ama,
> *Who changes everything, who leaves nothing similar.*
> *Whoever walks in the bush, will be in the village;*
> *Whoever has food in the bowl, will be fed with leaves;*
> *Those who shed tears, will laugh;*
> *Those who laugh, will shed tears;*
> Ama, *the changer.*

The other gods, Lèwè, Nomo, the *binu* (possessing spirits), the spirits of the bush, are also addressed to attend the sacrifice. The major villages at the cliff face, from Yugo to Koporo, where the Dogon first settled, are invoked to give heed to the sacrifice. Djenné, the major Islamic center, is called as well. Amaza puts his statue next to the altar, as Meninyu intones a long list of ances-

IN TIRELI, VILLAGERS sacrifice a goat and spill blood over an altar called *Ama yéwé*. This altar is said to make its owner stronger, and the ritual, called *kudomonu* (literally "rest the head") should lead to tranquility. The meat of the goat will be distributed among participants after the sacrifice, and copious amounts of millet beer will be imbibed during this annual ritual to maintain an altar that represents the thought and will of its owner.

tors, those lineage elders who have been danced to in the last *dama* mask festival. They are asked to "please all attend the sacrifice":

> This is Amaza Ama, the altar of his house;
> If there are words, please protect him and his kin.
> If there are things to give, then give them to him.

At this point Yengulu pours millet gruel over the altar and the statue, transforming the brown earthen cone into a splendid white. He then sprinkles beer around the cone (not on it) and puts little bits of food on top of the altar and the statue:

> Give us peace, give what we do not have;
> Let the millet ripen, let the good rain come,
> Thanks to you.

The first chicken is sacrificed, the blood dripping on the altar:

> Heed against illness, do not mix the words.
> This is the chicken for purification.
> For the mistakes, for the failures, forgive us, forgive us.
> Please those who have passed, do not disturb our killing.

Meninyu watches the blood trickle over the statue. All watch how the chicken dies. All is well, as the flapping bird ends its life lying on one wing. Flat on its belly would have been an unfavorable sign. Dogolu, who has joined the group, hands Yengulu a large male goat, and the two of them hold the struggling animal over the altar, while Yengulu cuts its neck.

Now, the altar and the effigy are a fiery red. Meninyu, in order to assure a good reception of the sacrifice, rubs the goat's blood all over the statue. Yengulu, an experienced butcher who often sells meat at the weekly market, skins the goat and extracts the liver. After roasting the livers of goat and chicken, Meninyu smears some liver on the altar and the statue: "Thank you, thank you, eat now." All present then partake of some of the food and the liver, Amaza first, as the owner of the altar. The whole procedure is relaxed, easy, and matter-of-fact. People chat and watch, though at the moment of actual killing they fall silent. Women are not supposed to watch the actual killing of a goat, and avert their heads.

Just before sunset, Aninyu the fox diviner, who had prescribed the details of the sacrifice and who has been sacrificing at his own shrine, enters the compound with loud greetings for everyone. Content to see the outcome of his divination advice, he bends over toward the altar, puts the palms of his hands on the ground, and greets the altar in a resounding voice:

> Greeted in the evening, Ama, greeted, Ama of Amaza.
> Give us peace in this house, give us health in this compound
> Give all of us here two more years.

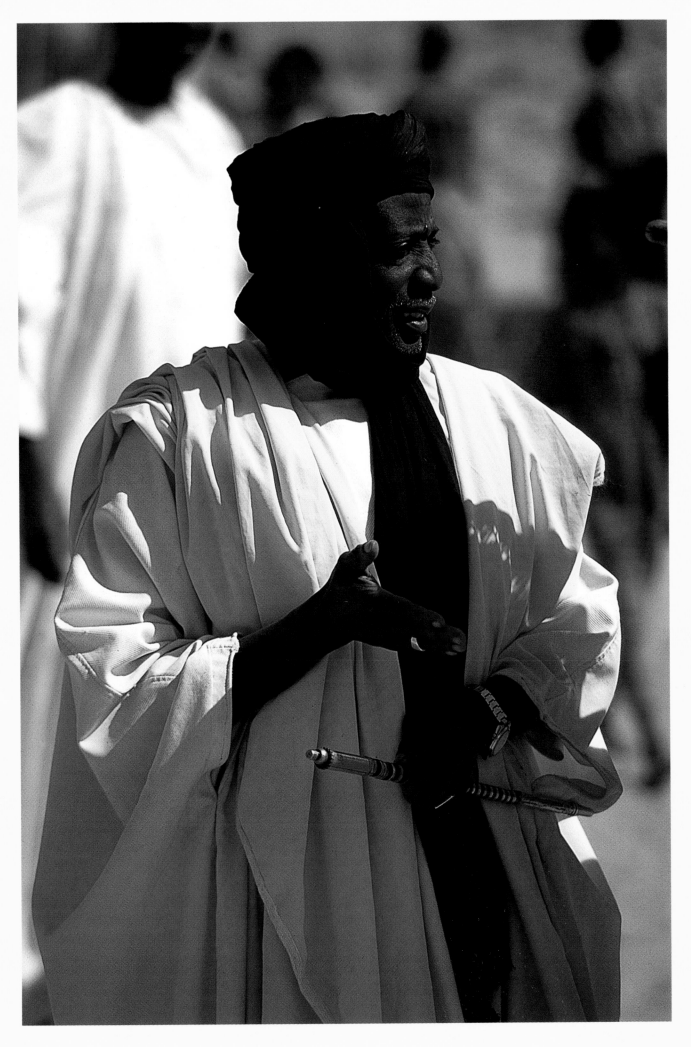

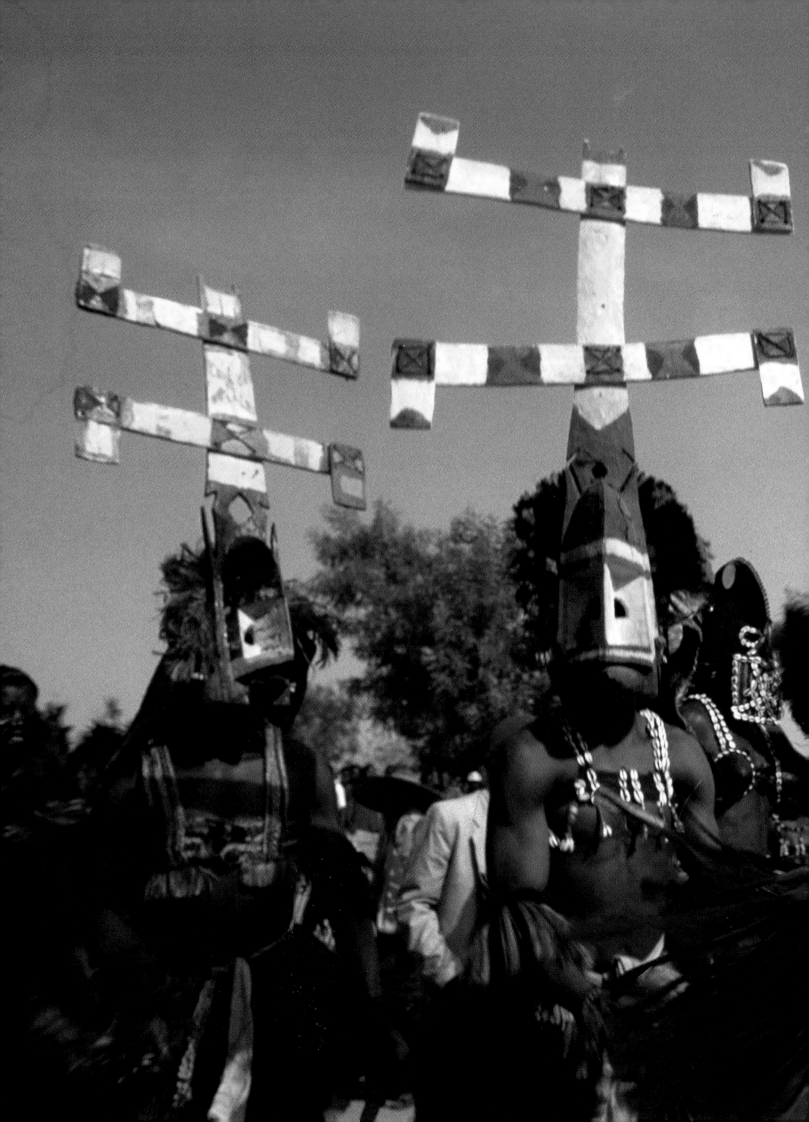

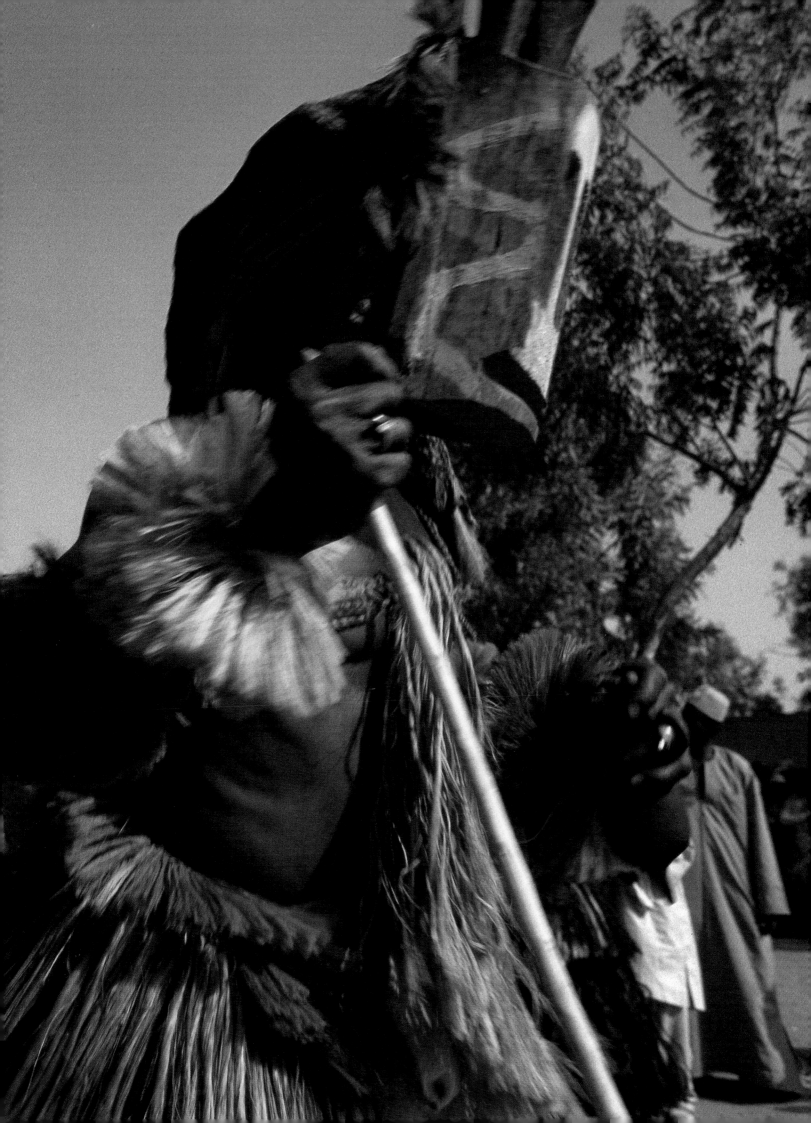

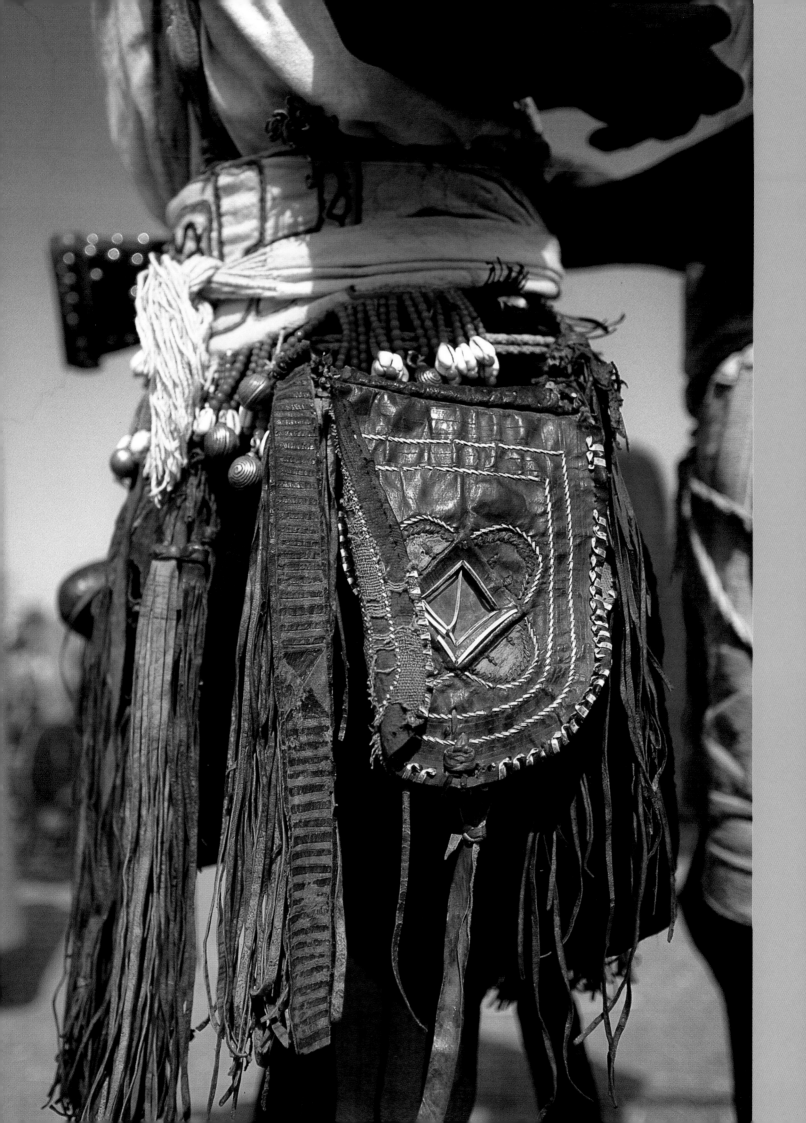

showing off their rich clothes and marvelous umbrellas, the youngsters stop first at the compound of a father-in-law of one of their number. There, the young men dance and sing, profusely thanking the master of the house for the wonderful gift he has given one of them: his daughter. All age-mates join him in the greeting, and give some money to the bride's mother and to the musicians.

One of the group shouts out at the top of his voice the amounts being given, exaggerating each gift: 50 francs (about a dime) becomes 5,000 francs, a 100-franc coin becomes 10,000. At the rear of the long procession, the young wife enters her father's compound dressed in splendid robes, and wearing sunglasses and necklaces. She especially shows off the scarf wrapped around her head, which her husband has covered with bank notes. Her father can rest assured: his daughter has married a well-to-do man and is being cared for properly.

Like all old men during this festival, the father-in-law has not dressed up, and acts very subdued, almost embarrassed by the huge crowd of supporters his son-in-law has managed to whip up. "Welcome, welcome. Sit down, I do not have much in the house." The visit takes about an hour, and when all beer pots are empty, the troupe moves on to the next father-in-law's compound.

Toward the end of the afternoon, the people of village ward acknowledge with loud shouts the female relatives of their mothers: "The mothers have come, the mothers have come." Visiting, dancing, giving gifts, and the usual Dogon good-humored joking go on well after sunset. When all the beer pots are emptied, the whole procession, somewhat less carefully organized, returns home, content with a job well done.

After the greeting days, comes the grandest of all occasions of the yearly *buro*, a ritual called "parading the market," which turns into a kind of contest of wealth between the two village halves. From early afternoon onward, people gather in the marketplace. Spectators from neighboring villages create a large arena to view the procession that follows. The "older" of the two village halves begins the event. Youngsters set up two rows of brightly decorated bicycles. The bikes are draped in gaudy blankets and adorned with anything the kids can find that shines. Then, with the approving roar of the crowd, and blessings and exhortations yelled by the older men, a troupe of six noisy motor scooters circles the marketplace, followed by a throng of younger children pushing other decorated bicycles. At the end of the procession, a group of young women parade with their most colorful blankets, carrying horsetail whisks and an occasional plastic doll. At this, the older women shriek and sing, shouting praises to their kin.

Then comes the turn of the other village half. This group counts on three men on horseback, riding in high-backed saddles hung with tassels, to carry the day. But, however much the Dogon admire horsemen, the scooters and bikes receive the most applause and are considered winners of the event.

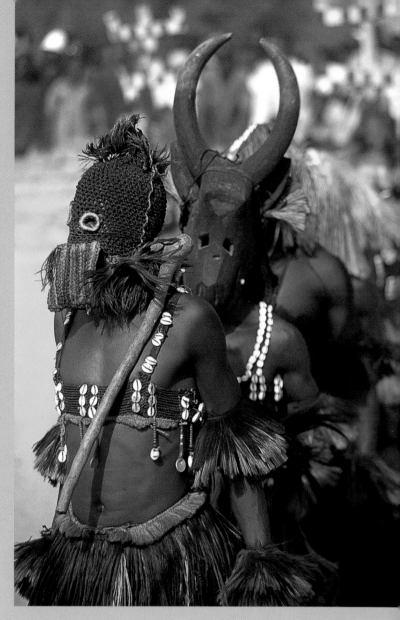

A DANCER FROM BANANI wears a woven "pupil" mask, a fiber mask covered with cowry shells and beads. Pupil masks are worn at some time by all new initiates. In the background is a bull's mask.

Opposite:
A DOGON HUNTER'S amulets are considered as powerful as his rifle. He believes that the animals of the bush all know the future and so can only be trapped by using magic.

The day after the market parade, the younger men gather at the clan house of the Hogon, the oldest man of the village. Accompanied by drums and flutes they each march carrying a millet stalk. This is the ceremony called "throwing the millet," performed the final day of the *buro*. It celebrates the Dogon belief that man's fertility and nature are one, for the village depends on human effort and agricultural good fortune. So, after the splendid show of human success at "parading the market," the crops demand the people's ritual attention, as rain should be imminent now.

After a benediction, the Hogon flings some handfuls of millet cobs with their seeds into the waiting crowd. In a general shuffle everyone tries to get as much of this millet as he can, because these cobs mixed with one's own seedlings guarantee a good crop. Drumming, dancing, and singing, the crowd then moves on, waving their stalks, to the next clan houses of the village. Finally, all return to the Hogon's house, where the old man gives a last blessing to usher in the rainy season:

> *Let salted rain fall on your heads!*
> *You are small bushes now, let Ama make you big trees*
> *Who has no wife, will get one, who has no child, will get one*
> *May you all enter into the new year, may you all have a next* buro
> *Ama give you health, Ama give you peace.*

Now the people wait for the rains to come and a new growing year to begin. After the ritual it is time for the hard work. And so it happened.

R A I N !

"Dust storm, dust storm, inside all of you, rain is coming." The shouts are sounding through the sleeping village, ricocheting against the high cliff. In the northeast a strange cloud, with whirling shadows expanding from a luminous core, quickly approaches in the early dusk. Behind the eerie dust cloud the dark mass of the rain can been seen, pitch black against the grayish horizon. At the shouts, everyone awakens abruptly. People jump up from their mats in the courtyards. Feeling the rising wind, the sweeping dust, and seeing the storm near, they quickly roll up their sleeping mats and flee inside the houses. Most doors are shut before the storm hits the village, but some are still

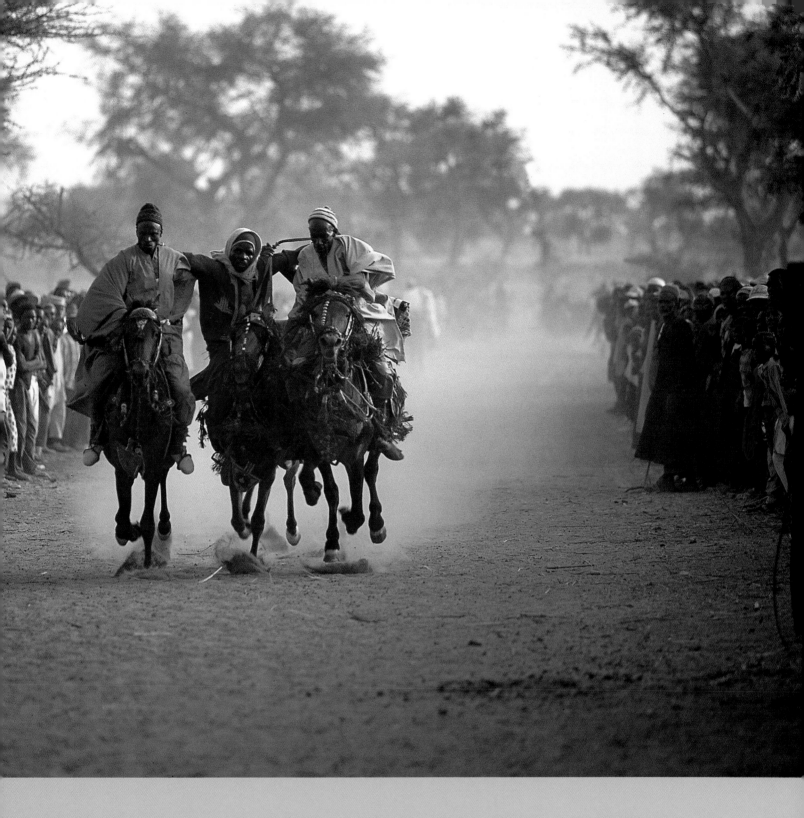

gathering in clothes and children, and struggle against the wind into the shelter of their houses.
Dogon houses have hardly any windows, so the families sit in the dark, waiting for the dust, wait-
ing for the rain to strike.

 Then the whirling dust hits the houses, the light Sahara sand penetrates into the dark recesses
of each hut through the cracks in doors and windows. Five minutes after the dust, the rain begins,
first with large single drops, then with the steady drumming of pouring rain. For an hour and a
half the rain pours down on the houses on the hillside.

 At the top of the cliff, a rare spectacle occurs: the cliff gullies run over, and two slim cataracts
fall from the top, two silver streams gracefully falling down some 300 feet. Gradually the rain
tapers off, the falls dry up, and very slowly quiet reestablishes itself in the village. The morning
light filters through the remaining clouds, young children run outdoors and with joyful shouts

Overleaf:
IN THE EARLY MORNING
the women from villages up on
the plateau descend to the Tireli
market at the base of the cliff.
With heavy baskets carried high
on their heads, they thread their
way single-file through scrabble
and stone.

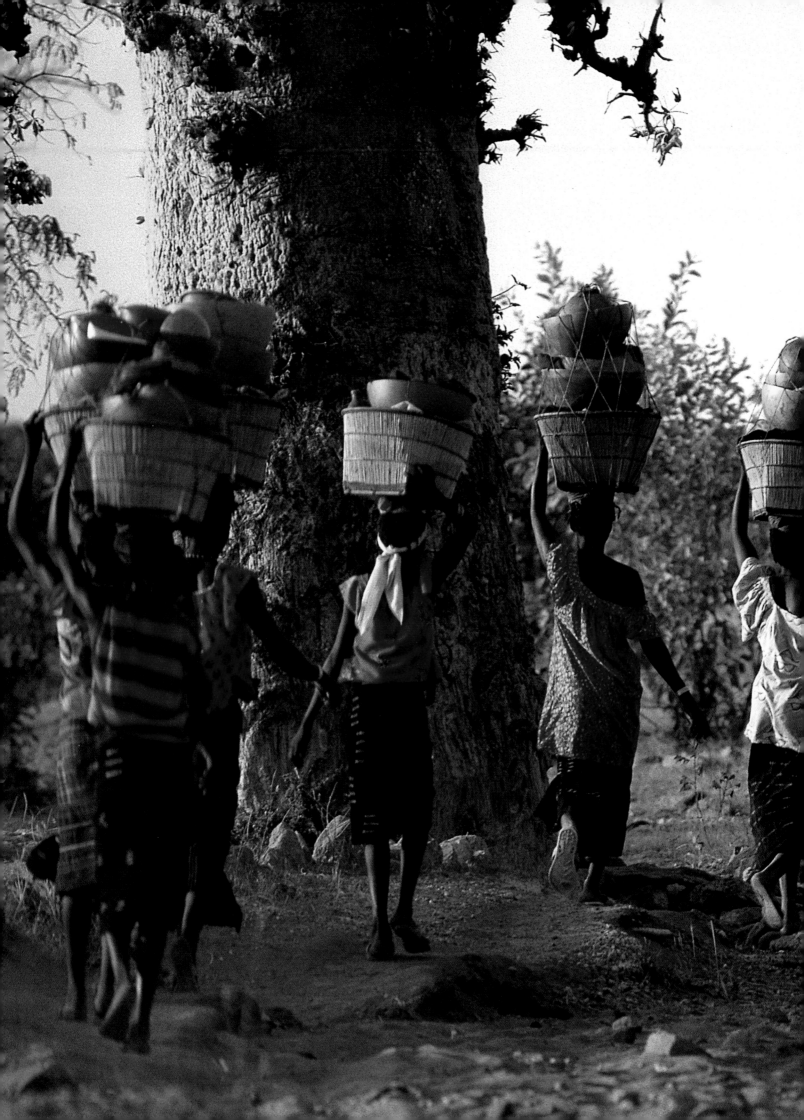

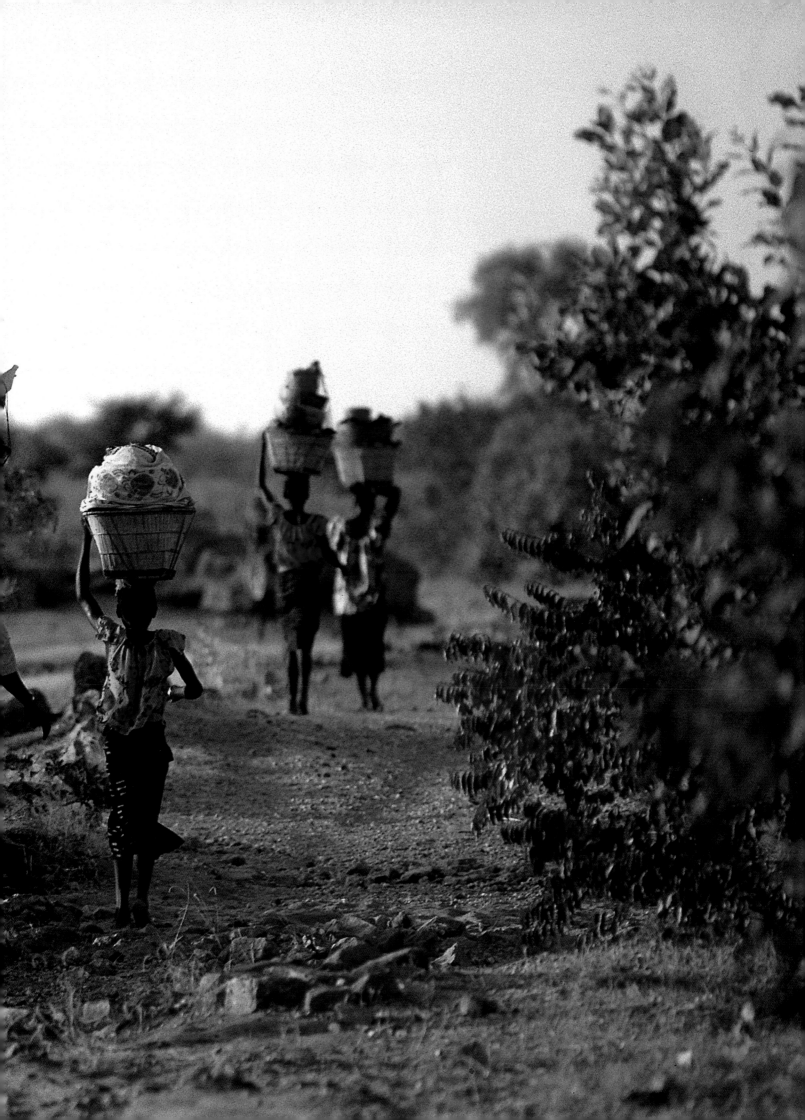

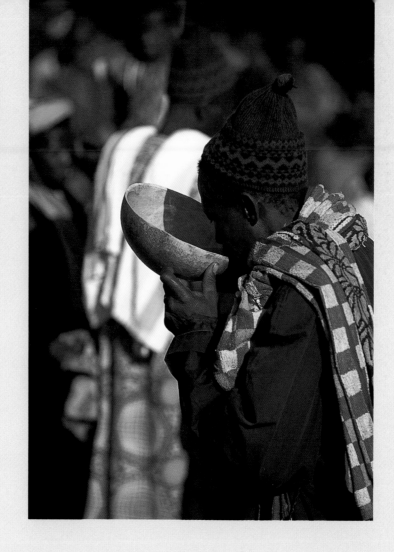

Right:

MEN AT THE TIRELI MARKET
scout around for the best-tasting
beer, taking sips at various stalls
before burying a calabash full or
a whole pot.

Below right:

AT TIRELI'S MARKET A
vendor stirs a stew made from
bats, a particularly favored dish.
Nothing is wasted here, where life
depends on the plentitude of every
harvest. Famine and hunger are
no strangers to the Dogon, who
watch as the desert creeps in.

Opposite and overleaf left and right:

ON MARKET DAY IN DOGON
villages, convesation and com-
merce occupy the women's time.
The women load the goods they
want to sell into straw baskets—
vegetables, roasted peanuts, pot-
tery, millet beer, and maybe a
calabash filled with peanut and
millet paste balls. Hoisting the bas-
kets on their heads, they leave for
the market long before the men
are ready. Dogon women may
keep whatever money they earn
from the sale of agricultural prod-
ucts they have grown themselves.

gambol in the little falls that run off the flat roofs. Jumping and shrieking, they exhort others to
join them.

Gradually the village life resumes its normal routine. People come out, chatting over the
rain: a good rain, a very good rain, right on time. This rainy season begins well with a rain like this.

Women start cooking some leftover
mush from yesterday as a quick starter;
in some compounds they boil the *punu*,
the well-liked millet porridge. Men
make coffee, and sip the hot brew in the
chilly morning. All quickly leave for the
first sowing: the rains have come
indeed. The new season opens propi-
tiously: rains, sowing, weeding. Later the
huge rituals of death and rebirth will
occupy them. Now the *buro* has opened
up the new year, for new Dogon to be
born, old ones to die, and very old ones
to become ancestors. But that will hap-
pen only after the next harvest.

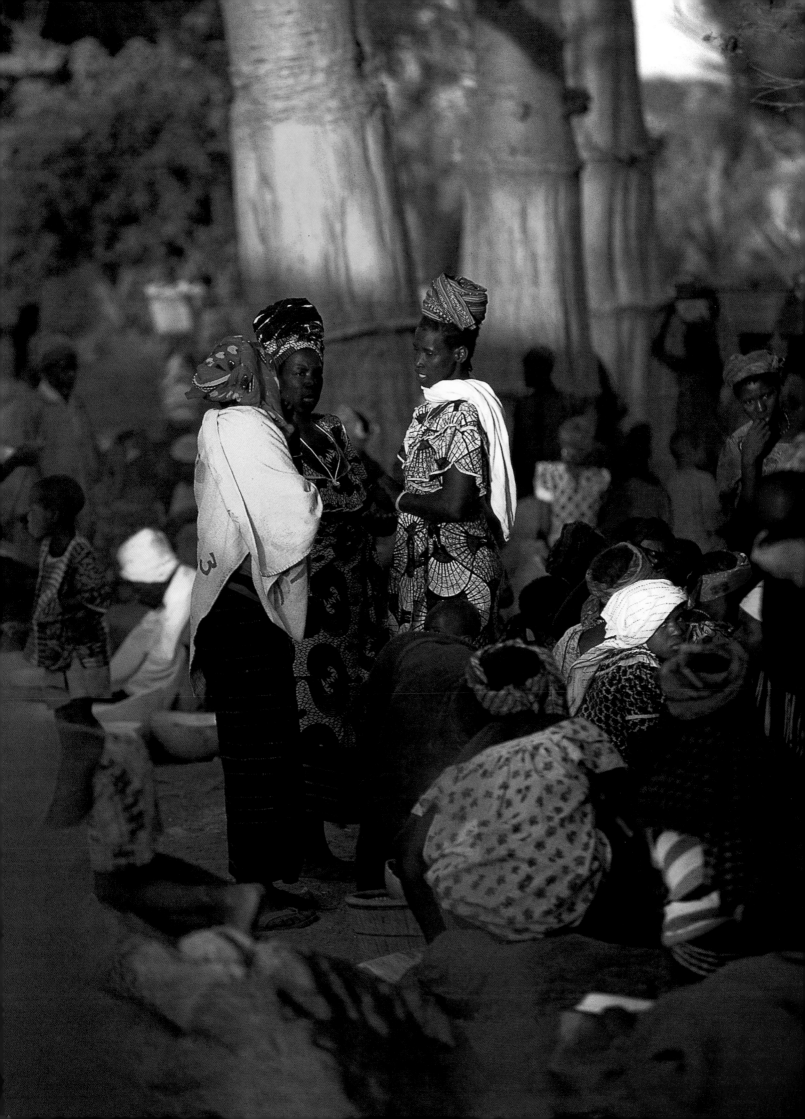

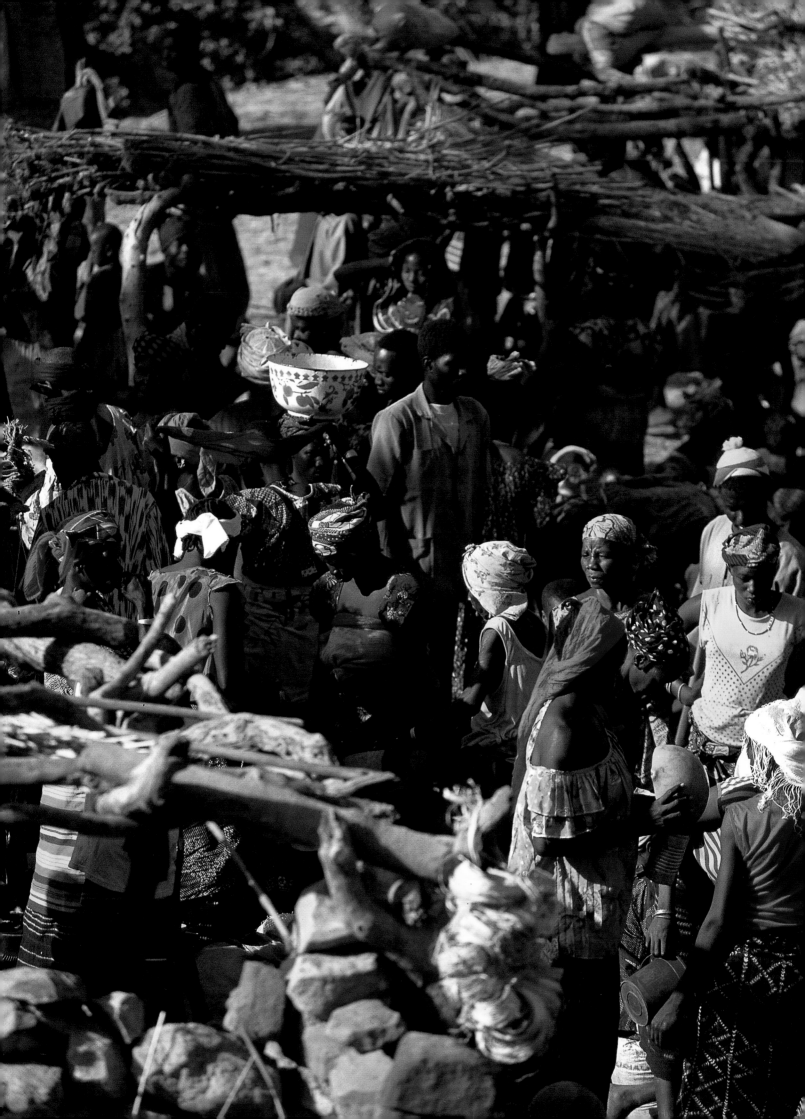

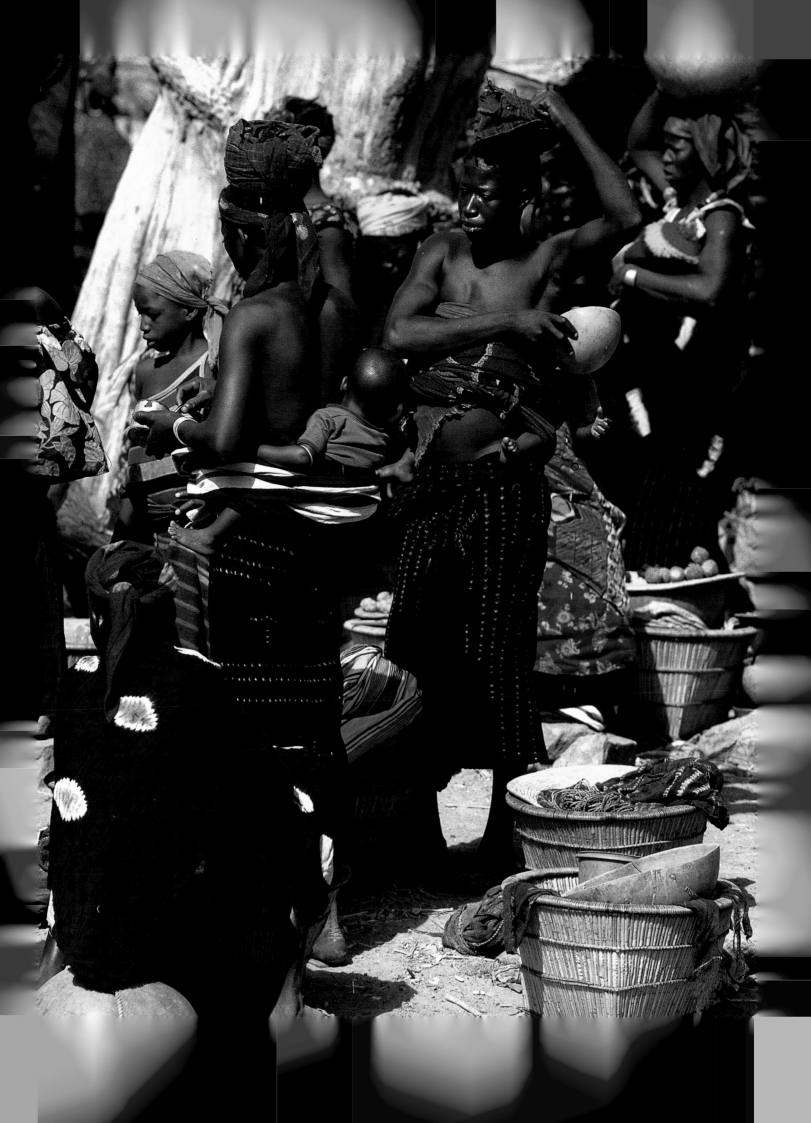

AT TIRELI MARKET TWO
elders meet and exchange greetings. Merchants display their wares in low shaded stalls while women spread their goods on the ground.

Opposite:
A WOMAN FROM TIRELI
offers her homegrown cotton to a man from Komakan. Dogon grow, spin, and weave their own cotton products. At the market, however, raw cotton is quite rare and quickly sold.

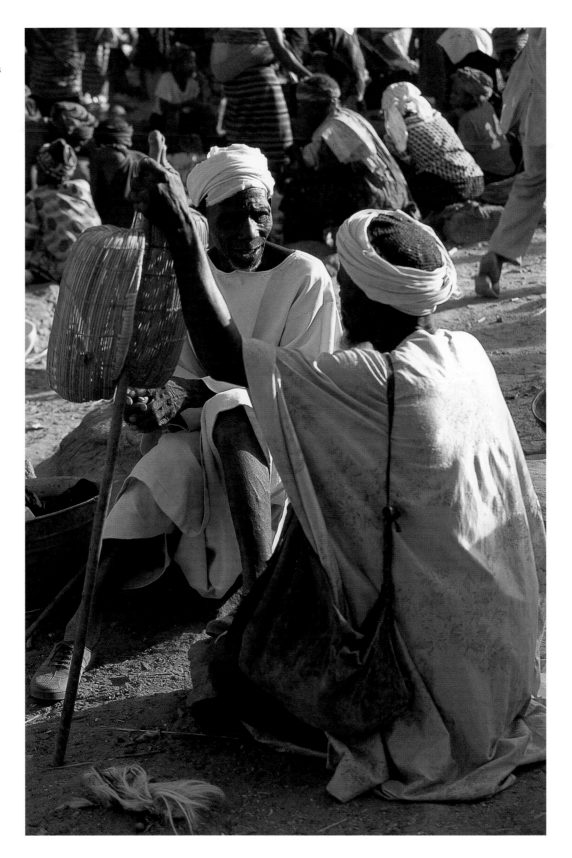

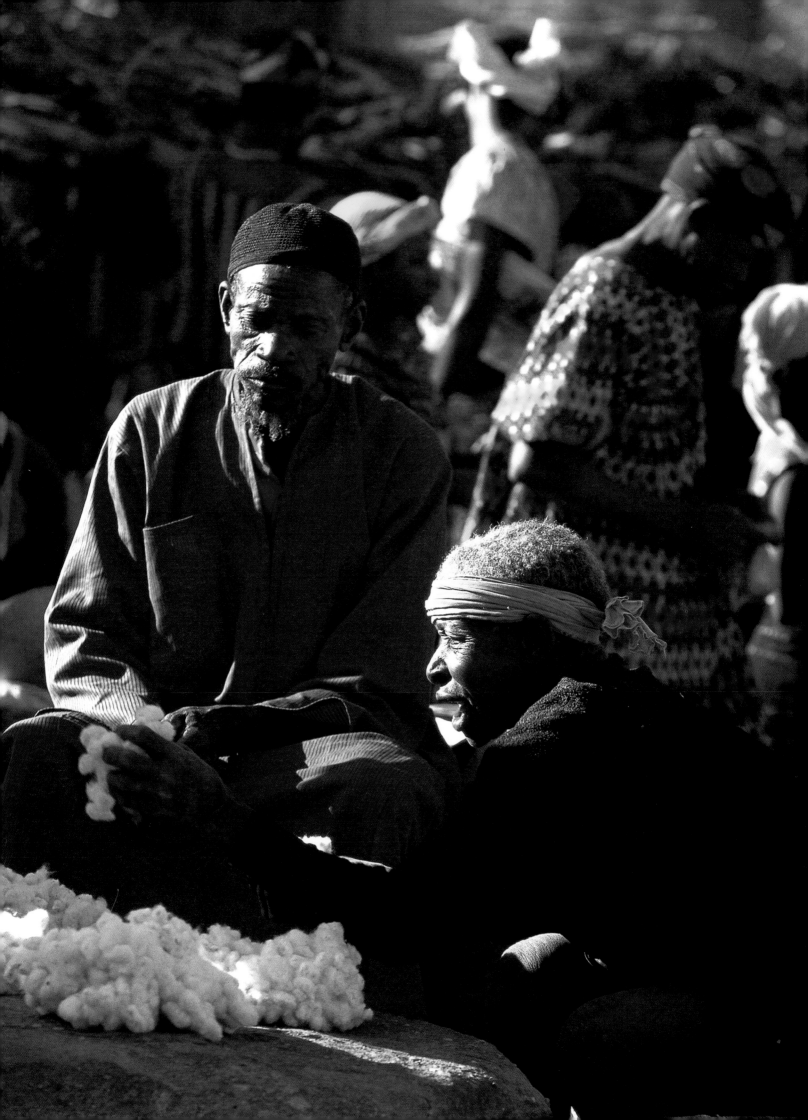

CHAPTER FIVE:
THE OTHER

All Dogon descended

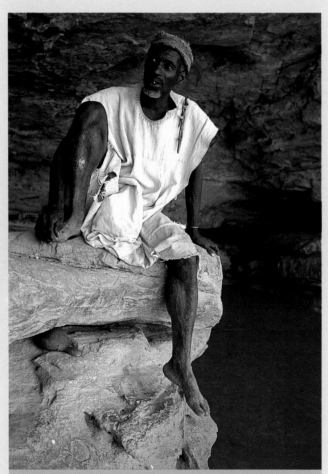

SITTING ON A BOULDER IN the cliff-hugging village of Eli, an elder wears a tunic made of homespun cotton that he wove himself using a back-strap loom.

from the first ancestor

at Tireli call themselves Say, and all people from the village share that name. As a visiting anthropologist and a photographer living in Tireli, the authors were immediately called Say as well. Pegue villagers some six miles along the escarpment also call themselves Say, since they claim descent from the same ancestor. Tradition has it that the ancestral Say settled first at Pegue and later moved to Tireli, so all people in Pegue are related. Together, the two villages also share a special relationship with the village of Aru, where their ancestor had established his main altar and his main house. Aru holds a very special place in the ritual geography of Dogon country; Aru's oldest man, the Hogon, is the most important priest in the region.

The settlements that people from Tireli created on the plains, when moving away from the cliffside area after the pacification of the region by the French, are called Say as well. Thus, some small villages in the plains are Say, as is Pomboro, a major village some twenty-five miles away that was founded by people from Tireli. All people of Pomboro are Say, even if many of them actually emigrated there later from other villages. The name of the first founder counts. Many people move from other villages, but all of them adopt the name of the ancestral founder of the village where they live. Neighboring communities have their own village names: Pudyugo in Amani, Duyo in Ireli, and Komakan and Dolo in Sanga.

For the Dogon these village names, also called *tige*, are their link with history. The Dogon have no creation myth, no deep story relating how the world came into being. (An anthropologist some decades ago probed his informants for creation myths so insistently that the Dogon, polite as ever, obligingly produced them. Some of his publications still in print as tourist guides perpetuate the mistake.)

ROPES WOVEN FROM BAOBAB
fibers provide young men the
means to scale the sheer cliffs
behind the villages. In the caves
above, the boys gather guano to
fertilize the onion gardens and
find antique objects left by
former inhabitants of the area.

The most important tales are the migration histories from Mande, a half-historical/half-mythical
place in the west, usually associated with the empire of Sunjata Keita. They tell how in the wake of
that empire people migrated eastward, and came to the escarpment. In the course of that journey,
the ancestors of the main Dogon groups distinguished themselves and established some rank and
hierarchy among them.

For the Dogon at the escarpment one of the main tales concerns Aru, the ancestor of a string
of villages, including Tireli. Aru received by supernatural manifestation the right to wear the red
bonnet of honor and be the greatest Hogon of all, the central priest for the area. The myths tell in
some detail how the people settled in the various villages, and in which order they came: the clos-
est to Aru being ritually the most important. (Aru itself is now almost a deserted village, with only
the Hogon family living up on the hill.) In the main Dogon rituals of death and rebirth, we shall
see this order respected. Thus, as one of the direct Aru descendants, Tireli counts Pegue as its older
brother. Yugo, a mountain facing Aru, is another important ritual spot, as the masks were "invent-
ed" there. From Yugo the masks came forth, and the oldest versions are still to be found there. And
from Yugo the *sigi* begins. But that story will be told later.

So each village knows who founded the settlement: the first heroes of the place, who made the
stairs to climb the hillside (always remembered in ritual texts), who dug the first wells, and who
built the oldest house in town. The Tellem, the group living at the escarpment at the arrival of the
Dogon, probably around the fifteenth century, are also often mentioned.

A DOGON PANTHEON

The Dogon worldview ties in with their history, and natural things and events easily blend into
supernatural ones. The supernatural world of the Dogon, their spiritual cosmos, consists of three
gods: a sky god (Ama), an earth god (Lèwè), and a water god (Nomo). Their relationships may be
complicated. Ama is the first power to be invoked in any sacrifice, ritual, or prayer. He lives "up
there," sees everything, and must be respected by other gods and spirits. However, the resemblance
between the monotheistic gods and Ama ends there. The Dogon view their gods as quite capri-
cious; Ama is depicted as essentially good but not reliable. He changes things: Ama turns happy
people into mourners, puts villagers in the bush and bush people in the village. Still, when asked,
people insist that Ama is good, but then one should keep in mind that European concepts of good
or bad do not apply to Ama. As in many traditional religions, Ama has a double face, a Janus-like
character, benevolent and threatening at the same time. A number of other spirits are associated
with the sky, and with rain; they share Ama's characteristics without his capriciousness: they are
titiyanaû, the messengers of Ama, who announce rain.

Lèwè, represented as a snake in myths and tales, forms a counterpart to Ama and receives much
ritual attention during communal rites. The earth god is just as ambiguous as Ama, whose adver-
sary he is in the myth. But he is also the giver of fertility. People swear careful oaths at his altar, for
he can be dangerous when lied to. In Dogon mythology, a classic struggle between Lèwè and Ama
occurs before every rainy season.

The story goes that long ago, Lèwè, the chthonic or underworld god, and the sky god, Ama, had
a dispute over hegemony. Who was the most powerful? After much boasting by Lèwè, Ama decided
to withhold rains from the earth. Month after month, no rain fell. The inhabitants grew desperate
and asked Ama to start the rain again. "Lèwè has to acknowledge who is the more powerful one,"
was the answer. The thickheaded water god Nomo refused to accept defeat. After more months of

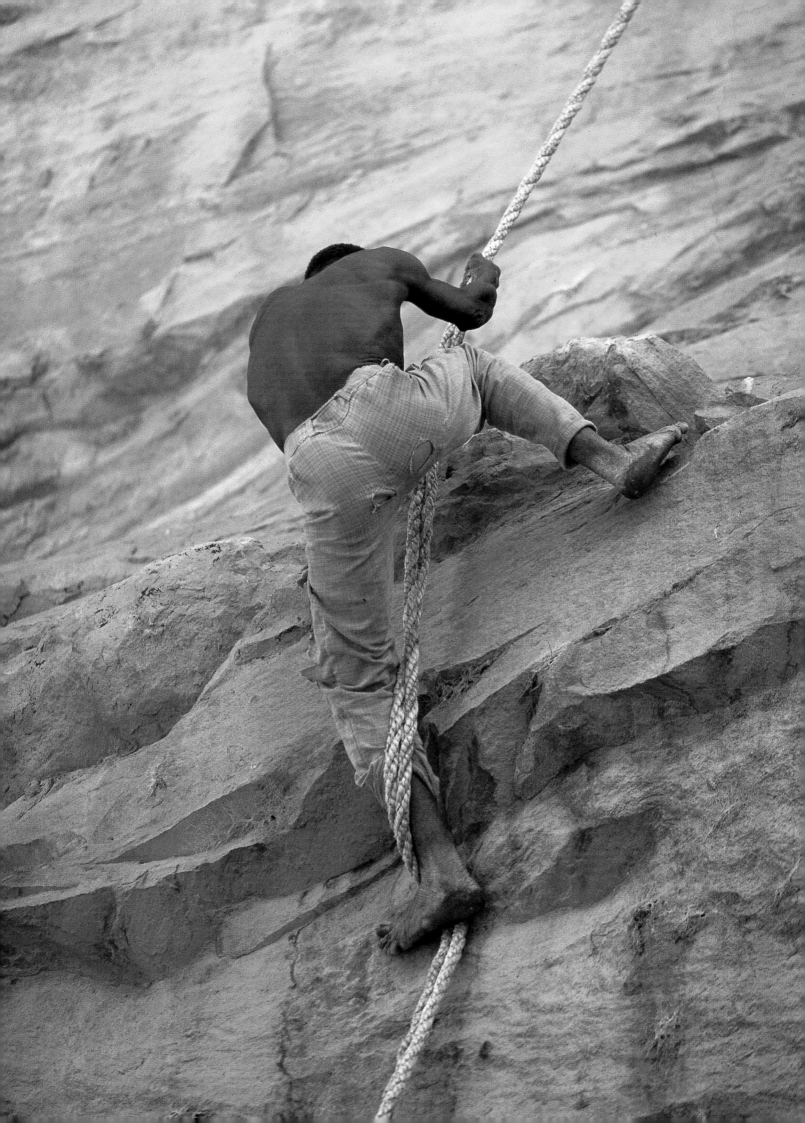

A WOMAN SHAKES A
calabash gourd covered with
cowry shells rattle as residents
celebrate Christmas Day.

THE HOGON OF TELI TWISTS
fibers from the baobab tree to
make rope with which the dead
are hoisted up to burial caves in
the cliffface. This Hogon, chief
priest of the Lèwè cult, rarely ven-
tures down to the village of Teli
on the plain below. Villagers who
bring him food and water believe
that he is washed by a snake who
licks him clean at night.

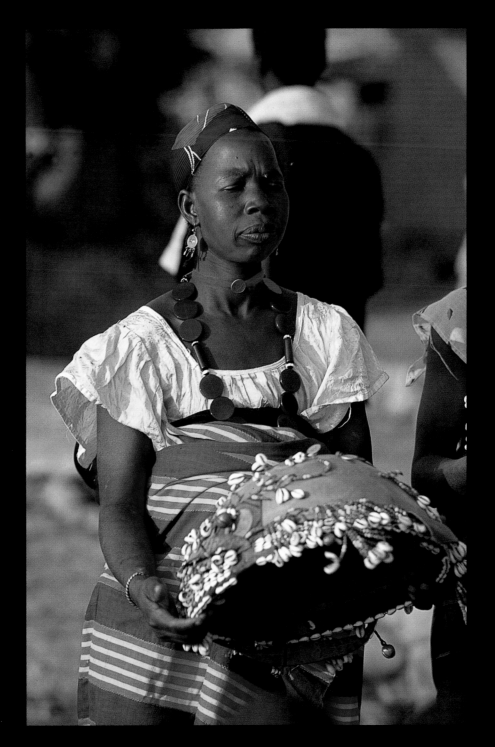

scorching heat, the people of the earth beseeched Lèwè to surrender, and finally he agreed to send
a message of surrender to Ama in the heavens. Lèwè's emissary, the serpent, painfully climbed all
the way up and told Ama that he had won. Immediately, Ama sent down his messenger, the *ana
sasa*, the rain bird, to indicate to Lèwè and the people on the earth that the rains would come
again. And so it happened.

The battle between Lèwè and Ama provides an explanation for the clear division between a
rainy and a dry season. In fact, the Dogon discern four seasons. The rainy season begins with the
arrival of the *ana sasa*, and from October onward a dry, cold season extends to February. This
gives way to the dry, hot season, which lasts until the end of April. In May, a brief in-between sea-
son, the humidity builds up and the temperatures do not reach the highs of April, in the range of
113° F (45° C). This transitional month is the battle time between Ama and Lèwè, which ends
with the onset of the rains.

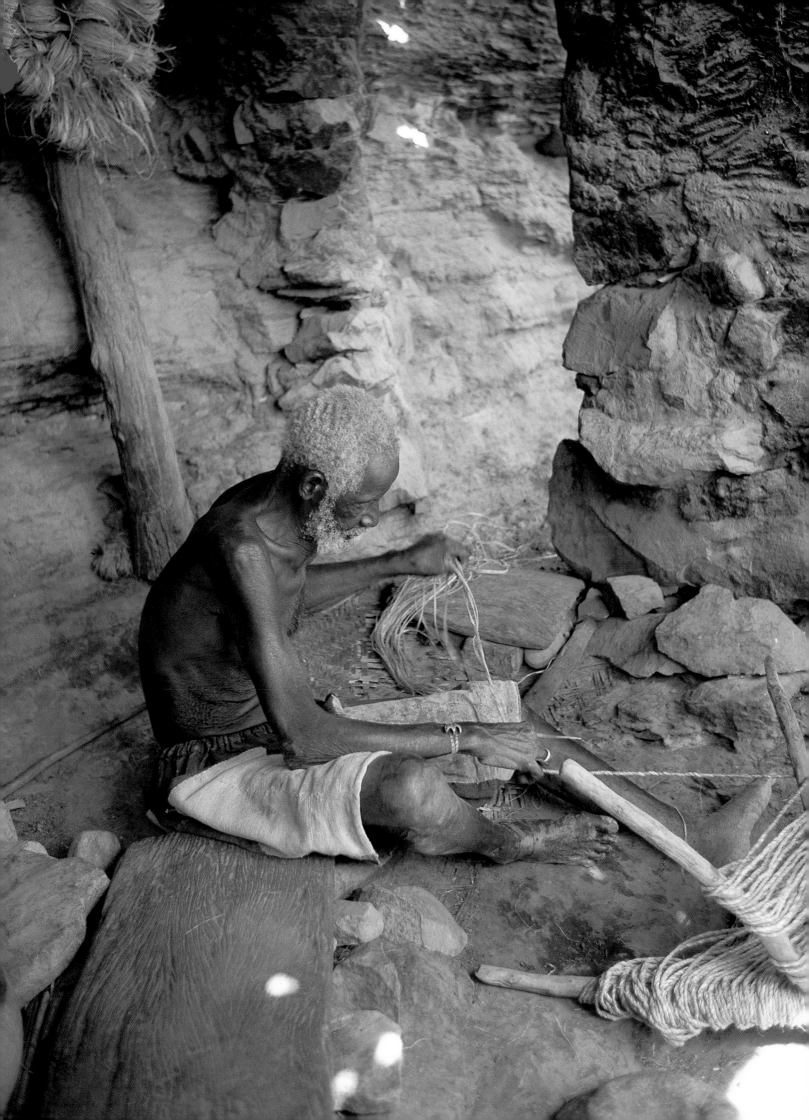

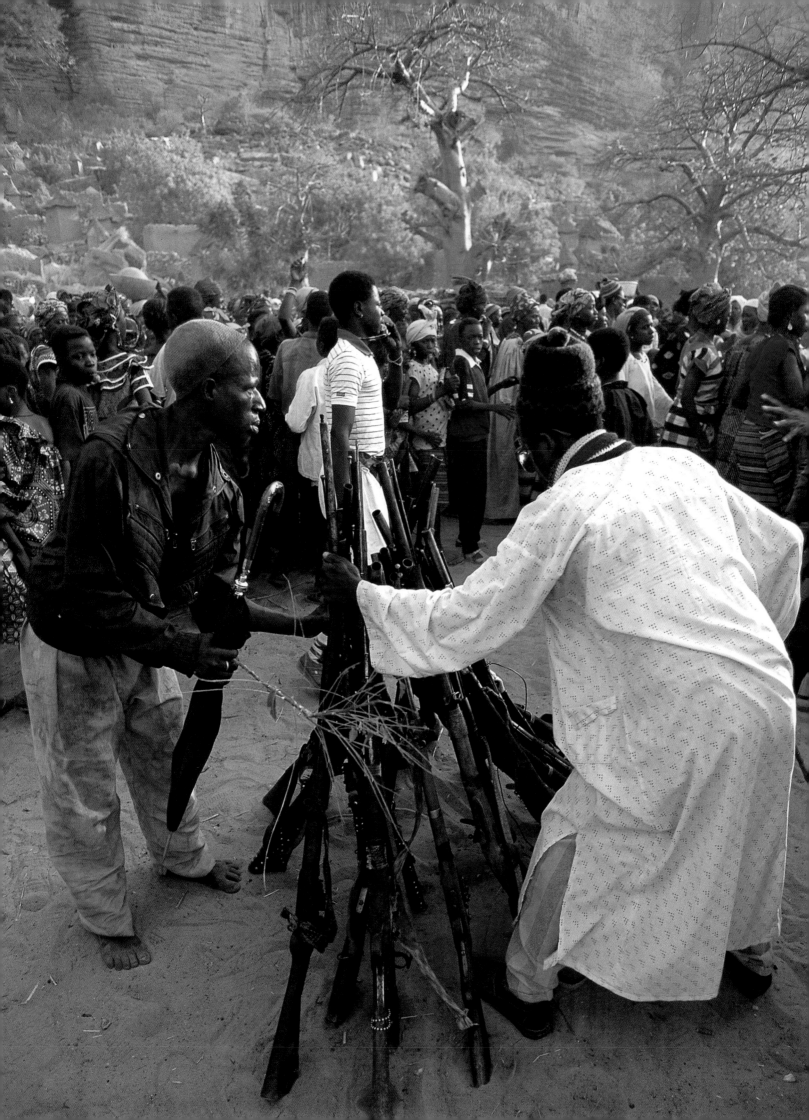

The most ambiguous Dogon deity is the water god Nomo. All things red, bronze, and multicolored belong to Nomo. An avaricious god, he takes anything that belongs to him: brass rings and bracelets, red skirts, anything colorful left at a waterside. Feared as no other being, he does not command a great deal of ritual attention but is the main inspiration for Dogon shamanic priests (*binukèju*). In fact, the elusive *binu*, spirits that take possession of the shaman, are closely tied with Nomo. A capricious god, he always changes his appearance and delights in trapping people in the water. The fear of drowning looms large in Dogon society, astonishingly so when one considers the dry climate and the virtual absence of water during most of the year.

In the rainstorm described above some goats had drowned, and later the message got through from neighboring Guimini that an old man had drowned in the flood. Again, Nomo the water god had taken someone. Dangerous as always, Nomo proved his fierce reputation. In Tireli, where no accident had happened, people commiserated with the bereaved neighbors. It is hard to lose someone to Nomo, sacrifices have to be made in order to retrieve the body, to make it ready for burial, and the whole family has to be purified in order to avoid later onslaught by the dangerous god.

During and after the rainstorm, the familiars of Nomo had a field day: the frogs, sheathfishes, and the occasional crocodile, especially in the village of Amani, the next neighbor to the northeast. A large pool, famous along the cliffside, contains a family of crocodiles throughout the year. During recent weeks, when the water in their pool became low, the animals had withdrawn into the deep recesses under the hillside, where water seems to be permanent. Now, when the flood reached Amani, they emerged, splashing around in the ample water. A special priest serves them, sacrificing chickens and an occasional goat to them, but only at certain moments of the year. Normally they are very much left alone, never hunted, feared, yet an asset for the village. After the flood, the old man sacrificed a chicken to them, thanking them for rain and water but also for the safety of the people from Amani: no humans had drowned.

Thus, Nomo and his servants command a deep respect. There are no known protections against the threatening side of Nomo, but some small offerings may make him release his prey. The Hogon priests make larger sacrifices and offerings.

Though rain does not come from Nomo but from Ama, as the myth makes clear, any place with water makes up Nomo's realm—wells, pools, and any great river. The Dogon are well aware of the rivers Niger and Bani, which they consider Nomo's strongholds, but Nomo has his special places also in the dry rocky cliffside. Dogolu once took the author to Bobonomo, "the place of Nomo," about a mile outside the village, on the hillside. It is a small crest in the cliff, difficult to reach and quite imposing. A huge conical heap of stones guards the entrance of this eerie place, silent and weird. The narrow gorge projects an inhospitable aura. On arriving, Dogolu called out: "Nomo, here we come, Nomo. Excuse us, pardon, we just come to greet you." At the far end of the gorge a small cavern houses a pool of deep, dark, cool water. This water never disappears, it is always there, the presence of Nomo himself. When other wells run dry, this is where people may come to fetch water. But they must be careful; the water is only for drinking. No washing may be done on the site, as Nomo hates soap.

MUSLIMS, ANIMISTS, AND Christians from the village of Nombori celebrate Easter together as they dance in front of their village. The hunters' flintlock rifles are arrayed in a stack during the first part of a dance. Though the rifles' barrels are now forged from the steering columns of scrapped autos, the flintlock mechanism is identical to the one in use in Europe since Napoleonic times.

ON EASTER SUNDAY
in Nombori, Dogon men
dance and stage mock combats.
Women freely watch and
participate as no taboos are
enforced.

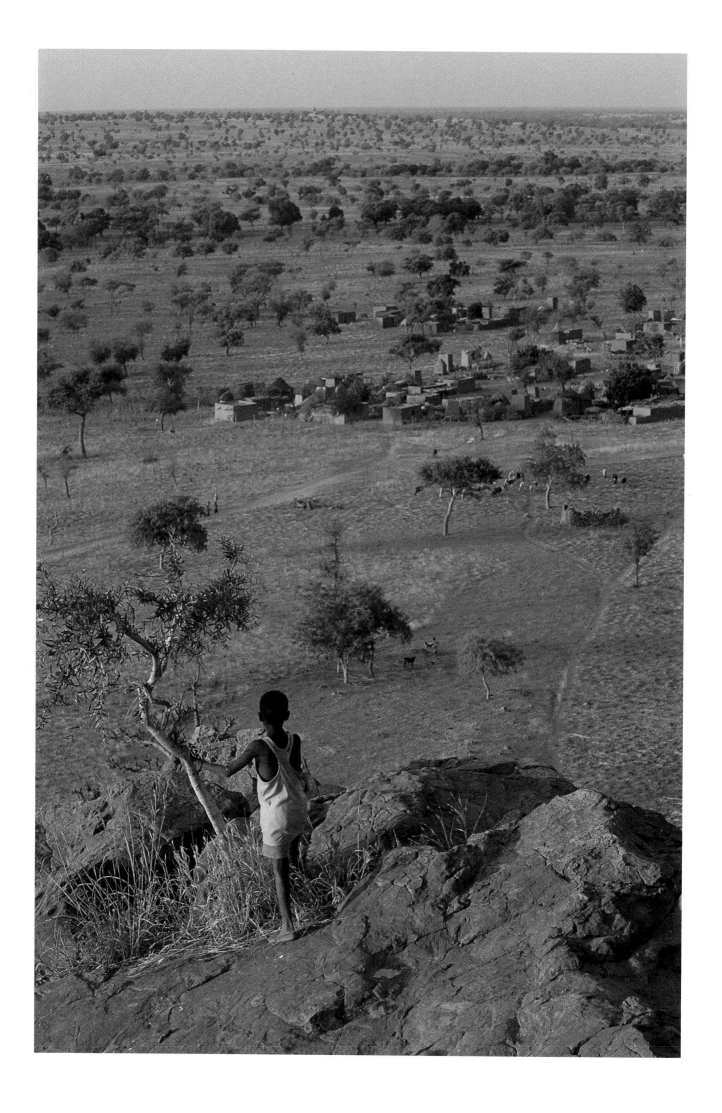

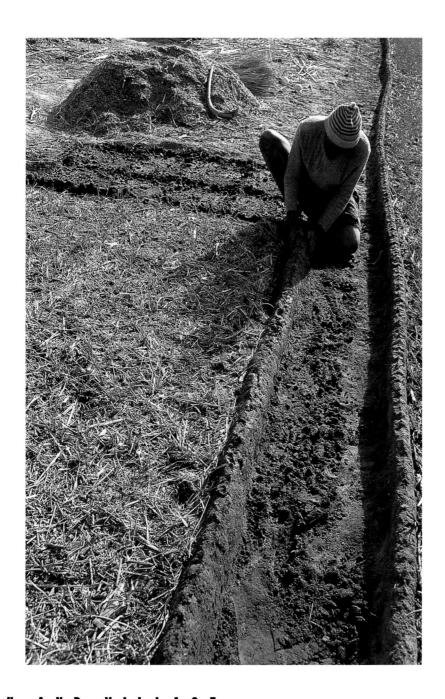

barren plateau, Dogon farmers have created onion gardens from nothing. They haul bags of soil to the cliff and plateau from the riverbank far away to build these terraced fields. Rocks piled around the terraces trap the precious topsoil and prevent it from washing away during the rainy season's torrential downpours.

Opposite:
THE VIEW FROM ELI IN THE cliffs reveals a world of sand and brush—the "bush" below. At Eli, the dry season's heat transforms the landscape into a monochrome vision, parched, with every stone hot to the touch. Heat shimmers off the cliffs in sheets.

Overleaf:
BLESSED WITH AN AMPLE supply of water, the villagers of Idyeli irrigate their onion fields along the plain. These gardens yield limes, mangoes, watermelon, and papaya, which are much sought after by other Dogon villages.

BUSH AND VILLAGE

Not only the rains but also the entire bush form part of a religious interpretation by the Dogon. They are acutely aware of the fact that they live from the bush. Thus, an important contrast exists for the Dogon between the village habitat and everything else: *ana* (village) versus *oru* (bush). One is safe in the village and never fully at ease in the bush. The bush is, of course, the raiding area of old, but it is also the region of spirits. Though most spirits are not thought to be malevolent, their very presence is eerie and unsettling. It is believed that evil creatures that take human form such as witches *(yadugonu)* and sorcerers *(dudugonu)* roam the bush after dusk.

The dangers of the bush are not evenly divided over the area: places near water are especially dangerous, as are stands of trees. At night one should be protected, isolated from the influences of nature, within the village, sleeping not on top of the roof (a bird might pass over the sleeping fig-

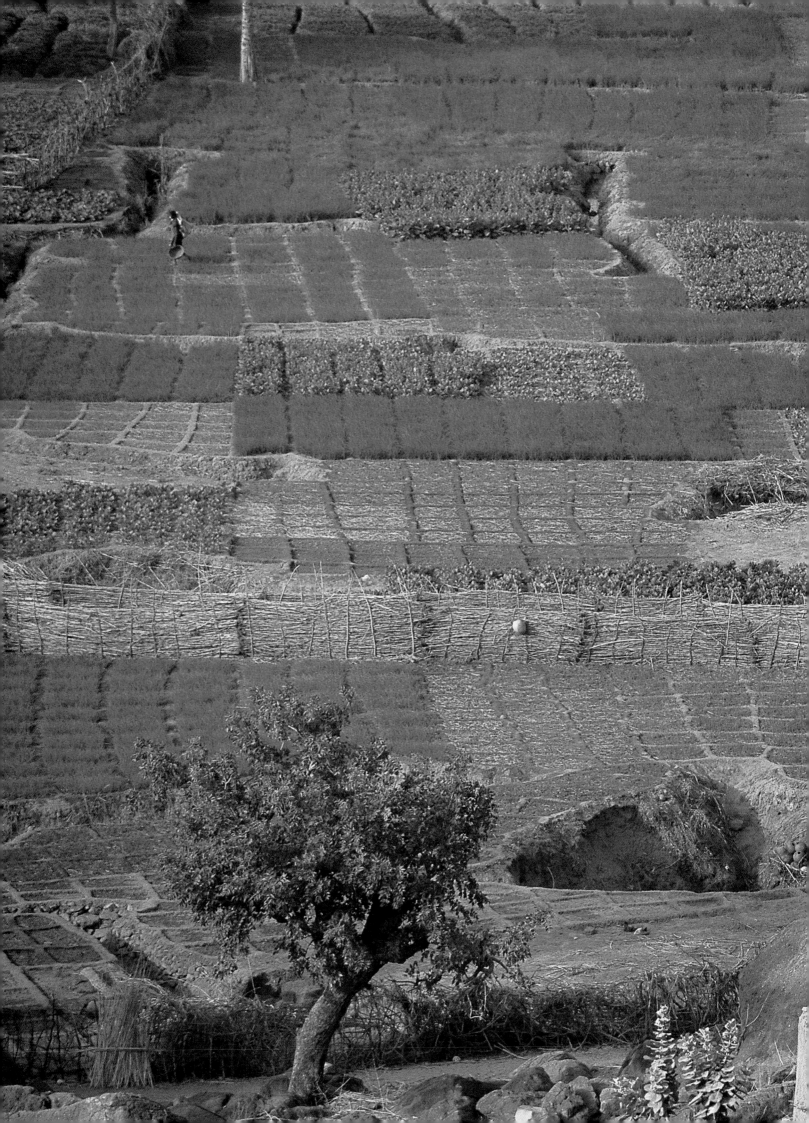

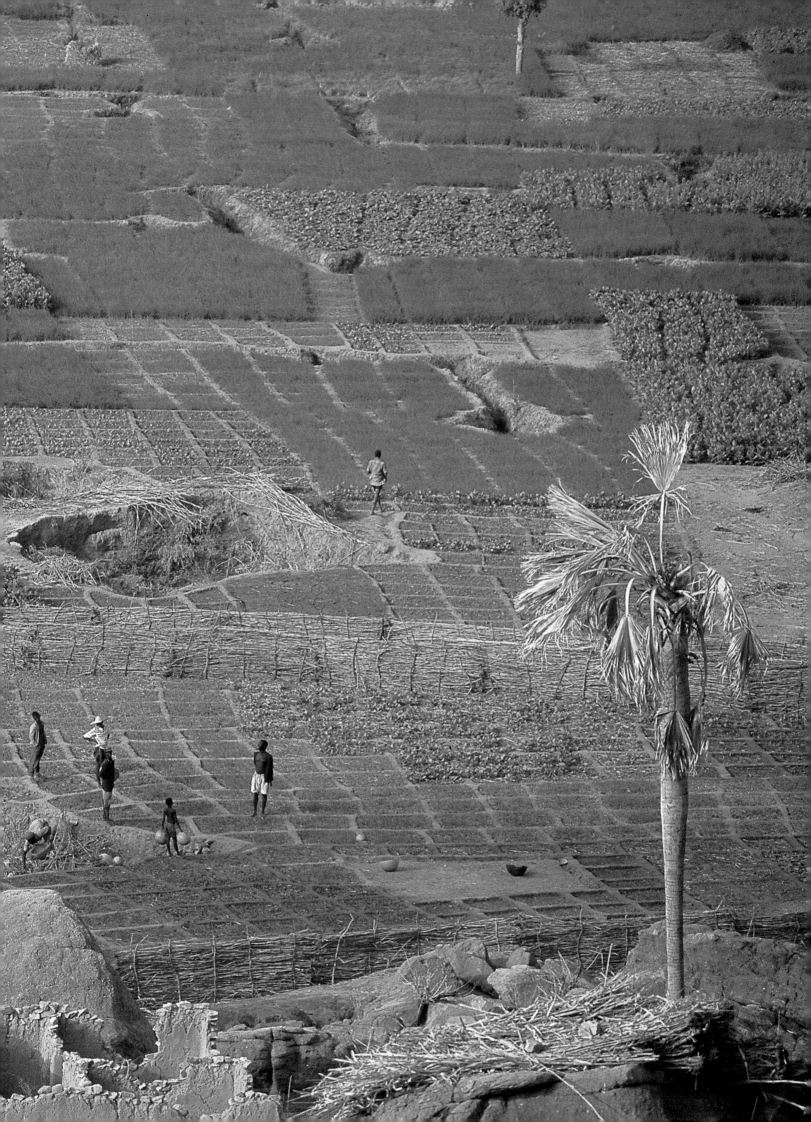

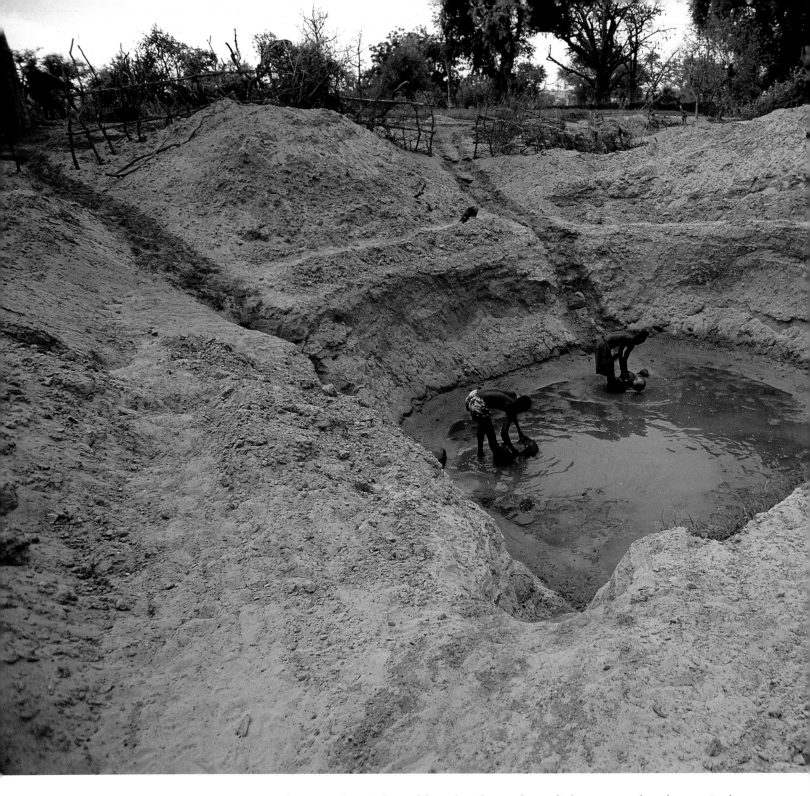

ure, possibly causing harm), but safely within the confines of a house or under a lean-to. In the Dogon view the village, where one is safe and secure, is surrounded by an inhospitable vastness of bush. The *oru* can be cultivated, but it remains basically untamed. Beyond the perimeters of the villages things are not domesticated; they have to be "tamed" over and over again. The way to tame the bush is to build houses, grass lean-tos at first, more permanent houses later, if possible within sight of other settlements. Fellow humans are preferred as companions over the "things of the bush."

The notion of *oru* is complex. On the one hand the bush suggests danger: no one will ever venture to sleep out in the bush without the protection of huts or people. The Fulani people, who do sleep out in the bush, are not considered by the Dogon to be fully human, simply because they sleep in the bush. (The pastoral Fulani living in the area consider themselves protected by their cows from the dangers of the bush, but no Dogon takes this seriously.) The Dogon believe that sev-

eral types of spirits—*jinu* and *yènèû* spirits—may attack people or exchange body parts with them. One often-voiced fear is that spirits will exchange eyes with the humans, rendering one blind. Vivid descriptions abound of spirits that change for a limited time into human beings, visit the market, and disappear again.

On the other hand, the bush harbors extremely powerful positive forces, which are hidden in animals, rocks, and trees. The Dogon attitude toward these reflects the second and more secret notion of the bush: from the *oru* stem all wisdom, knowledge, power, and life. The bush contains everything that makes life possible. It is believed, for example, that the animals of the bush all know the future; they have a perfect awareness of what a person is up to—their intentions, mistakes, transgressions, and frailties. And they all know what the future holds in store for the humans, hence the fox divination described in the last chapter. Divination can be performed with any animal—a fox, the songs of the birds (especially doves), the traces of the black ant, the sudden movements of an ant lion, the howling of the hyena—or in fact with any non-domesticated animal.

A consequence of the power of animals is that success in hunting for the Dogon depends not on technical skill but on magical powers: only those with potent magic, strong *sèwi*, can hope to deceive the animals.

When an ordinary person sets off into the bush with only a bow and arrows or a flintlock gun, all animals in the bush will be perfectly aware of his presence and intentions. A perfect hunter would have so many magical means that he would not need a weapon at all: the animals would come to his door by sheer magical force. This kind of hunting lore belongs among the cherished topics of discussion of the elder men. Hunting, in Dogon culture, forms a bridge between the bush and the village. So in the mask ritual, the mask of the hunter expresses the double identity of bush and man: the mask sports a fierce countenance, with large protruding teeth, a bulging forehead and apelike aspect, fierce but still human.

Beyond wisdom and knowledge, life and death also stem from the bush. The main rituals that aim at procreating life (the *sigi*) and regulating death (the mask rituals) originated, according to the founding myths, with the spirits of the bush and its animals. The main preservers of the cultural treasures, the *orubaru*, are initiated over a three-month period in a cavern outside the village

THE DOGON SAY THAT THERE are two things that money can't buy: water and health. Prayers to Ama. the sky god who commands rain, dominate Dogon rituals. As Tireli's onion farmers wait for the rain to arrive they must dig the communal watering hole deeper, in the quest for water badly needed to irrigate their onion fields.

Overleaf:
ON THE PLAIN BELOW THE village of Tireli the men irrigate their onion fields with water they have carried in calabashes from a well nearby.

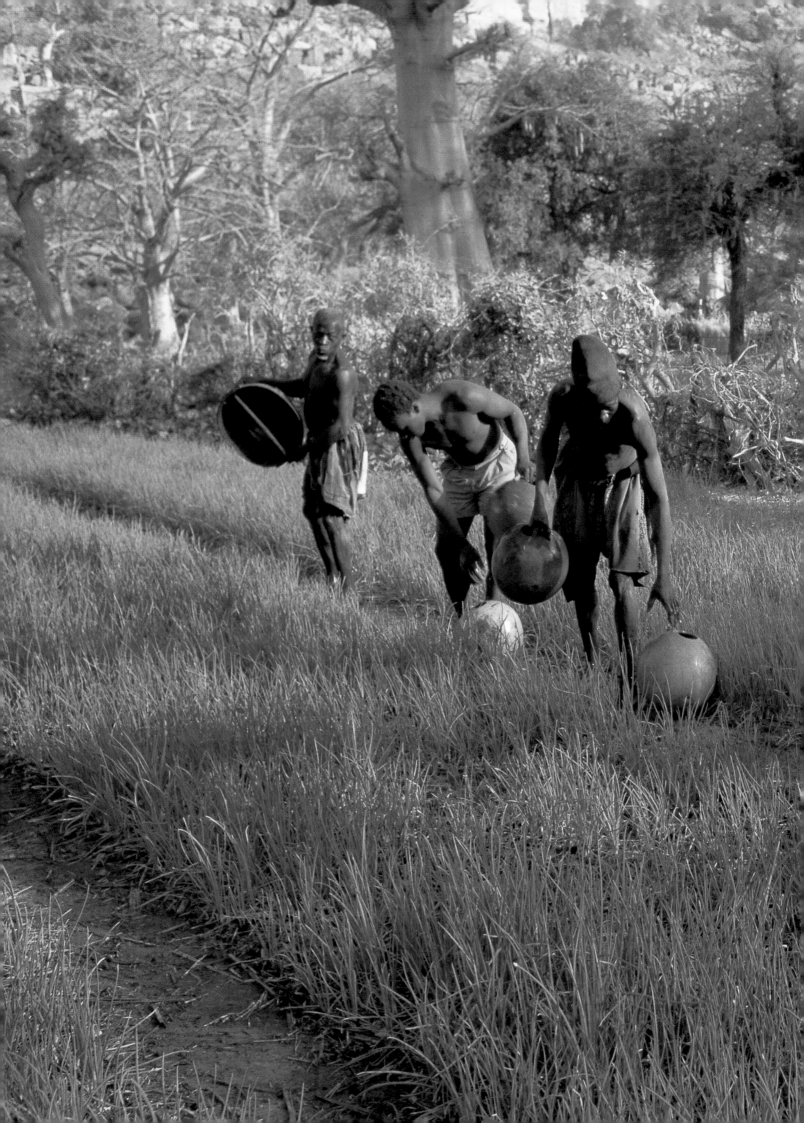

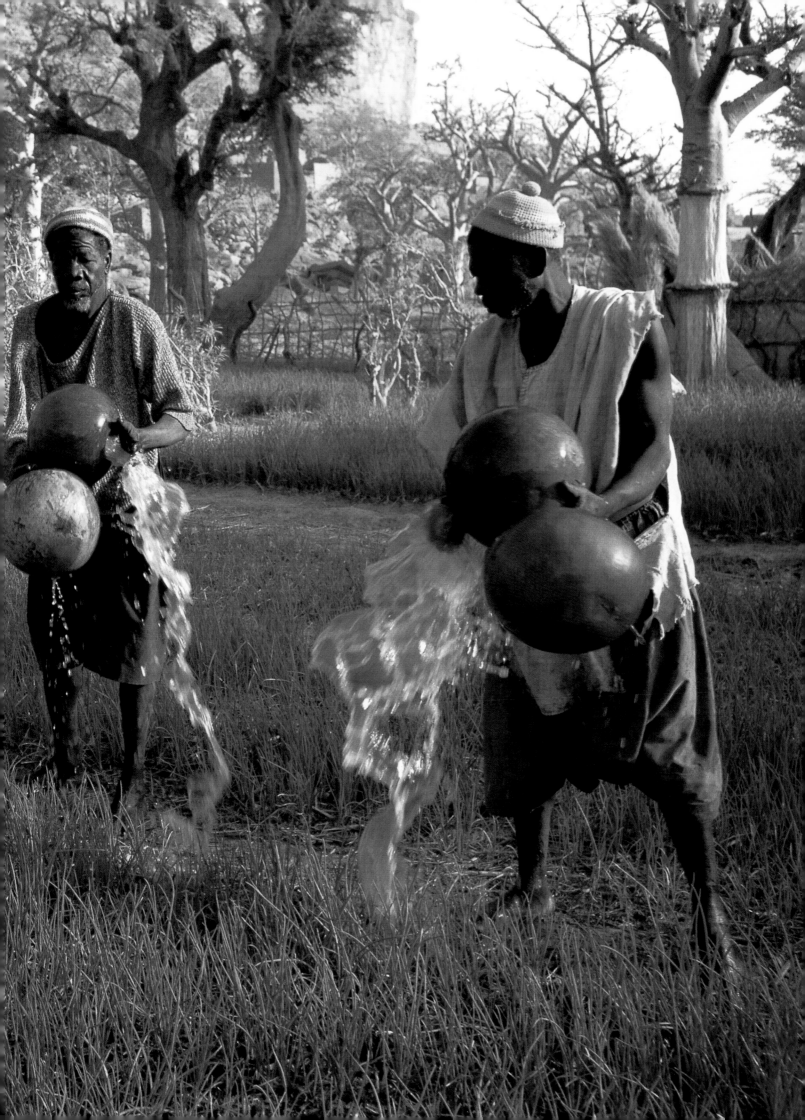

borders, living as animals as much as possible (no clothing, no speech, sleeping on the ground, no sexual interaction). In fact, the word *orubaru* means "added to the bush." "If they are not like animals, they can never learn wisdom" an informant explained. In fact, the seemingly most human of all arts, speech, also emerges from the bush in the form of the secret language *sigi so.*

Rocks, trees, and water share the ambivalence of the bush: some rocks, often close to the cemeteries, are known to roam the village borders. Anything in the bush can move and change, in any season. Sand dunes move, gullies retrace their beds, trees and rocks wander. Only the village stays put, as the fixed point in the Dogon spiritual geography. Inhabited by a series of succeeding populations (Toloy, Tellem, and Dogon), the villages are nevertheless the only places where things remain the same. They are the areas of stability. At the same time, however, they represent stagnation, the places where the forces of the bush whither away. Life and death, wisdom and knowledge coming from the bush are applied in the village but are used up and worn down in the process. Knowledge dissipates, the people of the past inherently knowing more than those of the present. Thus, human power evaporates unless reinvigorated from the bush. (This view, in some way, closely resembles the ecological picture, in which a constant flow of energy from natural materials keeps the human settlement alive.) From the bush, people are fed, the sick are healed, knowledge is gleaned, and discipline is meted out.

Trees share this aspect of power and life of the bush. "All trees are medicinal," a healer insists. "You only have to know how to use them." The same holds true, though less potently, for all herbs.

Healing power comes from the bush: even the words used in spells, *anga tî*, have to be learned either from the spirits or the trees themselves. A true *jojongunu* (healer), another intermediary between bush and village, speaks with trees at night in order to learn his craft. Some trees are "initiated," *yèm*, and walk at night, conferring among each other. Three species are known to be inveterate walkers, the *jiû* (*Ceiba pentandra*), the *omuru* (*Tamarindus indica*) and the *siwèlu*.

A typical Dogon story tells about someone who slept under a *jiû* near a neighboring village. Waking up at night, he found the tree gone. Perplexed, he stuck his knife in the ground. Before sunrise the *jiû* returned and ordered him to take away the knife or else the tree would kill him. The man took his knife back but died within a month nevertheless. Folk tales abound with episodes of talking and walking trees.

The Dogon value trees for several reasons. Fruit forms only a small part of the Dogon diet, as most trees of the region do not bear edible fruits. But some trees add important ingredients for seasoning and shortening the sauce added to the daily meals of millet mush. The *oro* tree, a baobab, (*Adansonia digitata*), for example, bears leaves that when cooked with sesame yield a dark green, rather slimy sauce greatly relished by the Dogon. "It gives you strength," they say. The women stockpile leaves for the dry season, as no daily diet is complete without them. The baobab tree's sweet-sour fruit pulp is both used in millet cream and sucked raw between meals by children. And the bark of the tree is stripped at regular intervals for rope fibers. Used more intensively than other trees, the baobab yields poor firewood and consequently is never cut down. Other trees that are

IN OGOSOGO, AS IN MOST Dogon villages, onion fields are watered by children and men of the village. The trek to the fields with heavy water-filled gourds can be a long one.

A DOGON BOY CARRIES
calabash gourds filled with water
to pour on his father's onion fields.

Opposite:
IN ELI, THE SON OF ARSHOGE,
the chief, gathers water from a
stagnant pool located in a cave in
the cliff. Although a small spring
feeds this pool, its water is brack-
ish and infested with parasites.
After seeing their other water
resources dry up, most villagers
of Eli emigrated to the plain.
Those who decided to remain
behind believe that their destiny
revolves around their *gina* (clan
house) and that it is their duty as
custodians of the original families
to remain. Arshoge says, "I have
no other way to live. I can go no
other place. I'll remain here until
my family dies."

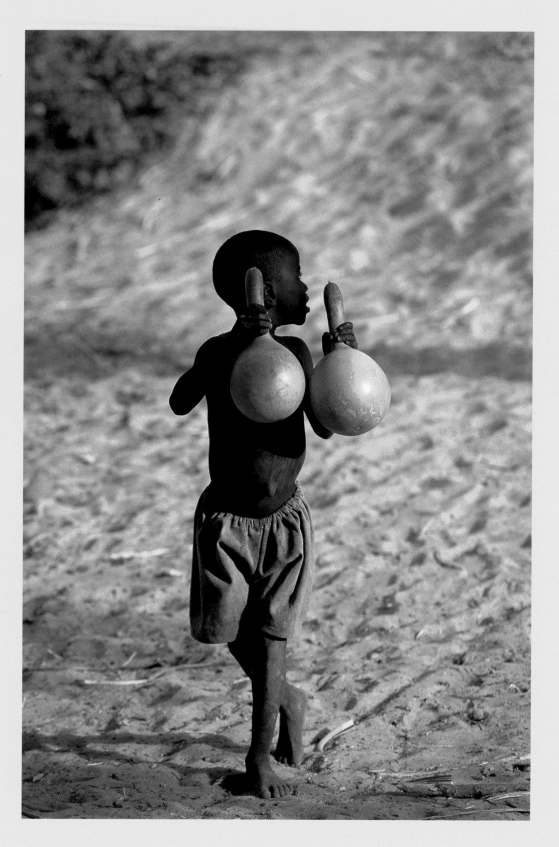

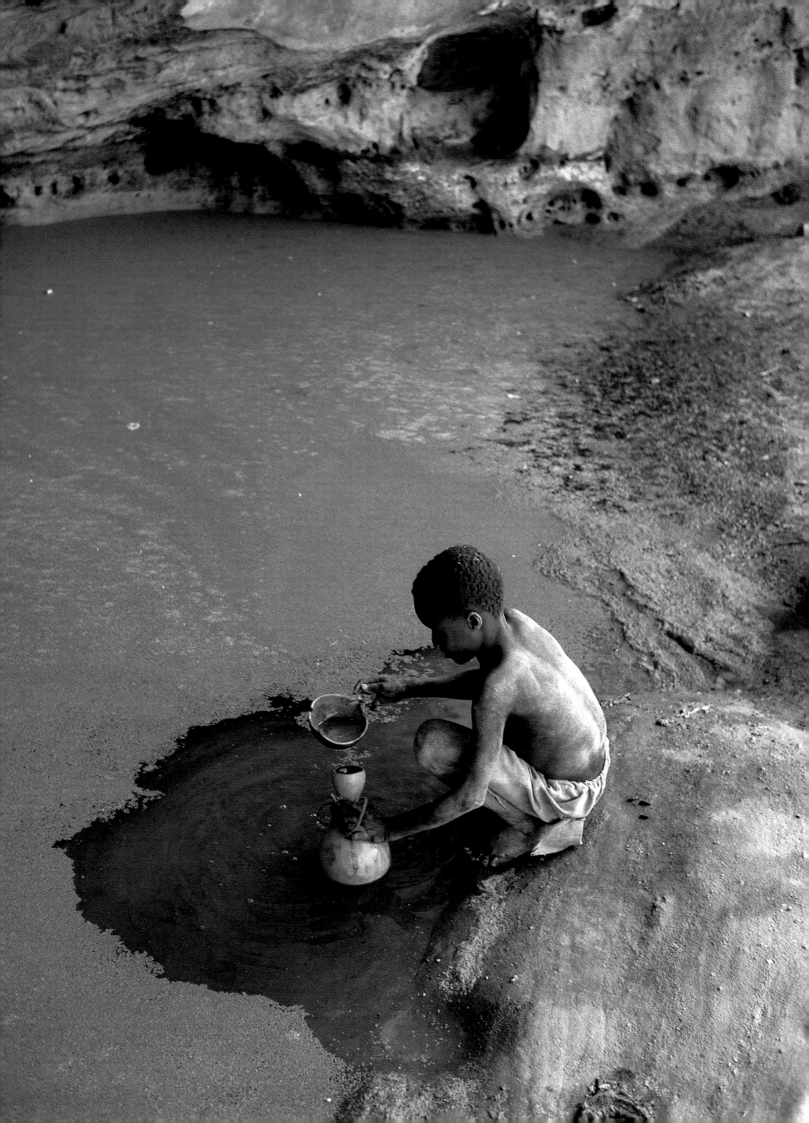

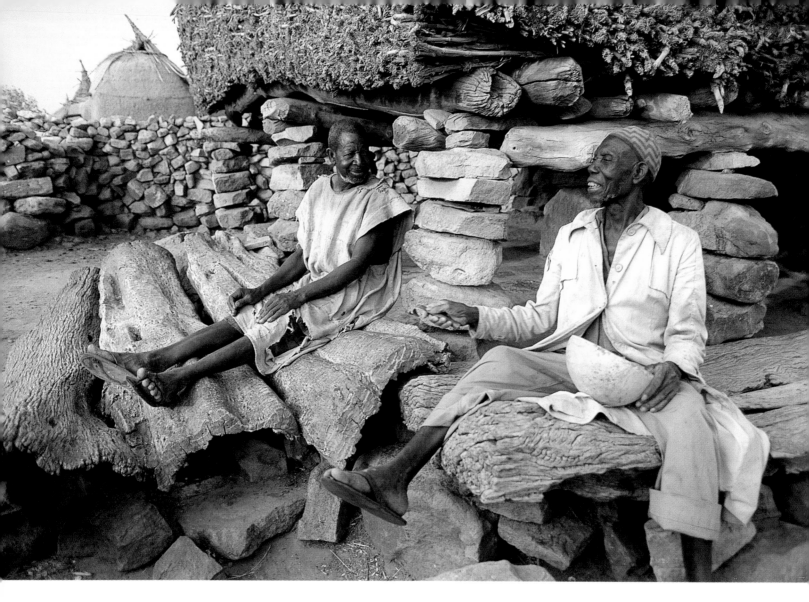

FOR DOGON MALES the *toguna* represents the center of village life. (*Togu* means "shelter" in Dogon and *na* means "big".)

important for their fruit are the *ponu* (*Detarium microcarpum*); *omunu* (*Tamarindus indica*); *sa* (*Lannea acida*); and *yurò* (*Parkia biglobosa*). Leaves of the *sèngè* (*Acacia albida*) are used as fodder for goats and sheep and as mulch for the fields. So, all the more reason to have respect for trees.

The question of respect in relation to trees forms the core of a Dogon legend, a story that explains why Tireli village is less favored in this way than some others. During the nineteenth century, a blind bard, a prophet called Ambirè, toured the plains and cliff areas. From the moment of his miraculous birth in the northern part of the region to his death in the south, he toured the settlements to sing his ballads, prophesying about the future of all villages he passed. (These ballads, called *baja ni*, form an integral part of the Dogon funeral proceedings.) One of the prophecies made by Ambirè concerned Tireli. The elders of Tireli, according to the text of the *baja ni*, were annoyed with Ambirè, for unstated reasons; they had the reputation of being "hard people" anyway. They did not believe that he was really blind and had announced that they would "operate" on him to see whether his eyes could see or not. Ambirè, like a good prophet, immediately knew what they were up to and did not enter the village territory of Tireli. Making his detour through the bush, he cursed Tireli: the village would never have a forest, a thicket of trees between the hillside and the dunes. So the evil ways of its ancestors—in other words, a lack of respect—robbed Tireli of a potential resource.

PROTECTING THE TREES: THE *PURO*

Among the many Dogon mask rituals, an important one relates to trees. From time to time, in the hours of the night just before dawn, shrill cries echo through the sleeping village of Tireli: "Hée hee hee, hée hee hee". The quiet peace of the village is rudely interrupted as twenty or so young men dash through the steep and narrow alleys winding along the hillside. They shout at the top of their voices the high pitched mask cries: "Hée hee hee, hée hee hee—be warned women, be alert men, the masks are here." A few youngsters beat small wooden split drums or tap sticks to arouse the villagers. Still dazed from their sleep, the women slowly heave themselves from their sleeping mats on the ground inside the compound and reluctantly enter their huts, where yesterday's heat still lingers. They know that they are not permitted to set eyes on these maskers.

From their sleeping mats some men raise their voices to greet the masks in the *sigi so*, the ritual mask language: "Welcome, welcome, how did you spend your day, thank for you coming. Be strong and powerful." The shouting youngsters who behave as mask dancers are not fully adorned as such. In fact, they seem sloppily dressed, not at all like the normal mask outfit in which a good and careful grooming is standard. Some wear a dilapidated mask half over their faces, another has only put on the red grass skirt that forms the central piece of his costume, and a third just tied a strip of fibers around his head. The *puro*, the wrath of the masks, has come!

After waking the village, the masks descend the rocky slopes in search of the stacks of firewood on the first duneridge, where most of the women keep their fresh supplies of wood. The women need firewood for cooking and pottery making, but the sandy dunes close by only harbor a few battered trees alongside the creek bed, trees that are protected by a taboo. Elsewhere nearby there are no trees. The women have to walk about four miles to find any suitable wood. The *ponu* trees make

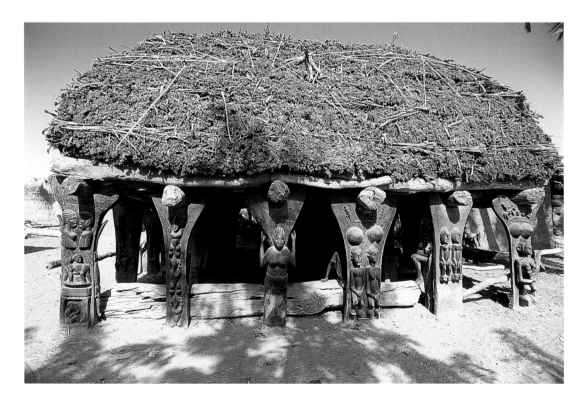

CARVED POSTS FASHIONED from forked tree trunks support the roof of this *toguna*. Posts such as these, treasured by foreign collectors, are often stolen and sold for cash to art merchants.

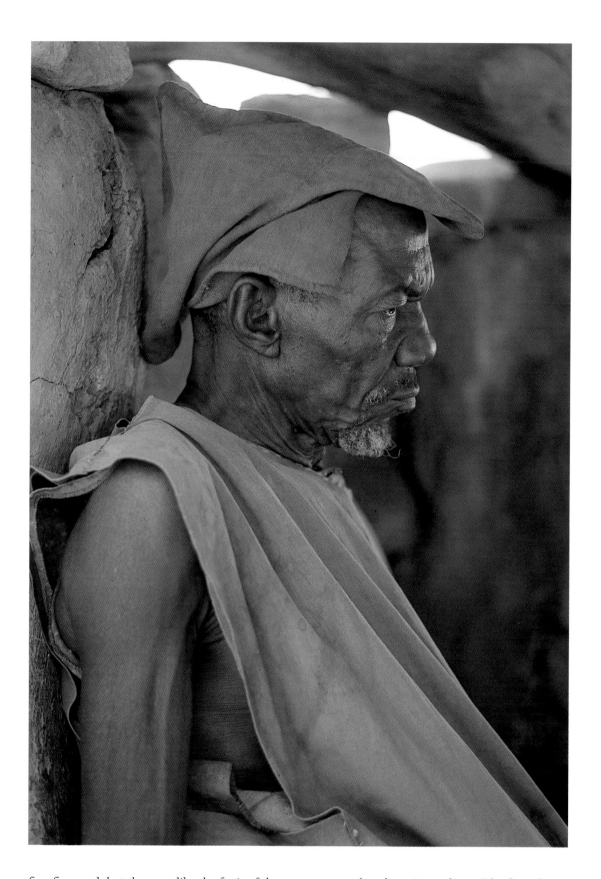

A DOGON ELDER RESTS in the *toguna* at Banani chatting with others and occasionally sipping millet beer. This man wears the traditional pointed cap and tunic fashioned from hand-woven cotton favored by elders.

fine firewood, but the men like the fruit of the *ponu* too much to have it cut down. The fruit does not give much nourishment, as it mainly consists of a large inedible kernel, but the men like to suck its scanty covering. The masks, therefore, are looking to see if the women have collected any wood of the *ponu*. Shouting, drumming, and dancing, they overturn the neat piles of firewood, dragging out all the *ponu* branches they can find. Other youngsters join them, some partly masked.

The dancers' cries rise to an even higher pitch as they find large quantities of *ponu*. They march to the center of the village to display the offensive wood to the male villagers' high indigna-tion. In the village, family compounds are searched for more *ponu*. Meanwhile, the older men are

gathered in and around the main men's house, the *toguna*, to discuss the seriousness of the female offense and to decide the fines needed to offset the wrong. A few fully clad masks from the other side of Tireli join in to add to the general feeling of male superiority. However, this feeling is slightly offset by the presence of a woman, called Yasigi, one of the ceremonial mask sisters. Undaunted by any mask, this older woman freely mingles with the spectators and dancers. She contrasts sharply with the rest of her Tireli sisters, who sit in their huts, quietly and a little subdued, yet also amused by the whole proceedings.

At noon, the crowds disperse; all the men slowly return to their homes and daily chores, feeling pleased about the day's events. The women have learned a lesson they will not easily forget. True, it has cost some money, as each husband has paid his wife's fine; but it has all been worthwhile. The women themselves now leave their huts to fetch water and cook millet mush. Normal life returns again to Tireli.

Apart from being great fun for the men and mild amusement for the women, the *puro* reflects a basic conflict between men and women in Dogon society. The issue is not so much that women's need for firewood denies men an occasional tasty treat. It is a matter of control, for which the men employ the masks. Of course, the masks are worn by village men, but it is an accepted fundamental taboo in the whole complex of masks and mask dances that the women should not know which of their male kinsmen may be dancing in a particular outfit. Obviously they know very well, and even can distinguish precisely which boy is dancing which mask. They can, furthermore, judge how well he does it. But they play along, pretending not to know in front of the men, and joking mockingly about it when no man is present. In the *puro*, when the masks are incompletely dressed and no disguise is possible, the women are not allowed to see them at all and are confined to their huts. These *puro* rites can be held for any grudge that the men of the village may hold over women, be it quarreling too much or running away from husbands. In recent times, trees have figured prominently in *puro*.

The proper attitude that people should, therefore, have toward the bush combines two elements: respect and work. Respect *(bawa)* is a key term in Dogon social life, operating in a fundamentally hierarchic system where age, sex, and to a lesser extent, knowledge and riches are the main parameters. Older people, in-laws, and ritual officiators must be respected. Other living things beyond the human sphere must also be respected, especially those from the bush. Within the family dwelling compounds the main representative of the bush that commands respect is the millet *(yu)*, the Dogon staff of life. Eating millet mush, drinking millet beer, and the very cultivation of millet are subject to a number of taboos, all centering on the notion of respect. With a lack of respect, the millet will vanish from the granary. Even when speaking about millet one should be quiet and respectful: millet has ears. Other staples have fewer taboos, but respect must be paid to all of them.

In the bush respect must also be given to plants and particularly trees. Trees stand out among all things in the bush through their association with wealth. Folk tales abound with trees (especially the baobab) showering men with riches if they show proper respect. This respect may be expressed in several ways. Using a tree for medicinal purposes involves holding a ritual conversation with the tree. Cutting wood for construction or utensils must be done with care and restraint, using the proper axe in the proper fashion. Felling a whole tree must never be done by one individual alone,

and sometimes a small offering should be made. If a tree has been cut to make wooden utensils, such as mortars, pestles, mush bowls, stools, and metal tool handles, these wooden objects are never to be burned when they are out of use but should be left in the compound to decay slowly. Firewood is another matter, but even cutting firewood can engender problems. Women must be careful when, where, and how they cut their firewood. They may not cut major branches; they have to avoid trees in the near vicinity of the village (unless owned by their husbands); and they should select trees in the *saû* (the uncultivated bush area).

Trees close to the villages are owned in principle by the owners of the fields near them, the so-called infields. Ownership of these fields rotates in a complex way between the oldest men of the various lineages, and the trees go with the fields. When individuals have planted and watered trees, they are in command of them. The Dogon plant only the baobab (*Adansonia digitata*) and the *yuro* (*Parkia biglobosa*). Other trees are either not productive enough for them, or die when transplanted, the tamarind for example. In the village the *wènye* (*Ficus lecardii*) is sometimes planted for shade in the compound, as is the *kumu* (*Ficus umbellata*), in public squares.

The second attitude of the Dogon toward the bush involves work. The Dogon believe that one should work hard in order to extract a living from the bush, and that a depleting environment simply means working harder and longer. This strong work ethic stands as a corollary of respect, work being considered a positive social value on its own. The onion gardens near the villages call for a tremendous amount of labor, as do building houses and roads. Infield millet cultivation means constant, but less intensive, fertilizing. Trees in the bush do not demand work, but within the village certain trees are planted and watered.

The bush is viewed as not only the ultimate source of life but as an inexhaustible source. The Dogon view themselves as being at the bottom of their environment, dependent upon it. They may shape parts of it, and in doing so enhance their chances for survival and wealth, but in changing it from things of the bush to things of men, they realize that certain truly fertile, life-giving aspects of the bush are lost. Whereas the bush evokes life, culture means entropy. So the Dogon are not very interested in modifying their environment, other than crop cultivation. The resources are not theirs to replenish. Fields are inherently plentiful, if only somewhat more distant nowadays. Water sources may have to be dug deeper. Trees, of course, can be conserved, a notion that is in perfect harmony with respect. Wood should not be burned indiscriminately, nor trees felled without good reason and ample discussion. Cooking has always been done with a minimal loss of heat, and wood from abandoned buildings can be reused. Consequently, working harder can be a perfectly feasible solution to all environmental strains.

MEDIATING BETWEEN THE WORLDS

In the Dogon worldview the animals, the wild ones, bridge the gap between bush and village, between nonhuman and human. Three groups stand out as important. First the familiars of the main gods, such as the serpent, lizard, tortoise, crocodile, and the rain bird. They represent the gods in this world. Sometimes they get ritual attention, as in the case of the tortoise. In the clan houses of old, a male land tortoise was kept as a direct representative of the ancestors. That animal,

old as the ancestors and slow as heaven, would get the first taste of all food, as a true old grandfather should. He was never killed, and when he died (which some Dogon deny ever happened) he was buried with a proper burial, like a human being.

The second group of animals is the one associated with knowledge of the future. First and foremost the fox. Yurugu, as he is called in Dogon, has received from Ama the knowledge about the future and is the center of many Dogon tales. He is not a god himself, nor an actor in some creation story, just an animal who combines knowledge of the future with the ability to converse with humans. Formerly, one story goes, the fox came to the houses of the diviners and spoke with them in person. Then, on one unlucky day, the diviner's wife got jealous about those secret conversations and tried to kill the fox. Too smart to be caught, the fox escaped, but from thenceforth, he said, the humans would just have to make do with his footprints, and they would have to come out to the bush to find them.

In this same category are the hyena and the red working ant, both of which also know the future well. But it is recognized that asking a hyena for anything can be pretty dangerous, and to read an ant's footprints would strain the eyes. Yet, "they know even more than the fox" the Dogon claim. The hyena is considered immortal (he only dies when he eats some of his whiskers), and the ant always knows where water can be found: they always build their nests over a water source. More important still, the ants are the very animals that "invented" the masks: it was their mask that a bird dropped at Yugo, as the start of the masking tradition of the Dogon. The dove and the ant lion are two other animals one can converse with, but less clearly so.

The third group comprises all other animals, especially the antelope, several birds, the hare, and the buffalo, which are depicted in the mask festivals. They too, in a lesser way, represent knowledge, power, and wisdom. Domestic animals are a group apart, too human to be counted as *oru*.

Finally, the main intermediaries between Ama or Lèwè and the humans, are of course the dead kinsmen, the ancestors. As elsewhere in Africa, ancestors for the Dogon form the important bridge between heaven and man. Though not as crucial as in some other African cultures, the great dead in Dogon religion plead with Ama on behalf of their descendants. Sometimes people pray directly to their ancestors or to one specific ancestor they still happen to know. The advantage of ancestors is that they are kin and share the same values and interests of the living. By virtue of their death, and by grace of their importance in life, they have the ear of Ama and can intervene with some efficiency. They are addressed in the burial rites, in all sacrifices; they eat with the gods, plead with the gods, and admonish their people. On the other hand, they tend to check their descendants on strict adherence to rules and taboos. They may inflict diseases in cases of serious transgressions of Dogon taboos. When this happens the afflicted person has to ask the diviner for the reasons and the remedy.

Dogolu tells a story about a group of tourists who wanted to see and film how Dogon men danced with guns on the roof of a house during a funeral ritual. A neighbor offered his roof for a practice run. Immediately afterward he fell ill, with severe headaches and fever. A diviner explained to him that the ancestors would not tolerate such behavior. After all, no one in his family had died. So his lineage elder arranged for a blacksmith to purify his friend that evening. The next day the affliction was gone.

CHAPTER SIX: BECOMING FULLY

A "PERSON" IN DOGON

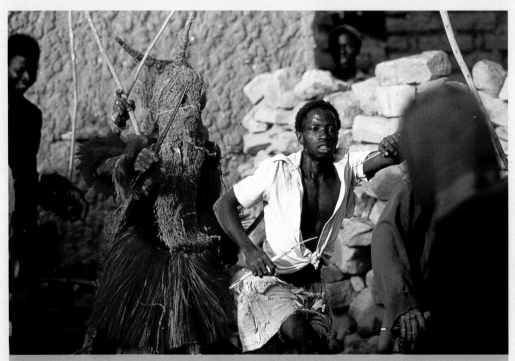

ANACANA DANCERS MARCH through the village in a snakelike fashion, weaving in and out to the beat of drums. Women go barefoot in Anacana because it is believed that women who wear shoes will bring evil to the village..

As the natural and

the supernatural are merged in the Dogon worldview, so they are in the Dogon idea of what makes a complete person. Once a child has been named, it is recognized as *inè*, a person, made up from a *goju* (body), along with two qualities called *hakilè* and *kikinè*. The body comes from the father, both other elements come from Ama (God) and the parents. The *hakilè* is the most complex concept. Located in the *kinè* (liver/heart), the concept may be translated as intelligence, imagination, and character. It is the essence of the personality through which one distinguishes oneself from others.

All living beings have *hakilè*, though in widely divergent ways. Whereas the body's function is to perform physical labor, the *hakilè* works to keep people together, remaining alive and functioning as part of a social group. Animals have *hakilè*, the cunning ones more than others. The fox, the black ant, the rabbit, the pigeon (all animals associated with divination) have a great deal of *hakilè*; sheep have only a little. But anyone who can find his way home has *hakilè*. During pregnancy the child in the womb has the *hakilè* of both parents, and being a real *inè*, it speaks with God. At birth, one of the two parental *hakilè* is erased and the child takes on the character of one of its parents. Though boys usually have the *hakilè* of their fathers, and girls the one of their mothers, this may cross sexes. Ama decides which one prevails.

Not only can one *hakilè* be stronger than another, one person may have more of it than another. Whoever has much *hakilè* learns quickly, has a strong memory, is able to follow several conversations at the same time, and possesses a strong imagination. In stereotypical social categories, smiths and leatherworkers should be endowed with much *hakilè*. Troubadour entertainers, the *griots* or *goû*, use theirs mainly to trick people, but this is according to the Dogon, among whom troubadours hold lower status than among Bambara, Malinke, and Soninke peoples.

Dogon consider that one who is less endowed with *hakilè* has difficulty in remembering things and speaking coherently. Facility in speech, however, does not always signify less *hakilè*: a well-known deaf-and-dumb person in Tireli was generally considered to have much *hakilè*. Those who may have a considerable amount of *hakilè* and still have difficulty in speech are considered to have "short" *gele hakilè*, while someone whose abilities lie mainly in speech has a "long" *para hakilè*. Other character traits depend on the *hakilè* as well, such as being gentle, quick to react, patient, or jealous. A bad *hakilè* leads to jealousy; a good one to equanimity.

A witch's *hakilè* induces her to poison people. Witches, who are mostly female, are described as having another, quite bewildering trait. In addition to administering poison, they roam the bush at night and attack people who inadvertently come their way. Most victims are male. Flying through the air with burning sticks in their hands, the witches land on the victim's head, sometimes urinate on them, paralyzing them for some hours and rendering them incapable of speech. It is not the shadow of the witch that does this but the witch herself. The remedy for bewitching is to consult the shamanic priest, who performs a ritual involving an emetic. The patient then vomits a hairy worm, which immediately restores their mobility and speech. Some men are reputed to be stronger than the flying witches and are able to hold them off for an entire night. In those cases the witch women remain friendly later, though they may pass on the name of the strong man to their colleagues to try him out.

Male sorcerers, who aim their craft mostly at enemies rather than casual victims, when very old, teach their trade to their sons, selecting the one, it is said, who "knows his words." Female witchcraft passes matrilineally from one *yadugonu* to her daughter or younger sister. However, this full inheritance of the *hakilè* is believed to happen not at birth but at the death of the old witch, and may lead to an unbroken chain of ten generations of witches. If a woman wishes to end her witchcraft, her daughters become infertile. Even if a woman possesses the *hakilè* of a witch, however, the passing on of the witchcraft does not happen involuntarily; witches have to wish to become so. Once they have chosen the path of poison, and, as it is said, "it resides in their granaries," the way back is very difficult.

Hakilè, however, is more often a positive quality than a negative one. Their *hakilè* makes some people into *inè piru* (literally a "white person"), open, friendly, hospitable, at ease with everyone. Their opposites, *inè ma* ("dry persons") are difficult to deal with; they are individualists who dislike company. Still others have a *kinè piru* ("white liver") and are generous with things: they give gifts of food to anyone in need. The essence of *hakilè*, after all, is keeping people together.

The notion of *kinè*, meaning "liver" but often also used for a quality of heart, is important here. Its general implication is that of the inner person, and all qualities are thought to reside in it, emotions and thought included. In fact, it is also the residence of the *hakilè*, its point of reference within the body, and often both terms are used interchangeably.

The second part of the *inè* was the *kikinè*, which can be translated as "spirit." The term is closely related to *kikinu*, "shadow," but it is by no means identical. At birth, the *kikinè* inhabits the person. Coming from Ama, the *kikinè* enters the body, takes on the qualities endowed through the *hak-ilè*, and will leave again at death. Meanwhile, the *kikinè* travels at night, gathering information through dreams, which everyone has, or through clairvoyance, which is only given to some. Though the *kikinè* in principle has no visible aspect, some people have the capability of seeing the *kikinè* in others (*kikinèyènuyènu*).

After death, the *kikinè* of an individual can return for many years, at least until the next major mask ritual, the *dama*, which takes place approximately every twelve years. Until that time, the *kikinè* settle down somewhere near the village. The *dama* mask festival aims at sending the spirits of the deceased away from the earthly plane to the ancestors, to live with the old ones and eventually become one of them.

SIGI, THE STORY

There is more to a person than simply being born and dying. One has to be born, in fact, twice. Once every sixty years, the villages in the central part of the Dogon area celebrate the coming of the *sigi*, an ambulant ritual lasting over five years, in which the villagers renew their lives. Each Dogon should at least once in his life have danced or, as they call it, "seen" the *sigi*. The founding myth begins in the village of Yugo, a sacred place for the Dogon, on a lone mountain facing Aru.

Sen Senu, when herding the cattle of his father, Sanga Yengulu, and his mother Na Yengulu, grew tired and thirsty and climbed a tamarind tree to suck its fruits. The owner came along: "What are you doing in my tree? Shall I throw my stick at you?" Showing no respect, Sen Senu answered: "I want to suck them with my mouth, not my anus." Of course, the owner grew mad and hit him. Limping home, Sen Senu's father asked why he had been beaten and how he had lost the herd. "I have been hit by the owner of the tamarind tree!" His father promised to come with Sen Senu the next day and kill the man.

In the early morning the birds woke up Sen Senu and his father, and they walked to the tree. The owner met them. "Why have you beaten my son?" the father asked. The owner replied: "Because he has insulted me." And he told how Sen Senu had answered the question what he was doing in the tree with the remark that he sucked with his mouth, not his anus. His father asked Sen Senu if this was true, and the boy admitted it. "Please accept my apologies for my son," the father said. The owner, accepting the apologies, told the father: "Climb the tamarind and take whatever fruits you like, or suck as many as you like now."

The father, with his gun at the foot of the tree, climbed up and plucked a number of fruits. From beneath Sen Senu called him: "Why do you climb the tree, father?" "The owner has given me fruits for the porridge." Sen Senu retorted: "That is not the way, father. First you come to kill him, now you accept his fruits as a gift. If you act like this, I am no longer your herdsman."

"That is your problem, son," said the father.

"My way," Sen Senu said, "is the way of the sigi, I shall follow the sigi"

"All right, my son, that is your problem."

So Sen Senu set out alone into the bush and met someone herding chickens. After exchanging greetings, the stranger asked where Sen Senu was heading. "I am following the road of the sigi."

"That is a hard road, the road of the sigi."

"Still, I want to try it," said Sen Senu.

Overleaf:

IN ANACANA, A VILLAGE on the plateau, an unusually austere funeral ceremony takes place because crickets destroyed much of the millet harvest. Dancers wearing hibiscus fiber skirts appear from the bush and enter the village to announce the death to the whole village and begin the funeral proceedings.

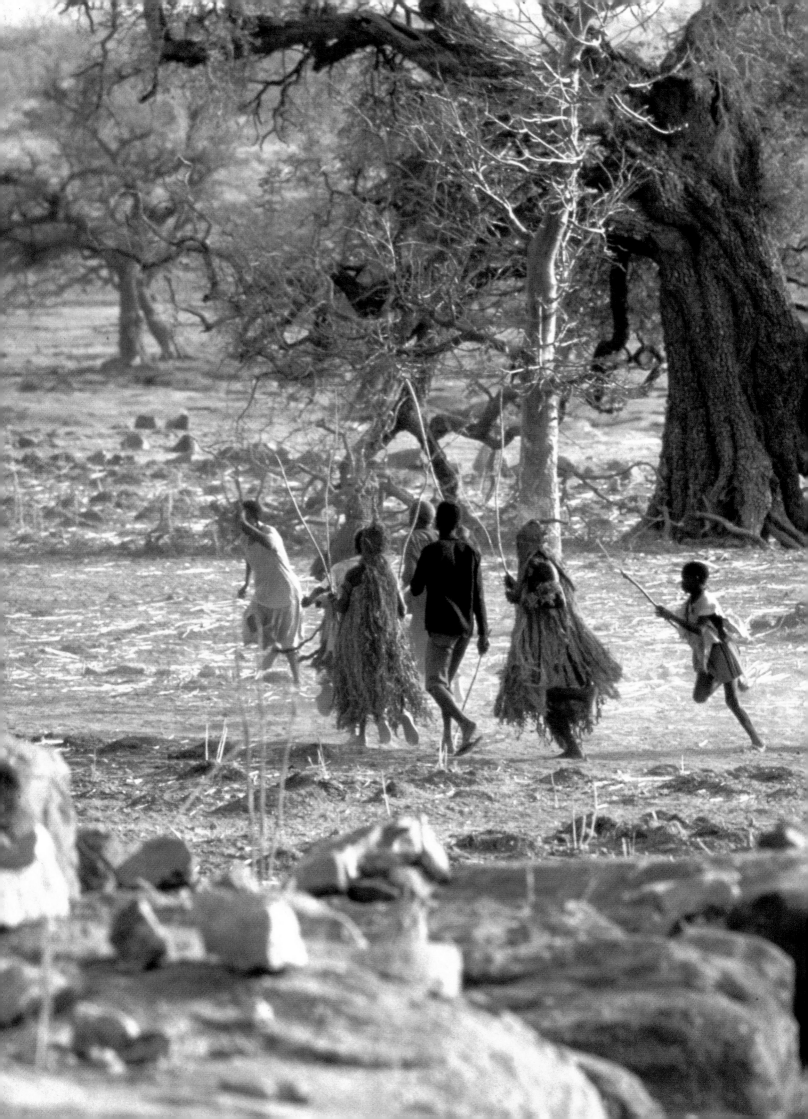

Sen Senu had further encounters with people herding goats, sheep, horses, donkeys, and cattle, and each time the same exchange was held.

"Where are you going?"

"I follow the sigi road."

"The sigi is a hard road."

"I shall try it anyway".

At last Sen Senu encountered an elephant [in some versions the animal is a lion].

"Where are you going Sen Senu?" asked the elephant.

"I follow the road of the sigi."

The elephant trumpeted, "I have the sigi."

Sen Senu said, "If you have the sigi, then do as you like," and the elephant ate Sen Senu.

For three whole years Sen Senu remained in the elephant's belly. One day the elephant grew thirsty and set out to drink at a water hole just outside the village. The animal then defecated, and out came Sen Senu, carrying with him a forked sigi stool, an oblong calabash, and a horse's tail.

Just then Sen Senu's sister came along to fetch water. Seeing Sen Senu she tried to speak to him, but he had no speech. She ran back into the village, calling out, "Sen Senu is at the pool." Her father thought she was crazy because Sen Senu had been eaten three years ago, and all obsequies had long been held. "Look for yourself," she said, and so he did.

At the water hole, his father asked Sen Senu to come home. Sen Senu began to speak in the language of the sigi, "Go and brew beer. Let everyone adorn himself in his finest. If not I will not be able to return home. So go and receive me."

Sen Senu gave very detailed instructions on how to brew beer, grind the millet, gather the firewood, and fetch the water. He told how to make porridge, how to ferment the beer, and how to distribute it.

When everything had been done as instructed, the elders came to Sen Senu and asked, "Who shall be in front?" Sen Senu then sang one of the twelve sigi songs, "Please forgive me, elders, you are the oldest, but if you do not know the road of the sigi, I am the first, and I will turn to the left."

The elders responded, "Yes, you know the way. Three years is not three days; you have been inside the elephant, you know more than we do."

Thus, Sen Senu came home, and this way the sigi arrived in the villages.

ONCE EVERY SIXTY YEARS: THE *SIGI* RITUAL

The *sigi* ritual consists of an ambulatory dance from the water holes in each village where Sen Senu was found into and through the home village. This central ceremony has a long preparation; over the course of three months a group of boys is prepared for their initiation into manhood, and a group of adult ritual speakers for the village is initiated. These men learn the Dogon traditions in the ritual language (*sigi so*), and they prepare their outfits: long Dogon trousers, a cowry-bedecked shirt (*goũ kai*), ear pendants, and a special white bonnet (*sigi kukwo*). They carry the other paraphernalia of Sen Senu, the *dalewa* (the forked stool), the horse's tail, and the oblong calabash. On their faces the men imitate with blue paint the female scarification.

On the morning before the day of dance, in strict order of age, all the men of the village walk to a public place where the representative of a certain clan puts some sesame oil in both of their ears so that they can receive the "language of *sigi*." Present here are the pregnant women, whose bellies are touched with a *dalewa*; thus, the baby in the womb has already "seen" the *sigi*. That night the

initiated boys leave the caverns where they have been confined for three months, and sleep out in the dunes.

The following morning all the men, in full attire, throng around the initiates and take them to the water hole, whirling in the air noisemakers called bull roarers, made of short, flat pieces of wood tied to long strings. About 100 yards before they arrive at the waterhole (which is mostly dry at this season) they let the initiates run to the hole, trying to dip their feet in first (which brings riches). Mud from the water hole will be smeared on the feet of small boys and the bellies of pregnant women: that way the small children as well as the unborn ones are part of the proceedings as well and will "have seen the *sigi*." At this point the men return home to have their heads shaved. Then, taking up their *sigi* implements, they return to the foot of the scree, at the "start of the village," where the initiates wait. The boys, dressed in their traditional outfits—head coverings studded with red agates, rich cowry shirts, heavily decorated *dalewa*, and calabashes with mask decorations—have just washed themselves for the first time in three months but have not shaved their heads.

At the foot of the scree the *sigi* line is formed, strictly following age, with the oldest in front. A line of initiates, headed by the oldest who have not yet "seen" the *sigi*, follows behind them. The smallest toddlers close the line, unless they are too young to walk, in which case they are carried on the shoulders of men. Accompanied by the village drums, the initiates march along sounding iron bells. The tortuous *sigi* route takes the immense line of slowly dancing men and boys through most of the village, passing the major ritual spots, before ending at one of the two main dancing grounds. A long line of beer jars waits for the men.

The initiates then begin reciting the major *sigi* myth (Sen Senu's story) in the ritual language, and recount how he stayed in the elephant's belly for three months. The boys give thanks for the food and beer and may recite some general remarks on how they will behave toward elders, kinsmen, and strangers. Then, with all men sitting on their stools, the oldest initiate puts his horse's tail into a beer jar, swings it to the four cardinal directions, pours some beer on the floor, and passes the jar for all initiates to drink. General drinking follows, with the passing of the calabashes always done with the left hand.

When the beer at the dancing ground is finished, the men go home and eat and drink the beer their women have brewed. Throughout the ritual, the women, dressed in their everyday clothes, have only been spectators, kept at some distance by the older men who, having "seen" a *sigi* already, are too old for active participation, and just watch and comment upon the proceedings. For the women, the rest of the day is spent eating and drinking at the home of kinsmen, age-mates, and friends.

All girls born during the *sigi* period (from the start of the initiation learning stage until the end of the beer drinking) are called *yasigi* and will perform a special role throughout their lives: they are the sisters of the masks. For them, the taboo against seeing the masks does not hold and they may freely mingle with the masked men. They are the ones who fetch water for the mask dancers and bring them food during the days of the *dama*.

Why does the *sigi* constitute a second birth? The Dogon male persona in its full embodiment calls for two kinds of birth, the second one being the *sigi*, a way into a transcendent power. In the *sigi*, men are reborn in an inverse way, and in order to become fully mature, a man

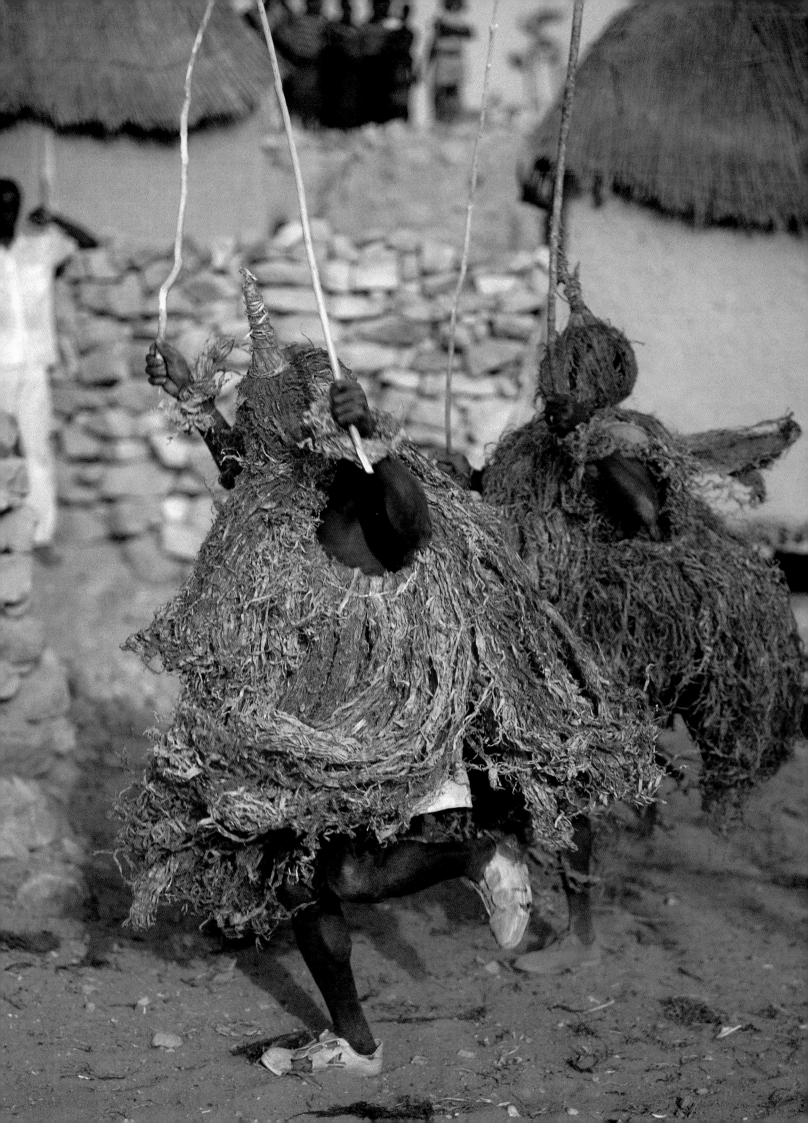

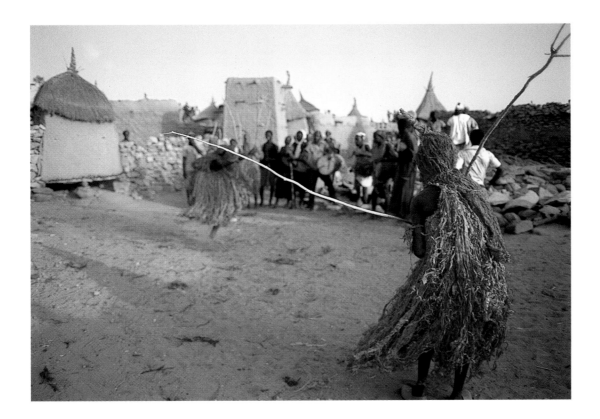

must experience this inverted process, at least once, irrespective of when it may happen in his life. The model is the story of Sen Senu, who was reborn in a manner opposite to a normal birth. Lost for three years, he re-entered the world through an animal not a woman, and he emerged in a way other than that of a womanly birth. Further, he was adult and not childlike, fully clothed and not naked, and speaking a new language, not speechless as an infant. Finally, he was not empty handed, but carried ritual objects. At his rebirth Sen Senu had superior knowledge, especially of brewing beer, and was respected by the elders as someone "older than they." His was a purely male birth; no woman had a hand in it.

From the inversion depicted in Sen Senu's story stems a new power for men, a new life. Paradoxically, this power of regeneration, and in a sense of fertility, implies the negation of the central values of Dogon culture. During the *sigi*, and during a boy's initiation, a faithful initiate does not speak, wears no ordinary clothes, shows lack of respect to older non-initiates, and renounces his sexuality. During *sigi* the initiate learns the language of the spirits. In fact, the same spirits that threaten pregnant women more than anyone else are the very ones that teach the language of *sigi* to men, give them the masks, and confer a continuing source of power. In the rituals of *sigi* the very same bush that is extremely dangerous for pregnant women, empowers the men. What the bush may steal from the women, it gives to the men.

The inverted, male-oriented birth enacted in the *sigi* has another, seemingly paradoxical, meaning. It forms a part of the complex of mask rituals (*dama*) that are closely associated with death. Though in the *sigi* the men do not don masks, the two exclusively male activities are closely associated. Both *sigi* and *dama* are linked with the bush spirits, addressed with the same ritual language, and use the same songs: in fact the most sacred songs consist of twelve mask songs and twelve *sigi* songs, and they are always performed together. While the myth of the masks and that of the *sigi* feature different people and situations and do not refer to each other, they also are part of one complex, death. The same powers that endow the men with their fertile forces are the ones that stipulate their mortality.

IN ANACANA A *SAGIRI* mask threatens with a stick spectators who come to close.

Opposite:
SAGIRI MASKS, THE OLDEST of all Dogon mask types, usually perform during the annual *buro* festival, just before the start of the cultivation year.

Masks belong

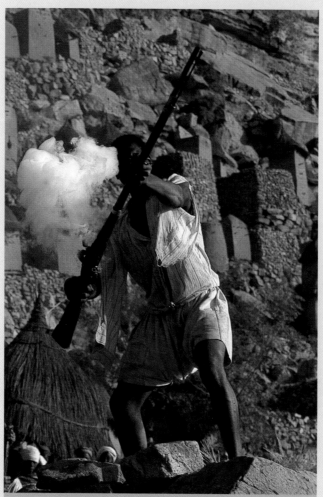

THE SOUND OF GUNSHOTS signals the beginning of the *nyû yana*, as Komakan's men rock gently to the sound of drums while firing their muskets into the air. The echo of the gunshots travels along the cliffs to nearby villages.

DEATH

to the realm

of death. One of the reasons that masks are taboo for women is precisely this taint of death. Masks are central in the burials of men, masked dances feature in all burial proceedings, and the main mask festivals are in large part the closing rituals of the mourning period, the final farewell for the dead. Like birth, also death has double aspects. Two major rituals accompany death: the funeral with the burial (*nyû yana*) just after the death of the person, and the *dama*, the mask festival performed some years later.

BURIAL: INTO THE CAVES

After a Dogon death, a complicated funerary ritual takes place. The burial, a funeral, and the mask festival described next follow specific examples of recent years that we witnessed.

Dogolu's mother Yajagalu has died at the age of seventy-five. The village will bid her a fond and warm farewell. Dogolu's sons and nephews, all grandchildren of Yajagalu, gather on the rooftop of her house soon after her death, each carrying his long flintlock gun, the hallmark of a Dogon burial. Just before sunrise, they load their guns, sway in a common dance step, and fire their charges. The loud boom wakes up the village. Within the hour everybody knows who has died.

In Dogolu's compound Yajagalu's daughters gather and wash her body. They wrap it in cotton bands, then cover it with a large white cotton sheet. This will be her final covering for the burial, but for the funeral the death blanket, *worodèwè*—a white-and-blue checkered cotton blanket made in a village on the border of Dogon country—will be the central object. (For a man the pattern would be parallel stripes.) Yajagalu has kept her own blanket in the iron box most Dogon men and women use to store their valuables and clothing.

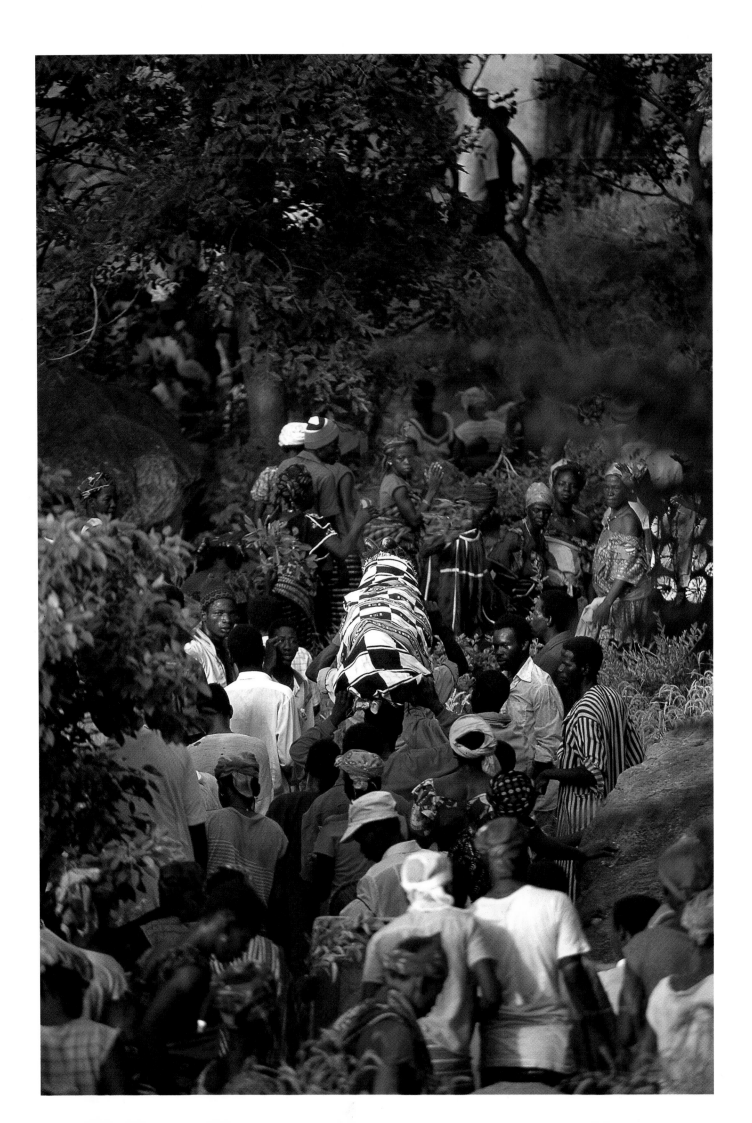

The men prepare a wooden bier, and the stiffening body is tied onto it, ready for Yajagalu's last journey. Two grandsons carry the bier over their heads and dance-shuffle toward the compound exit. The other men fire their guns, the women shriek and weep, while Dogolu intones a mighty but sad farewell:

> Greeted mother, greeted mother of a man
> Greeted mother of many, greeted in your evening.
> Your evening, the big evening has come,
> Greeted from our grief, greeted into your grief.
> It is not our fault, it is not your fault.
> We shall leave it to God, the God who created us, who changed us.
> Greeted mother.

The guns fall silent when they leave the compound on their long way to the cliff. Barefoot and bare-chested out of respect for the spirits of the deceased and for the dead they will encounter, the pallbearers climb the winding footpaths. After a few hundred yards another two take their place, as every able-bodied young man of the ward wants his share in this burial. Beyond the village the going gets rough: no path, just rocks. Still, the youngsters easily attain the steep cliffside, where others have to assist them to carry the corpse upward. The last part is the hardest, a steep climb, with hardly any hand- or footholds. Many young men have joined the climb, eager to be part of the proceedings. Skimming the cliff on a narrow ledge, then squeezing between two rocks, they finally arrive at the ward's burial cavern, 150 feet above the village. In the village below people watch the familiar spectacle.

Above, the sixty-foot deep cavern is shielded from view by a wall, and is filled with bones and skulls. Generations of Tireli people have been buried here. A grandson unwraps the checkered blanket and folds it, while another covers the body of his grandmother with the bones of her ancestors. The boys take a quick leave.

At Dogolu's house, the women have begun preparing food. Gradually, some old men wander into the compound, to pay condolences:

> Greeted in your sorrow, greeted welcome, welcome,
> Greeted in your sorrow, welcome, welcome,
> Greeted in your sorrow, greeted, welcome, welcome.

The ritual exchange of greetings goes on for some time, the visitors holding up a clenched fist to express the strength of their feelings. When the unison greetings are finished, the visitors sit down and partake of food and beer. The sober mood does not preclude a general and lively conversation to develop. The guests stay about an hour and leave when new people from the other wards of the village enter the compound. Dogolu is an important man, and his mother was well liked. The whole day people come in to greet, to eat, and to chat.

The burial done, Yajagalu's family has to wait for the funeral. Because no old lineage head has died so far in this season, a man for whom a funeral would have to be done immediately, the *nyû yana* (funeral feast) is held in January, after the harvest.

AS PART OF A FIRST FUNERAL called *nyû yana*, the body of a dead woman from the Tireli ward of Daga is carried to a burial crypt high in the caves above Tireli. Relatives of the deceased woman, who once lived in Tireli, thread their way down the narrow pathway. The corpse, wrapped in a traditional black-and-white checkered female funeral shroud, was later hoisted up the cliffside with ropes, but no photographs were taken to honor a request made by the family.

Overleaf:
DURING A DAMA IN IDYELI, masks dance to bid final farewell to those who have died in the past few years. Women and children can only watch the dancers from a distant stony perch: taboo prohibits them from seeing the masks close up.

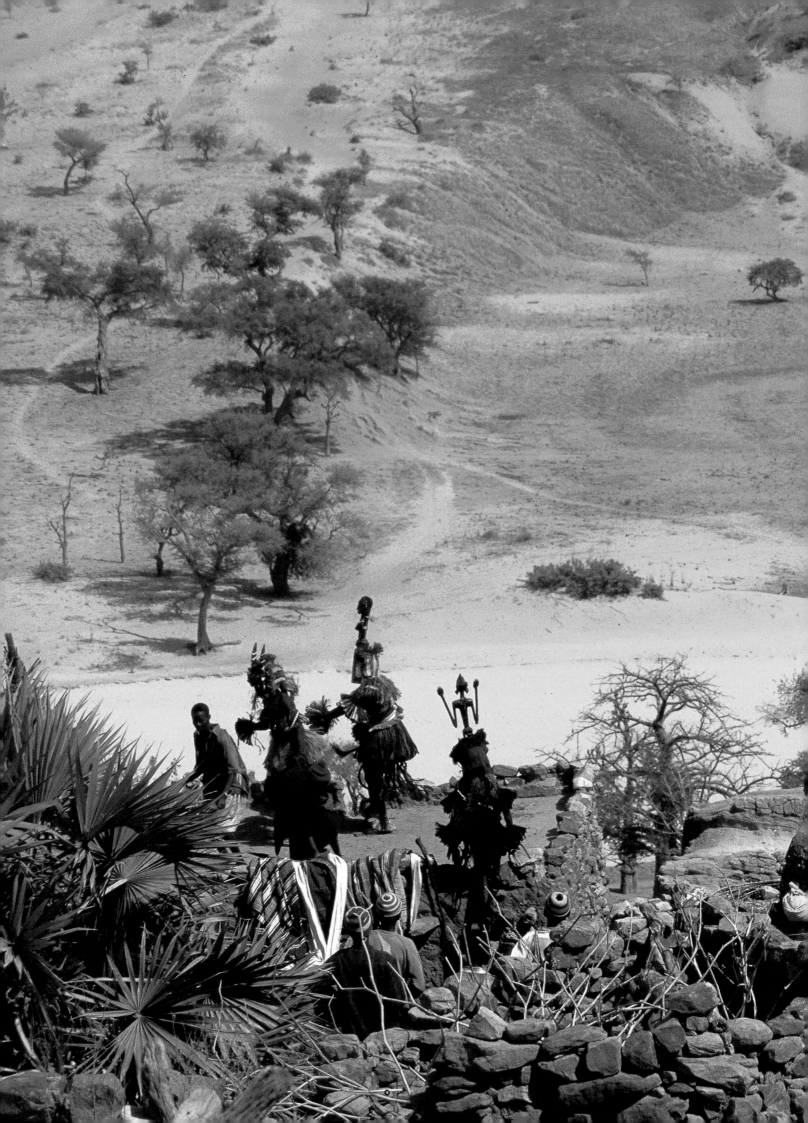

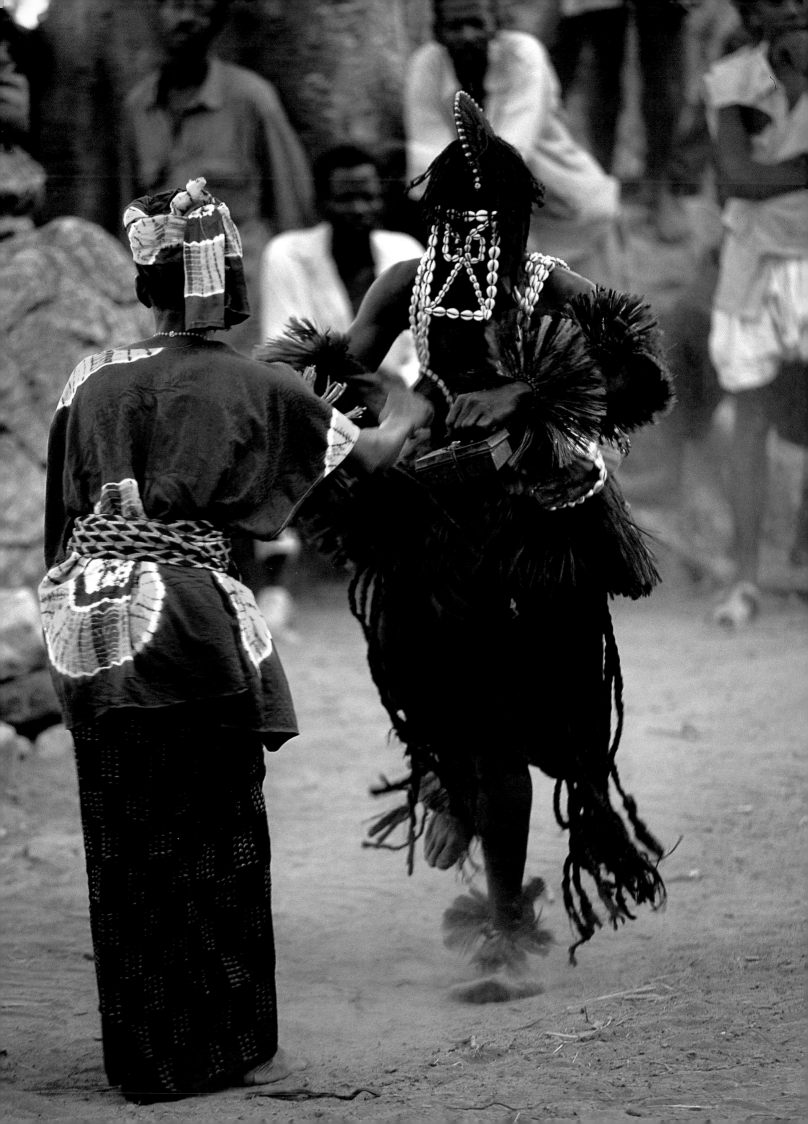

Nyû yana is a long ritual, the most complicated of Dogon culture, and it is actually a collection of many rituals, songs, dances, and feasts lasting three days and four nights. As a funeral it marks the farewell of all the villagers who have died over the past year. The boisterous rites for the dead begin in silence. In the late afternoon people stop speaking when a hooded figure, its head covered with a plaited cap, and clothed in red raffia fibers, slowly and ponderously walks through the village carrying a large calabash spoon. To announce death to the village, the mask squats down at each of the sacred places of the village—the dancing square, various altars, and men's houses—and touches the ground with the spoon four times. Few people dare to approach him; most prefer to watch from a distance or simply wait silently until he has passed.

After this ominous, silent announcement, the nights and days of the funeral are filled with slow dancing and mournful singing. On the first night the drums beat a steady rhythm, and the young men and women shuffle around the heap of stones in the center of the dancing square, singing

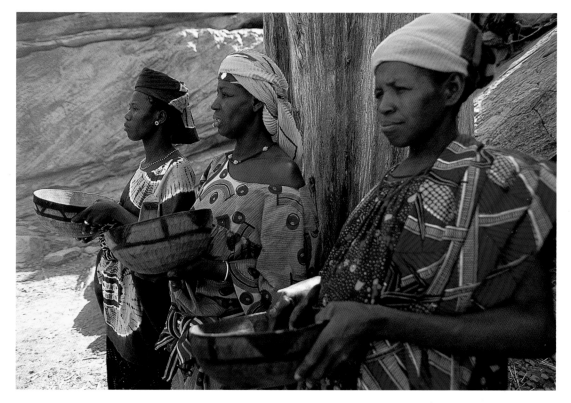

DOUROU RELATIVES hold eating bowls belonging to their deceased kin, which they will ritually break later in the ceremony.

Opposite:
A DOUROU WIDOW approaches a mask carrying a small cash box that belonged to her husband, one of the dead being mourned during the funeral farewells.

one of the long songs of Dogon culture. Drinking, drumming, and dancing last until well after sunrise, and end in large volleys of gunshots from various rooftops.

On the second night, the people spend a few hours singing *adumuno ni*, the farewell songs. Then, at eleven o'clock, the specialists who know the long text by heart gather to sing the *baja ni*, an enormous song commemorating Ambirè, the blind prophet who roamed the area in the nineteenth century. They continue for a solid seven hours of singing, until sunrise. This is the song of songs for the Dogon, and it is imperative to sing it well past exhaustion. Only when fully exhausted can one truly grieve.

Several other rites follow in the days to come, but the days of the *nyû yana* are also filled with receiving guests amid the performing of various rites, including, above all, a mock battle. On the second and third days the whole village gathers in the largest dancing place, in the afternoon, to stage a "war." All men and boys turn out with their flintlock guns, a whole army of them: they parade, dance, and shoot blanks at each other. The women shriek, exhort, ululate, dance, and praise the men for their valiant defense of the village. A splendid theatre it is, loved deeply by the

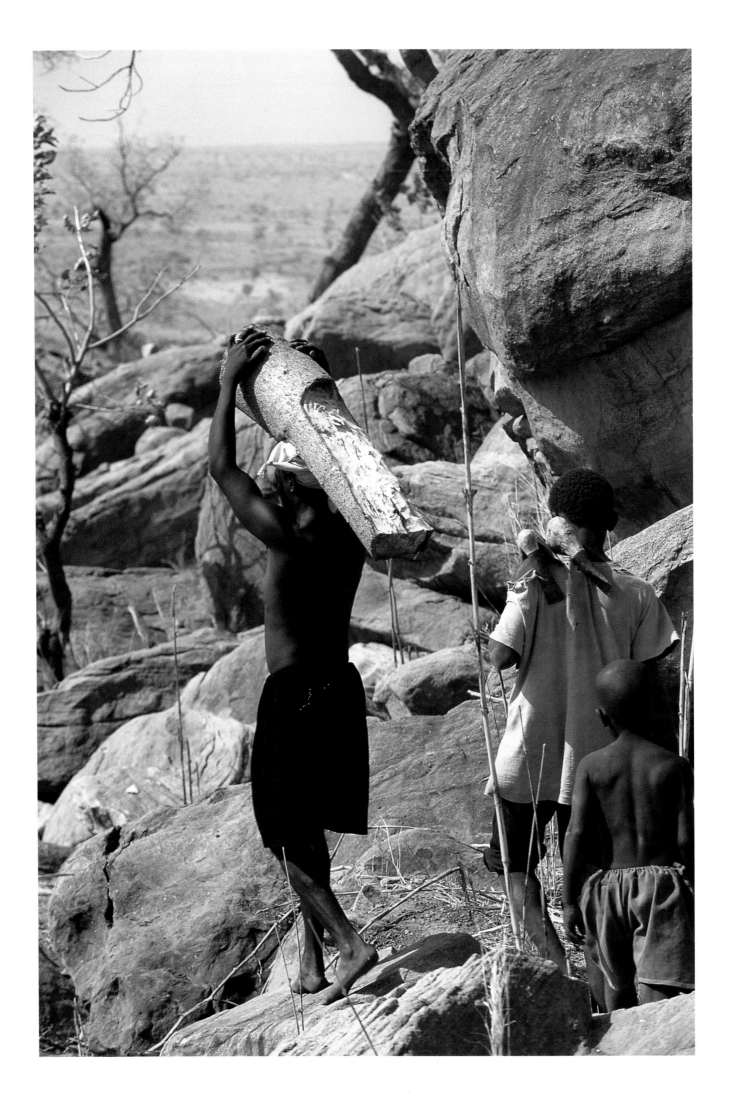

Dogon. Everyone dresses up, women carrying their most colorful blankets on their heads. The air resounds with the loud boom of the guns, firing huge loads of homemade gunpowder. All this gunplay is not without risks, however, as some muzzle blasts scorch the neighbors near the tight throng of dancers, but then this is war theater.

After the mock battle a farewell speech, a *toro*, is shouted to the departed kinsmen by the village speaker. This long, full invocation entreats all the gods, spirits, and ancestors to be gentle with the newcomers, to welcome the newly deceased in their midst.

After the *nyû yana*, the spirit of Yajagalu will continue to be very near, very present. Her grandchildren will pray to her when they are in trouble, and she will not be forgotten. Yajagalu's hut will remain unoccupied and empty. The few material possessions of the old lady have been distributed; her pottery workshop stands empty. In the next years Dogolu will let the hut simply weather away. Some of the beams in the roof will be used for another construction, and after a few years only the crumbling walls will testify to her presence on this spot. Her real remembrance will remain in the minds of her children, in her name.

PREPARING THE MASKS

Yajagalu's special remembrance is some years off still, when new grandchildren will be given her name, the so-called *naniyè*, a light form of reincarnation. But for this to occur, the second part of the funeral complex will have to be performed, the large and important mask festival, or *dama*. Usually the *dama* takes place every twelve years or so in the cliffside villages. Exceptional circumstances such as drought, large-scale illnesses, or internal dissension in the village may postpone the ritual, even for a long time. But eventually, the ritual must be held for all the deceased. Otherwise, they would be trapped between this world and the next and would never be able to gain their proper status as ancestors.

Opposite:

MASK MAKER MABUDU SAY carries a log from a tree that he has just felled back to his workshop located in a cave on the edge of Tireli. Tireli's elders granted him permission to cut down this particular tree species because of its ability to grow quickly.

Below:

MABUDU SAY HACKS OUT the rough form of an antelope mask, pausing to sharpen his tools on his workshop's stony floor. Some mask dancers prefer to sculpt their own masks rather than commission talented carvers such as Mabudu.

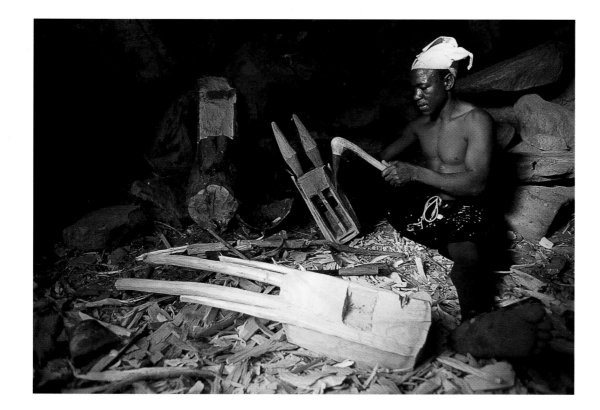

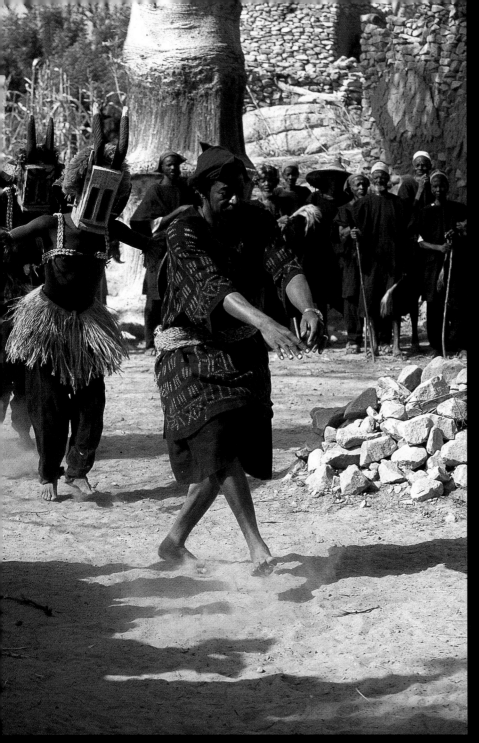

Now a *dama* is being held in Tireli's neighboring village of Amani, coincidentally where Yajagalu's mother was from. After a good harvest, which means that ample supplies of millet and sesame are on hand, the grandsons of the fourteen Amani men who were central in the last *dama* (thirteen years ago) have met and decided to hold a new *dama*. They asked permission of the fourteen oldest men now living to begin the proceedings.

Directly after the harvest, the village becomes the scene of mask preparation, although most of this remains out of sight. The young men who will dance for their first time collect huge quantities of hibiscus fibers, which they will need for their costumes, and then start to work on their masks.

The term mask usually suggests a face or head covering that disguises the natural head. Tourists, art dealers, and museum curators routinely call Dogon head coverings masks. For the Dogon, however, the *èmna* consists of a person dancing in a costume that includes a headpiece but is not limited to it. Masks are not worn; masks are men who dance, perform, and shout. The total outfit consists of a kind of skirt and arm adornments fashioned from red and black fibers, including hibiscus stems and flowers, a pair of very wide Dogon trousers, a headpiece with cotton bands for attachment, and various handheld objects relating to a particular mask, such as a dancing stick, a rattle, or a dancing ax. The essential elements in these ensembles are the fibers, which are considered powerful; sometimes a few are tied on a stick and used to prohibit women from entering a water hole. These too are called *èmna*. The headpiece defines the type of mask, but the fibers define the outfit as a mask.

For more than a month now the young men of Amani have been carving or plaiting headpieces, drying and dyeing their fibers, gathering cowry shells and beads for the decorations, and arranging the long Dogon trousers that belong to any mask outfit. Most of them have made their masks themselves. All will have to wear the *bèdyè* (pupil) mask during the first weeks; in addition they each carve or plait several headpieces, in order to change roles in different dances. The choice is more or less up to them. The smaller among them often choose the small "hare" or "rabbit" mask (*èmna goû*) which is easy to dance, and always appears in a group. Some masks such as the shaman's (*èmna binu*) are difficult to dance because the dancer runs the risk of becoming possessed during the dance, when he has to mimic a possession trance.

The most popular mask, *kanaga*, the most famous of all Dogon masks takes the form of a double cross, with extensions of the horizontal arms pointing upward and downward, like a human figure or a bird. (In fact it represents the latter.) Two masks are danced only by experienced men; the extremely long and heavy "tree" or "big house" mask places great demands on the masker's neck and jaws, and the *tingetange*, or stilt mask. The "tree" mask is swung to and fro in the dance, and whirled around, keeping spectators at a respectful distance. The stilt mask dances with small jutting steps of its long "legs," the upper torso in a vibrating balance.

The first few weeks of the *dama* are called *yange èmna*, referring to the fire or night masks. At night the young men gather just outside the village. A few of them beat the slit drum; the others practice their dancing. Fire and light are taboo for them, and no man passing by may carry a torch. Also, the maskers cannot be spoken to unless a death has occurred in their family. During this period the women of Amani may not leave or enter the village at night, as they would risk seeing the "naked" or unadorned masks without head coverings. If a woman crosses the village borders in the dark, the masks, adorned with just a few fibers over their trousers, will accost them and make them pay fines, also fining their husbands.

The heart of the *dama* begins with the arrival of the masks, first from the bush in the east, then from all other directions. The old men have set the timing of this some weeks in advance. At the crack of dawn, the dancers and many of the older men leave Amani, heading for a pond in the dunes toward the northeast. There they spend most of the day, drinking beer brought to them by the *yasigi*, the "sisters of the masks," who also fetch water for them. In the village the women and remaining men gather bowls with mush and oil of sesame and fill the huge beer jars standing at the meeting places.

About four o'clock in the afternoon, the masks enter the village from the bush in a long single file, the oldest men first. All of them are *èmna*, though the latter only have fibers around the waist, wear a pair of indigo trousers, and sport plaited headpieces loosely on their heads. The new *èmna*, the younger men, close up the rear, wearing white trousers without fibers. All carry a short stick and a thorn branch in their hands. Twice, at places identified by the oldest men, the whole line kneels, while Yedyè, the village speaker, shouts from afar his greetings in *sigi so*, the mask language: "God has seen you, has seen a good thing. Something big is there, something small, if anything is wrong, it is with God. This is not work for children, if you see a woman, beat her. Greeting, good heads, who came running, all the women are afraid, beat them."

After the second greeting, the masks shout their high-pitched cry, "Hèe, hèe, hèe", and disperse to the various places where beer and food are stored. The young ones swarm out into the village, chasing those few girls who have not disappeared yet and search out the houses where death has occurred since the last *dama*, signaled by a reed mat in the entrance. There the young men beat their sticks against the doorpost, throw stones into the yard, and demand a share of beer.

Though the masks have now officially entered the village, they are still seen as "naked," and they still work on completing their costumes. In the following days, the young men get their costumes and headpieces in order. Also, the drums of the village are repaired, and the men make some new drums. In the afternoons, some of the young men don their *bèdyè* masks, the fiber-plaited hoods, simplest of all head coverings. The masks roam the village, where they ask for beer in the compounds.

IN A PUBLIC PERFORMANCE
by Tireli's masks at the main
dancing ground of the village
the performer balances on top
of tall stilts as he dances
a *tingetange* a waterbird mask.
The mask wears the breast deco-
rations and fiber headpiece of a
pulo yanu (a Peul woman).

Overleaf:

TIRELI'S STILT DANCERS
perch on a boulder for support
at the edge of the village dancing
ground, waiting their turn to
perform in the dances that rein-
vigorate the village after many
years of loss through death.

ARRIVAL OF THE MASKS

These activities last at least about four Dogon weeks (of five days each). The time has been needed for the dancers to carve and plait the rest of their masks. When the final preparations have been made, the last stages of the *dama* take place. The elders have done their part, planting the *dani*, dancing pole, and building an altar at the heart of the dancing grounds. After some individual for-ays into the village, the masks finally emerge as a group. The drums are beaten to warn women and children not to approach the masks.

Finally, when the sun disappears behind the cliff in the late afternoon, the masks gather outside the village. Adomo, the chief of the masks in Amani, marches in front of a line of old men, who lead the masks along the paths to the dancing place. This year the traditional trail passes through a compound that someone has begun to build since the last *dama*, but all the masks file through the compound; the masks will not swerve. In a similar incident in Tireli a wall had to be torn down to let the masks pass; in Sangha, a whole house had been torn down. Because many years have elapsed since the last *dama*, the exact route to be followed has become a bit hazy: the old men engage in a heated discussion whether a particular stone should be passed at the right or at the left. These first day performances are not well organized, dancers as well as leading elders not fully secure about the "old ways" they are supposed to follow.

Finally, the masks arrive at the dancing place for their first performance. The arrival itself is still a time of high taboo: women, children, and strangers are absent, and only the men from Amani are allowed on the spot. Thus, the arrival of the masks at the altar site is a short dance without spectators, and the atmosphere combines both serious business and easy camaraderie. Some old men meticulously guide the dancers in the proper way around the *dani* and altar, counter-clock-wise. Because women are not present, there is no real need to hide the identity of the dancers, so after this short dance the dancers push their masks onto the backs of their heads to get some fresh air and have a better view of the proceedings. When a mask becomes damaged, as the *kanaga* sometimes do when touching the ground in their vigorous dancing, helpers repair the masks in view of everybody.

Now the stage is set for the first public performance, the real dance. Women and children, who have been watching from a large distance, draw nearer and climb on rocks and rooftops to get a good view. Foreigners, visitors from other villages, are guided to some places of honor next to the drum players; even if this first dance is not yet their "day," admiring eyes from neighboring villages are welcome.

The first to dance, on the sound of the drums and bells, are the *tingetange*, the stilts, as these masks are difficult to manage and dangerous when the dancers are tired. The *tingetange* dance at a small flat place close to the foot of the cliffs, where they can tie on their stilts while resting against a building. They are adorned as girl masks, either Dogon girls or Bambara ones, their plaited head-pieces covered with cowry shells, beads, little mirrors, and strips of metal; likewise, their bodices are a rich display of beads and shells around the jutting breasts made of baobab fruits.

The stilts dance as a group, admired by all, as this represents the most difficult technique of dancing. Years of solo practice in the bush precede this expertise, from little stumps under small legs the dancers have worked up to greater heights. The mask as a whole represents a water bird, and the dance mimics the characteristic jutting head movements of these birds. Shaking little moneyboxes and horsetails in their hands, the stilts trot along the square, while the elders shout

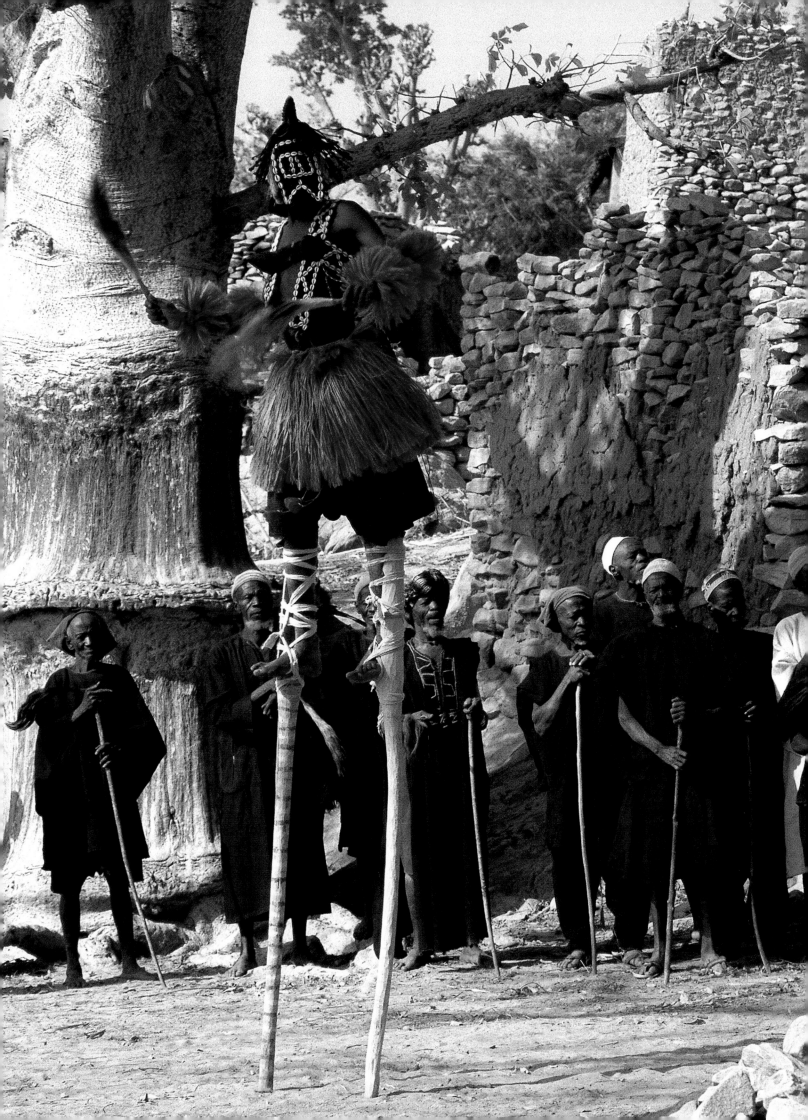

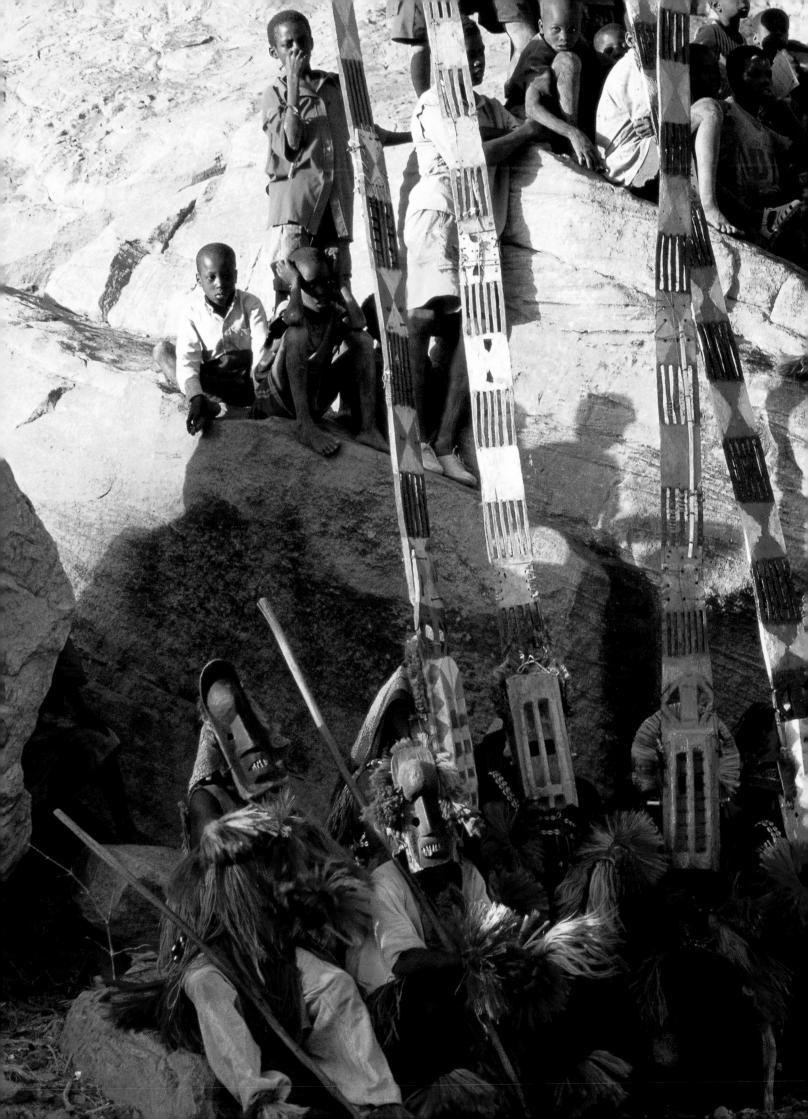

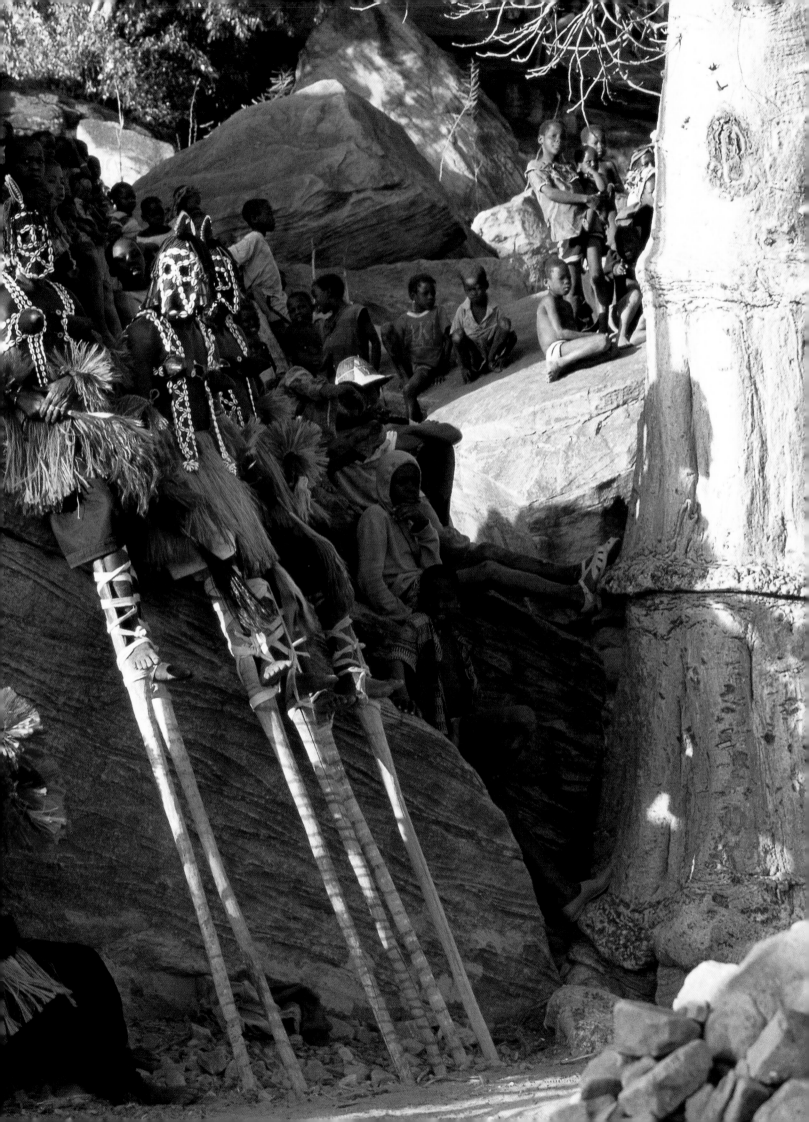

their exhortations in *sigi so* to them: "Greetings, God and masks, forgive us, it is your work, your work from the cavern. It is very good for the elders, people have come to see you dance, it is your work, up to you," while pounding their sticks on the ground before the approaching stilts. When done with dancing, the masks sit down on the edge of the roof of a small building next to the dancing place, untie their stilts, give them in custody to a kinsman, and join the rest of the masks.

As the next masks enter the dancing ground, the elders introduce them to the *dani* and the altar by circling around them three times, and then leaving the floor. First the main body of masks, the *kanaga*, come in, a long row of wooden crosses dancing more or less in unison, the other masks behind them. When they arrive at the dancing ground, all masks dance together first, circling the spot three times, all joining in the same dance routines. Then the masks perform individually, the *kanaga* first. Dancing with three or four masks at a time, each *kanaga* goes through a vigorous choreography, in which he shuttles his head, draws back, and then circles his cross to the right, touching the ground with its tip. Shouts of encouragement accompany this exercise, the spectators praising the good performers, boos and laughter aimed at the poor ones. The long line of *kanaga* takes quite a long time, as each mask tries to remain on stage as long as possible. Some have to be pushed off by an elder to make room for the next one.

Then the other masks get their share of attention. The spectacular *tiû*, 12 to 15 feet tall, move in together, like a walking thicket of trees. The heavy headpiece for this mask, representing a tree as well as a clan house, rests on the dancer's head but is tied to his waist with strips of cloth running through a mesh of cords at the back of the headpiece. In order to maneuver the mask the dancer grips a bar inside the wooden headpiece with his teeth. It takes a strong jaw, good teeth, and a powerful neck to dance this mask, as the huge contraption has to make vigorous movements. Swaying the "tree" to and fro, each time touching the ground and whirling it around horizontally, the dancer shows himself a real *sagatara*, a strong young man, eliciting shouts of praise from the bystanders, who keep a safe distance. On this occasion, one of the Amani performers fails to raise his mask from the ground after dipping and raising it once and is booed, while the spectators chatter about who he is and why he lacks strength.

The other masks follow when the "trees" are finished, in no particular order, except that the older men precede the younger ones. This year Amani has quite a few *modibo* masks, representing Muslim teachers (*marabouts*) with long, colored hairs on plaited hoods as their main characteristic. Next is a *sadimbe*, a mask with a female statue on top, a "sister of the masks," representing the first woman who found the masks. Behind it, a "door" mask representing the Dogon granary doors makes its appearance, a new type of mask, not seen before. The masks representing girls then follow with their dance, accompanied by the two *waru* masks. This latter type, called a buffalo but representing an Oryx gazelle, is by far the most active mask. Its task is to keep order in the proceedings, moving the spectators from the dancing ground, chasing women, girls, and small boys from the premises. The *waru* is the real performer among the masks, danced by the most imaginative of the dancers, interacting constantly with the crowd. Moving between masks and audience, he may greet oncoming strangers by running up to them to test their knowledge of *sigi so* mask greetings. A good *waru* mask is essential for a good show. He may sometimes be assisted, even replaced, by a monkey mask. But here at Amani, no monkey mask is present, and the burden falls on two *waru* who dance quite well, despite the scorching heat of the late May afternoon.

One of the *waru* spots a visitor from Tireli, whom he probably knows well enough, and with long gliding steps runs toward him, stopping just in front of him. The man is not easily scared, however, and knows his response. Raising his voice in *sigi so*, he greets the mask, giving the proper exhortation, and concluding with the honorific name of the mask, all in the ritual mask language.

Some other masks are present too, not as popular as the former ones, but interesting all the same. One is the *odyogoro*, oddly enough representing a "goiter," wearing a carved headpiece with a huge protuberance under its chin. A lack of iodine in the diet makes goiters common in Mali, and although such serious medical conditions are not funny, the mask draws gusts of laughter from the crowd, as it prances around, hacking away with an adz in midair, unable to bend down to the ground. More laughs are drawn by the *pulo* mask, representing a Fulani rider, with his horse. At the end of the long row, an elder carries the *agamagâ*. Ritually the most important of all, it represents the first mask and is never worn, just carried around. After the dance it will be brought back to the village.

At dusk, the masks end their performance. All have been on stage several times now, and both dancers and drummers grow tired. One "tree" mask wants to continue when the leading drummer has already stopped. "You are tired, you know," shouts the drummer, and the mask, who never speaks, denies it by shaking his head but has to stop anyway. It is the end for today. Slowly the masks mount into the village, with an occasional drum beating a solitary note.

DAYS OF DANCING

Before sunrise the next morning all the neophyte dancers gather at the foot of the cliff to hear the oldest man of the village pronounce his blessings over them. Crouching under the overhang of a huge boulder, clothed only in white Dogon shorts, they interrupt his long well wishes and admonitions in *sigi so* with occasional mask cries, the high pitched "Hèe, hèe, hèe" which is the only sound masks may produce. When the old man is finished, they eat and dress for dancing, clad in long indigo trousers, adorned with necklaces and other jewelry, cotton bands for tying the mask, and the tobacco-tinted cap they wear under the headpiece; in their hands they carry swords or horse-tail whisks. The rest of the morning is spent in what the dancers themselves consider one of the high points, a dancing contest without the mask disguises. Guided by the elders, they circle the largest *tei* of the village three times, then crouch in a large circle. An elder then gives a long public praise, with wise admonitions and frequent expression of modesty ("Pardon, pardon, you are the ones who do the work".) At intervals, the young men rise up, shout their mask cry, wave their horse-tail whisks, and sit down again. Afterward, in the various dancing grounds of the wards, the rest of the morning is used to decide who is the best dancer, the young men taking turns in the various mask dances, to the delight of the villagers. At noon the drums are silenced, the dancers drink their beer, and the crowd disperses, with a general consensus as to who is the top dancer of the village this time.

This day is called *manugosugo*, "descent from the plains," and is definitely the highlight of the program. The dancing program is similar to the last one yesterday, but with one significant difference: this day people from the neighboring villages will be present. Beer and water have been brought to the dunes, where in the early afternoon the men join their younger brothers who have looked after their masks and other belongings.

In the neighboring villages of Tireli and Yayé people prepare themselves for their part in the proceedings; women finish beer brewing, men don their finest clothes, and late in the afternoon they

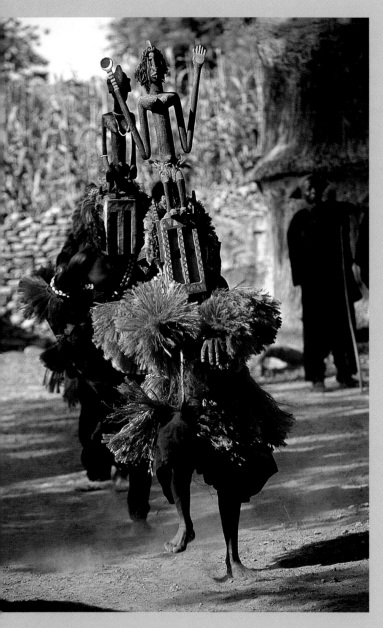

set out toward Amani. Dogolu, as one of the "grandsons" of Amani, has gathered up a large group of friends and kinsmen; he has to make an imposing presence. Arriving at Amani the visiting women disperse into the village to present the beer to their own friends and those of their husbands, while the men fan out into the dunes, where the dancers are busy clothing themselves.

The scree is already in the shade of the cliff, when the first drums begin calling the masks. First the *tingetange* start moving, walking at ease toward the dancing ground with the headpieces on backward, their faces "naked," while young brothers amble alongside them carrying their stilts. Accompanied by drums, the main body of masks then sets out, in one group. Their flanks are shielded by men from the two neighboring villages as a protection from the envious stares of villages farther away. In this way, it is said, no foreigners can usurp the strength of the village. The whole troupe, two *bèdyè*, four "girls," two *modibo*, five "trees," and twenty-two *kanaga*, move as a body; no one may interrupt their procession nor cross their lines. Only the *waru* walks outside the group, chasing away outsiders. The masks now are all fully "clothed," their adornment complete and their headpieces in place. This is the last and the greatest arrival of the masks,

THE SATIMBE MASK represents the woman who according to myth, was the first to find the mask, in Yougo, the first of all *yasigi*.

Opposite:
IN CERTAIN DOGON dances the masks act out stories as they perform. The *danana* (hunter) engages in a mock hunt as he pursues the *dyomo* (rabbit) around Tireli's dancing ground, spear in hand. The *dyomo* dodges the hunter, clapping his heels together in the air as he swings his hips to the beat of bells and drum.

and it is done in style. No discussions about the exact trail, nor about priorities, everything has been settled now.

Led by the elders, flanked by the neighbors, and admired by the visitors from other villages, the group of forty-four masks dances its way into the area around the altar and the *dani*, drums and bells accompanying them. Again, the stilts are the first to perform, nine of them today. Like a flock of gigantic water birds, they come stepping from the low building where they tied on their stilts, rattling their boxes, waving their wands. Since they will perform several times today, after dancing they rest against a tree near the grounds, watching the next group dance. As before, the *kanaga* dominate the dance, as all of them have to perform. The one *waru* is very busy, roaming the perimeter of the dance to keep non-initiates at a distance, as well as women and children. A throng of male spectators circles the ground, about half of them people from other villages. This is the time when the village of Amani is judged as a whole for its mask performance. The *dama* is "complete" now, fully clothed and adorned, fully danced. From far away, on the rooftops in the village, the women and girls follow the performance. Small boys creep through the spectators, to be chased away by the very active *waru*. The elders and the *orubaru* continually shout exhortations in *sigi so*, beating their sticks on the ground to stimulate and honor the dancing.

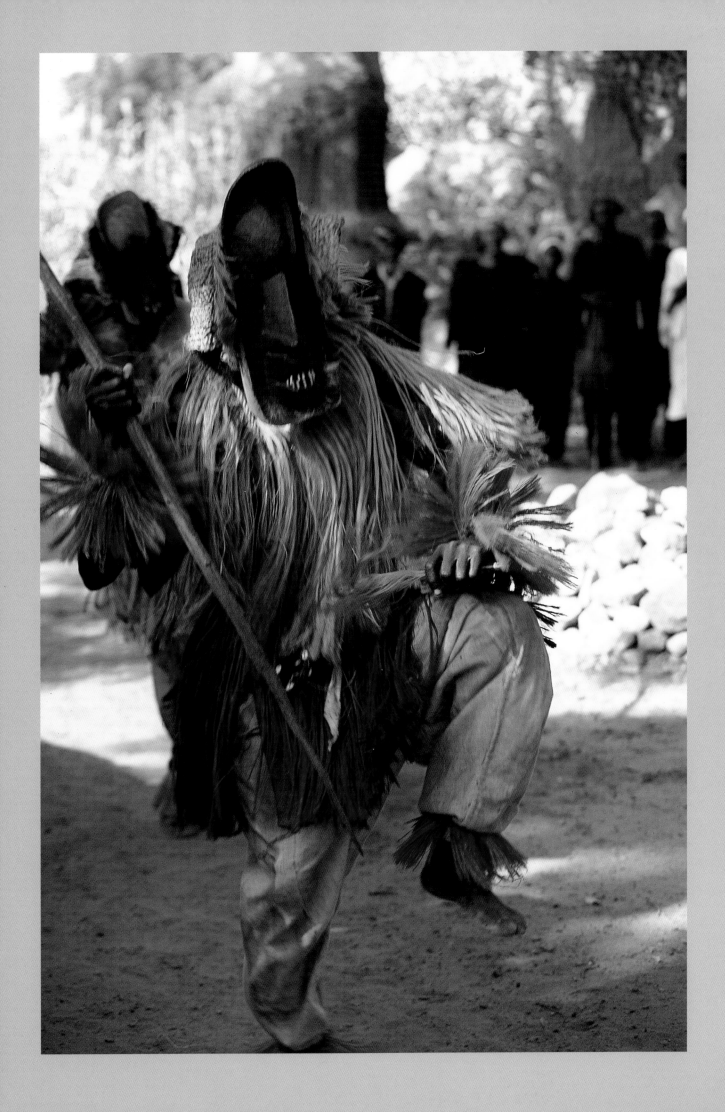

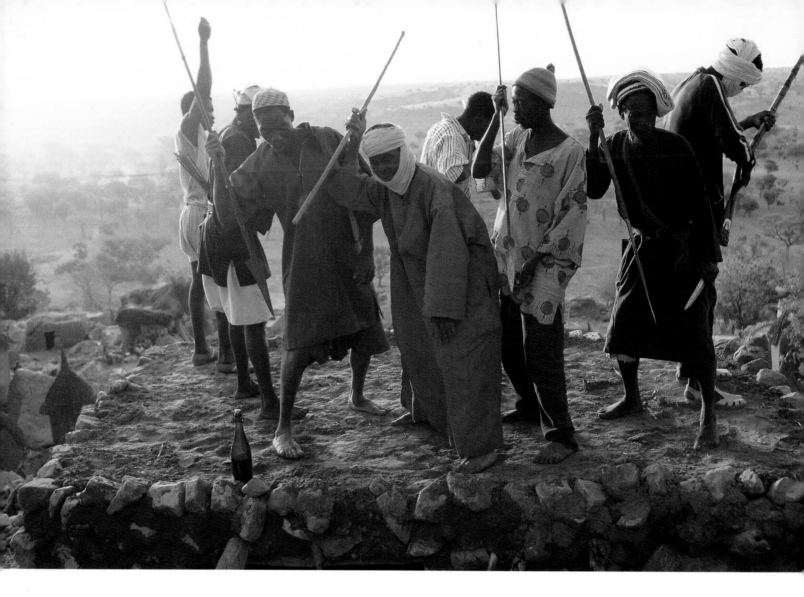

At dusk the dancing halts, the drums are silenced, and the masks and spectators repair to the village. At the deserted dancing ground, the old men in charge of the masks engage in the *dalewa lagu*, the first of the two farewell rites of the *dama*. Each of their predecessors, those who have presided over the last *dama*, owned a special personal stool associated with the *sigi* ritual. Carrying the stools of these men, each of the living elders in strict order of age calls upon one of the deceased, saying: "This is the end now, it is finished with you here, be gentle and have peace." Then, with a powerful blow, each man shatters the stool on the altar, then sacrifices a chicken. Leaving the dead chicken on the altar, they gather in the broken pieces of the stools and throw them into one of the deep crevasses of the scree, abandoned and never referred to again. Before leaving the grounds, the old men approach the *dani* at the dancing ground. Each of the elders touches the pole with his right hand, calling out one of the names of the dead predecessors, and then one of them uproots the *dani* and puts it back in the cavern in the village, where all *dani* are kept.

The next morning, the day of *yenu kèdyè* (meeting the foreigners), sees the start of the truly public dances. From the early morning on the masks will dance at the various *tei* of the village. Throughout the day masks will visit the compounds of the men who have died since the last *dama*, greeting the dead by dancing on the roofs of their houses. Afterward the dancers are honored with huge quantities of beer. Then they dress again, unite in groups of six to a dozen, and perform at a *tei*. Toward the afternoon, when all the dead have been greeted, the masks converge upon the central *tei*, where the whole village and numerous guests await their arrival. Accompanied by drums and bells, group after group performs.

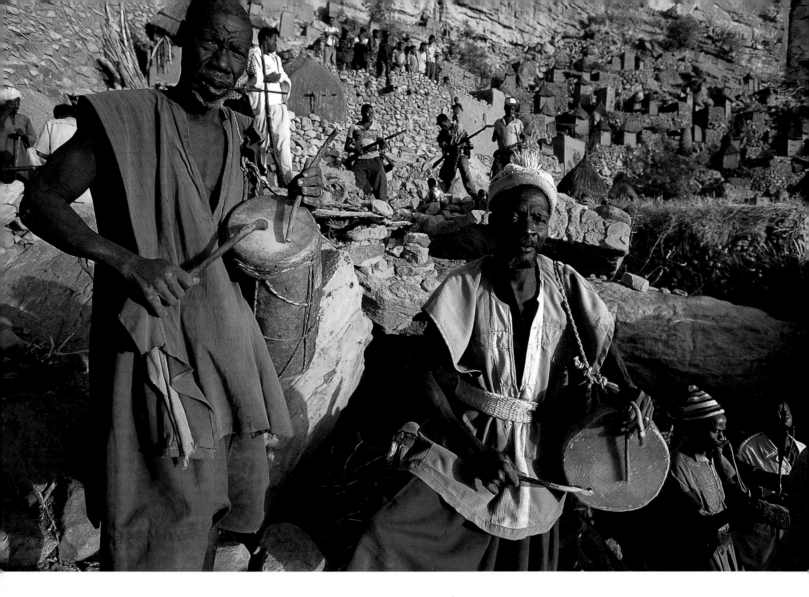

Toward dusk many of the guests from the other villages gather at the compounds of their Amani friends, especially those whose mothers came from one of the neighboring villages. For the guests this finishes the proceedings of the day, but for the people most closely involved in the *dama* one important ritual awaits: the *gèû buju*, "pour the black." At the central *tei*, relatives of all deceased men gather, each with two small jars of beer, and two tiny empty cups. One of the leading old men pours the beer, and as he fills each cup, he pours a considerable part on the ground as a libation: "This is for you, this is for you, it is finished now." The rest of the beer is poured into a large jar, an action called "gathering the huts," and all males present—only those of the village—quietly drink the rest of the beer. People from neighboring villages are definitely excluded in this part of the rituals. Thus, all the men who died since the last *dama* have been bidden farewell and the second funeral as such is over.

During the next day the masks draw the largest crowds of the whole festival, as after the termination of all major rituals, everyone from other villages feels free to enter the village of the masks. Gradually, throughout the day, thousands of people gather in the immediate vicinity of the large *tei*, where from the late morning the masks have performed in small groups. All rocks and roofs are crammed with well-dressed people, eager to watch the final dance of the masks. The women have come closer now, just a few rooftops away, while the young children sneak through the throngs of spectators to catch a close glimpse. Yet, the ever-attentive *waru* mask continues to chase them away. When the shadows of the cliff arrive at the dancing square, the delegation from the neighboring village of Tireli arrives with their drums and dancers and one mask, ushered in by one of the

THE BLASTING OF RAM'S horns and the beating of rattles and drum begin the second day of Komakan's *nyû yana* ceremony. Family and friends of the three village elders being honored now mourn in public. The larger drum is called *boy na*; the calabash drum *barubo*, and the drum with strings *gom boy*, talking drum.

Overleaf:
AS THE SUN RISES OVER THE plain below Komakan, elders sip millet beer and continue to chant with hoarse voices. They have been up all night during this first part of the *nyû yana*, standing and singing in a courtyard of one of the deceased being mourned.

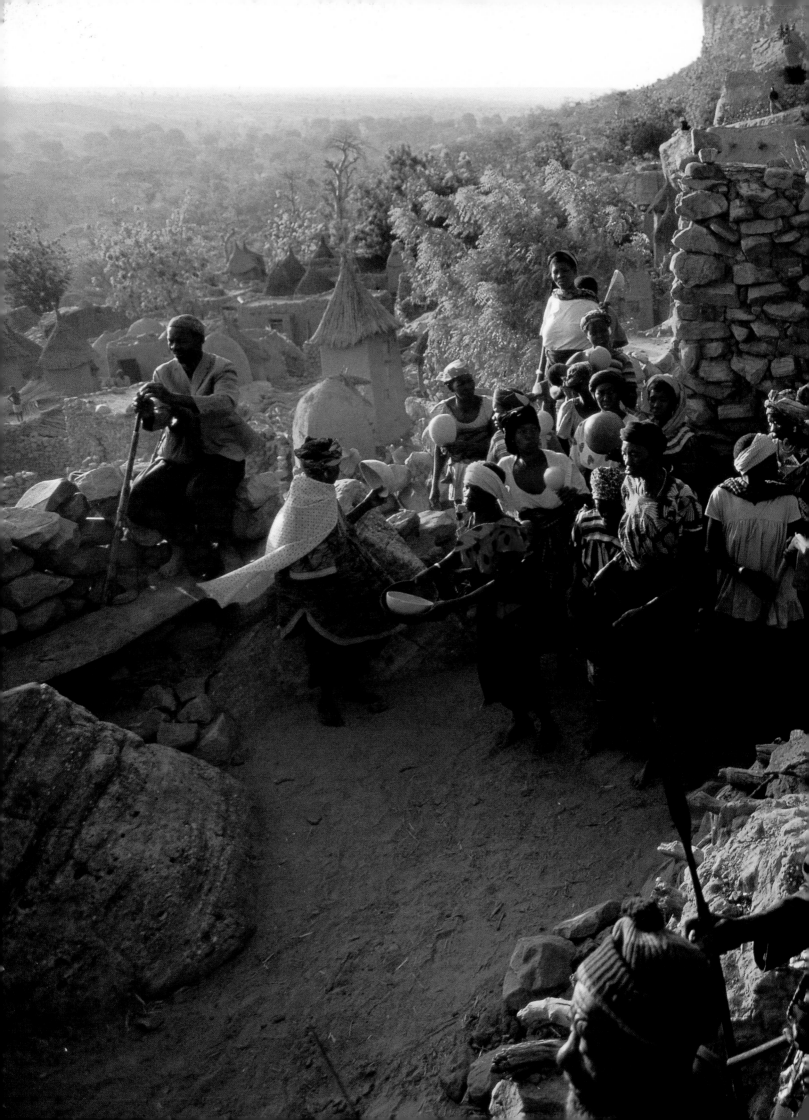

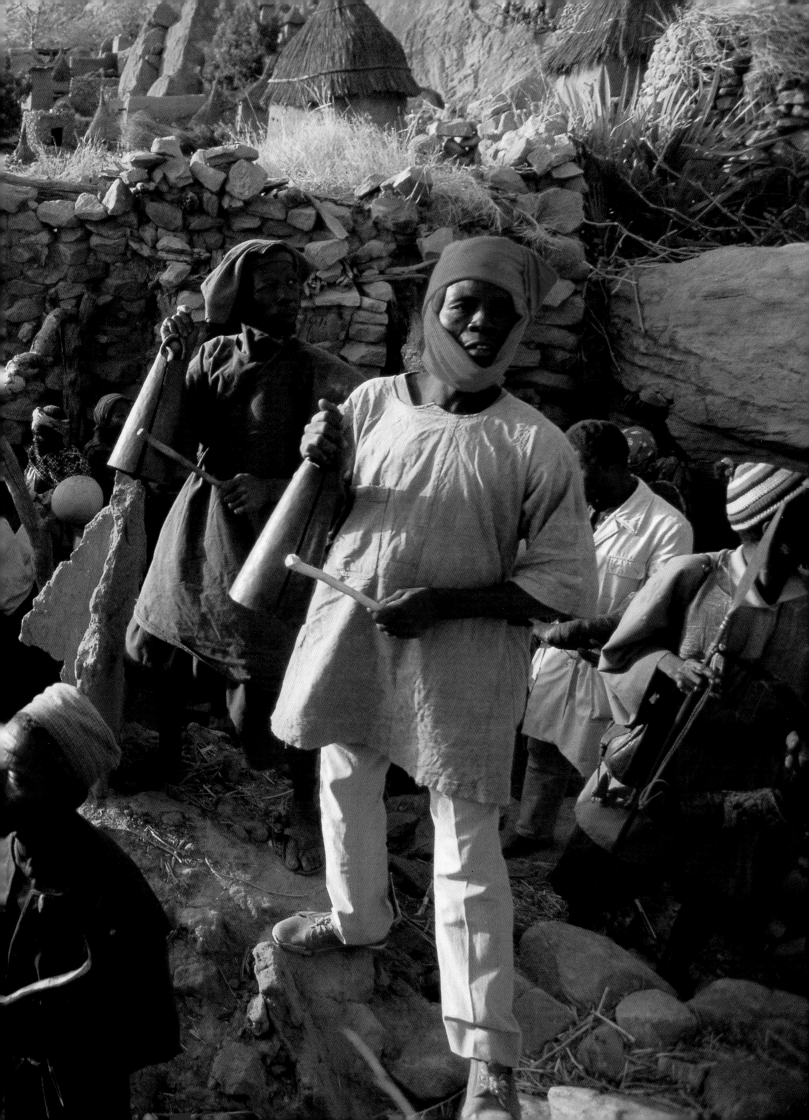

masks of Amani. The Tireli men dance into the square, while some of them join the musicians, playing the drums and bells. When they are finished, the Amani speaker thanks them in *sigi so* for supporting the *dama*. After the polite reply from the Tireli delegation, Yedyè then invites the guests to the beer.

As the steep Bandiagara cliff casts its dark shadow over the village of Amani the men of neighboring Tireli gather at the roadside to thank their hosts for the splendid mask festival. It has been a good time, this *dama* in Amani: the masks were beautiful and performed well, the visitors were received with honor, and the beer was plentiful. The ritual speaker of Amani leads the Tireli delegation to a deserted compound, where four jars of millet beer are waiting for them. The men gath-

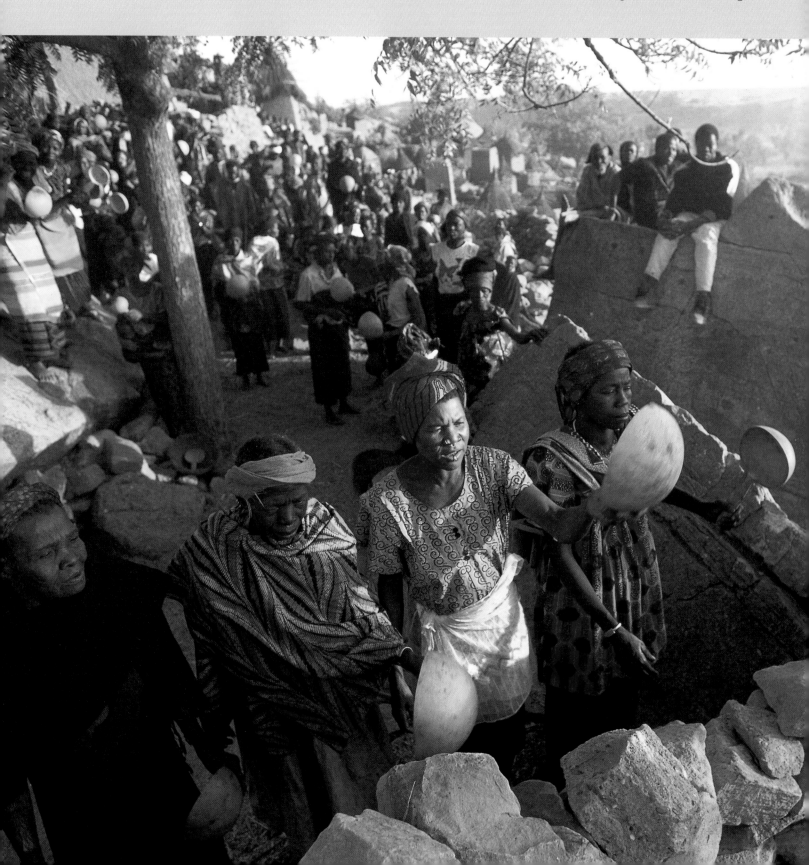

er around the brew and quietly down some eighty liters of beer. Glancing at their host, the leader of the men from Tireli taps his iron ring against a bell and starts singing: "Thank you for the beer, you who stood over there, poured out, and we drank, thank you." His clan brother follows with the second verse: "Thanks for Tepènyo [an ancestor of Amani], God has done well to the first settler here; you are sons of the same father, you will understand us." "May God help you"—sings the leader—"help the ones who work the millet, may the rich God help you; as brothers, you understand our words." Answering in proper fashion, after the many repetitions of the song, the Amani host launches into a long greeting, thanking his guests in the ritual mask language (*sigi so*): "What you said does not come from a child, it is truly the word of the old ones. When you came here, not even a dog could bark at you, no stone could offend your foot. Compared to you I am but a youngster, and we did not honor you enough; many men and women have come to look at our masks; you are the children of God, going back home no thorn will touch your feet." In return the men from Tireli thank their host for his graceful reception of their "thank you" song and finally gather their belongings and leave the dancing grounds where they have spent most of the last four days. It has been a good *dama*, and Amani can be sure of a good year with an abundant harvest. Next year in Tireli, perhaps.

Over the following days the *dama* slowly comes to a close. A few masks with a few drummers visit the outlying parts of the village and later walk all the way to a village in the plains, settled also by descendants of Amani. Before they leave, the old men gather at the *tei* and sing some of the mask songs, ending the *dama*, as now the ritual is transferred to other villages.

RELATIVES OF THE DECEASED chant and wave eating bowls during the second day in Komakan's *nyû nana* ceremony, a day of public mourning. A *nyû nana* celebration can prove costly for families involved, as they must provide food and drink to all participants, so mourners often group together and share resources for this important ceremony.

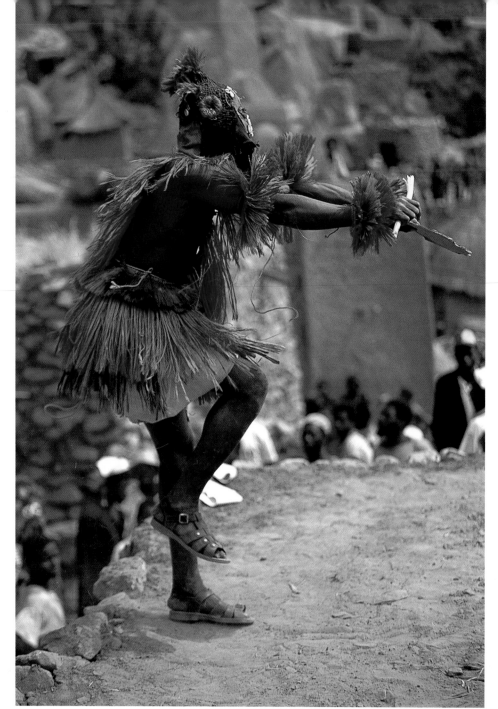

THE MEANING OF A MASK

ON THE SECOND DAY OF
Komakan's *dama*, known as
gondenu, the masks present them-
selves wearing fiber skirts and the
bèdyè mask representing a pupil.
They work their way up to the
cliff, wending their way single file
through the village. Women and
children now must disappear from
sight. The masks climb onto the
rooftops of the deceased, one by
one, as they perform the *baga
bundo* rite.

What are these masks, what is the meaning of this elaborate masquerade? The old men do not
worry about hidden meanings. They know it is important, they love to perform, and they are very
proud of this part of their culture. Still, the symbols used in the masks do betray some hidden
meanings.

First, masks clearly express male superiority—in speech ("Hit the women" is one of the exhorta-
tions), in the behavior of the masks, as well as in the symbolism of mask outfits and paraphernalia
(for example, the short stick with a rounded top to be used for beating women). Also, the central
taboo of the masks concerns women: women must not come into close contact with the masks,
either the headpiece, the paraphernalia, or especially the red fibers. Above all, women are not sup-
posed to know that masks are costumed men: of course they are perfectly aware not only that men
are inside but also who is inside. Women are also not supposed to comprehend the mask language
(*sigi so*)—though of course they do—and women who are "sisters of the mask" understand the lan-
guage without receiving any specific instruction.

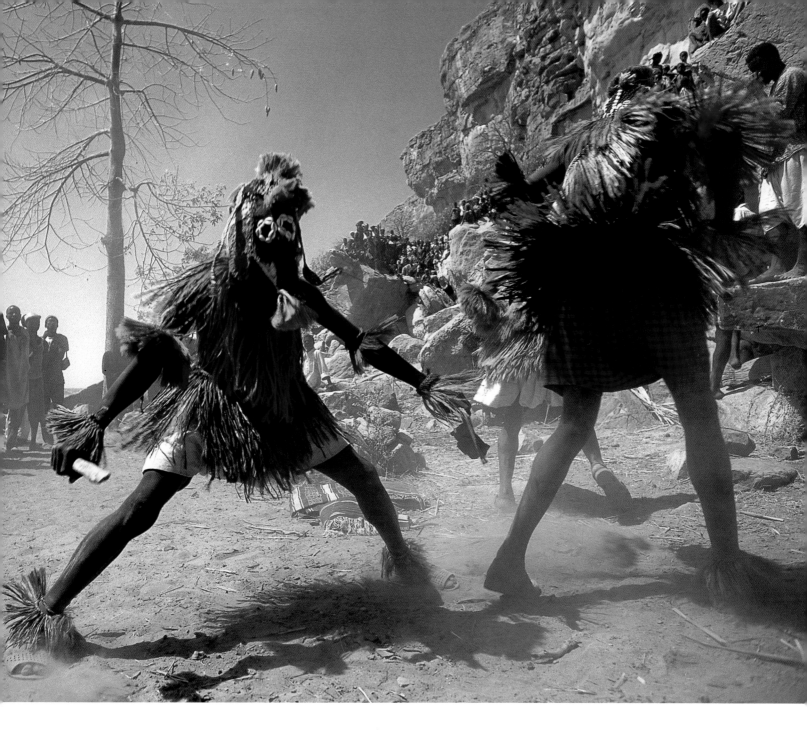

The myth of mask origin balances the roles of men and women: a woman who terrified her husband first found the masks. But with the help of an old woman the tables were turned on the women. Male power shows also in the *puro* where collective errors of wayward women are "punished" by a great show of anger by the masks.

So the masks represent a scare for the women, a fright to keep them in place. The balancing male scare is menstruation menstrual blood, as such, and more particularly, female genitalia. Yet the masks themselves, their headpieces, fibers, and paraphernalia embody some female characteristics: the pointed breasts, skirts, perhaps the red color, the jewelry (female beads and adornment): they feminize the men. This happens also in the *buro*, where the young men deck themselves out in female jewelry, and plait their hair in girlish fashion. This "feminization" has to do with fertility: after each *dama* crops should be abundant, just as the *sigi* should lead toward numerous offspring, to a splendid new generation. In both instances the women are absent, and the men do the performing; the whole mask-*sigi* complex may be seen as a male appropriation of fertility, in which

IN DOUROU THE MASKS dance in a special area in charge of the Hogon of the village.

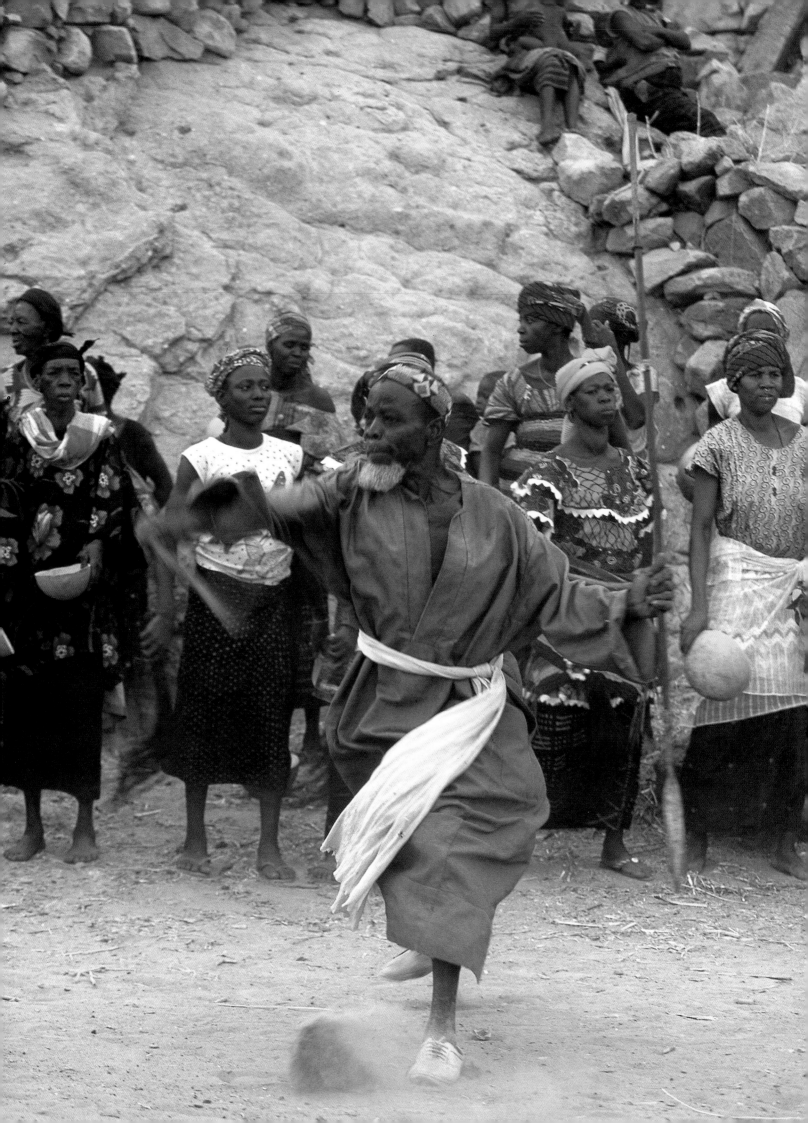

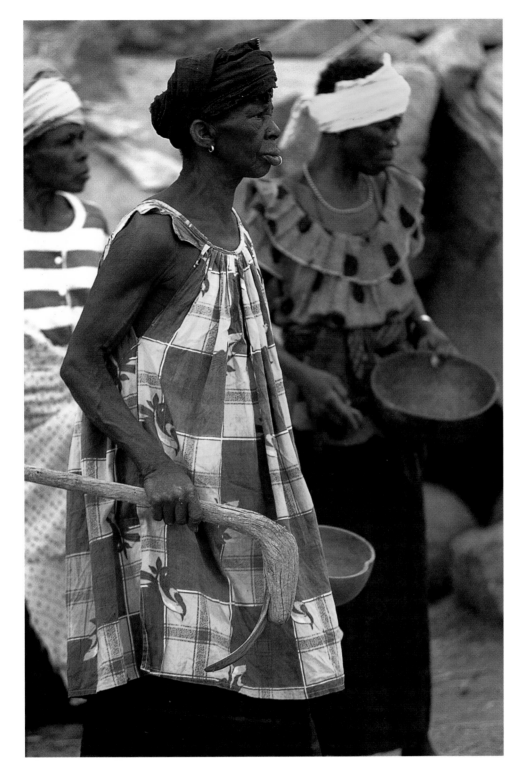

ON THE FINAL DAY OF
Komakan's *nyû yana*, a widow
dances in the public square carry-
ing a hoe used by her dead hus-
band. Village elders will later
destroy the hoe once in the bush
to show that the deceased will no
longer till his fields among the
living.

Opposite:
ALMOST THE ENTIRE VILLAGE
of Komakan gathers on the *tei*, the
dance ground, to celebrate the
final day of the *nyû yana* ceremony.
Elders wage mock battles, wield-
ing muskets and iron-tipped
spears as they dance and sway
back and forth.

the role of women is ritually marginalized and men, by transforming themselves, become self-suf-
ficient in procreation. In the masks the men proclaim themselves able to control the sources of fer-
tility, the sources of power, the sources of life.

The sources of that power are in the bush, *oru*. Masks are bush-things, representing the power
and the wisdom of the bush. They arrive at the village from the bush, first "naked" from the
"west," from the direction of Yugo, then in complete outfit from the plains where the spirits dwell.
At the end they leave towards the "east" for the next village, and finally for the bush again, back to
the place of origin. Language is a key. Masks do not speak: they shout a meaningless, high-pitched
cry, but never speak. Even when unadorned, speaking is forbidden. Speaking is human, silence is

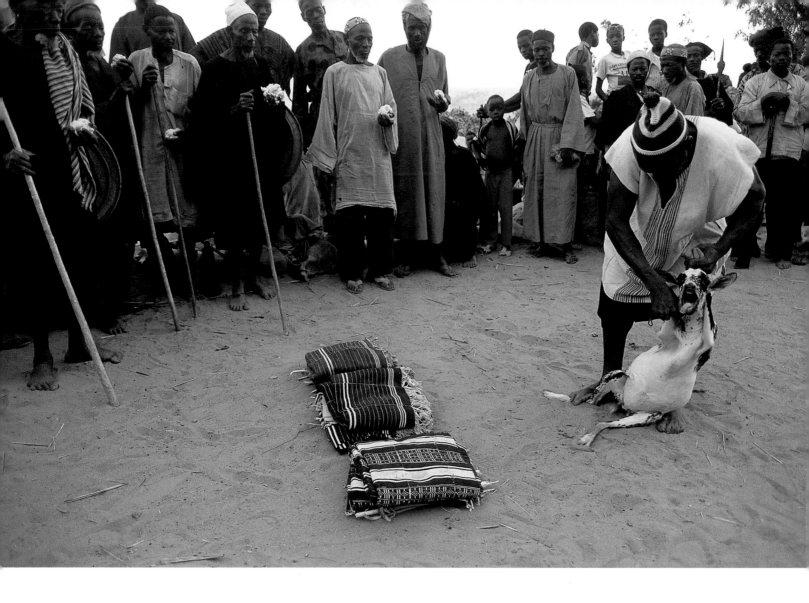

AS A FINAL FAREWELL to the deceased, who are represented by their indigo *worodèwè* (death blanket), a goat is sacrificed.

bush. Whoever can speak Dogon—greet Dogon—is Dogon. Masks are never addressed or exhorted in Dogon; they are spoken to only in the ritual language. *Sigi so*, a derivative language with a simple syntax and a 20 percent overlap with Dogon, is only used in a one-way communication: long texts, exhortations, greetings. But no one ever answers. Also *sigi so* is never spoken, it is nearly always shouted at the top of the voice, even when a recipient mask is quite close. *Sigi so* is a form of linguistic noncommunication. People speak to masks as people speak to animals, without expecting any response, shouting at a distance, in a language that stems from bush spirits.

So masks are "things coming from the bush." The central masks for the ritual, the *bèdyè* and the *adyagai*, do represent the bush as such: simple hoods with just two, four, six, or more eyes. The earliest masks that came from Yugo are the plaited hoods of the *bèdyè* and the *adyagai*, both the epitome of "things from the bush," unrecognizable, knowing and seeing, dangerous and powerful. Thus, many masks are animals, such as antelope and monkey, buffalo, water bird, hare. One human mask, the *sadimbe*, refers to the mask myth, the woman who originally found the masks. Other human masks are associated with the bush—the hunter or the shaman. The mask of the hunter, as said before, vividly expresses the bush attitude: a fierce countenance, with large protruding teeth and a bulging forehead: a nondomesticated human. The *binugèdyu* mask, the shaman, and the *dyodyongunu*, healer, have similar features: human and more than human.

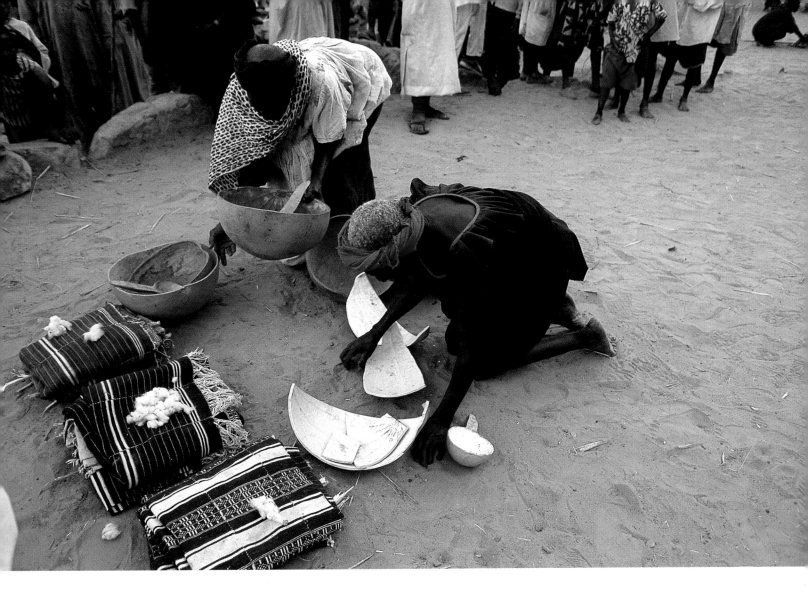

Mask rituals usher in a new existence for the dead—that of ancestor—and thus contain some rites in which the individual's existence on this earth is ended. Characteristically, the *sigi* stool plays a central role here: the old men in charge of the *dama* smash the *sigi* stools of the deceased and discard the pieces in a mountain crevasse. The end of the *sigi* symbol signifies the end of the individual's life. While the *sigi* constitutes the rebirth of the human being through strictly male endeavors, negating in ritual the female monopoly on reproduction, the male powers to create life are its very destroyers. That only men participate in the *sigi*, as in the *dama*, is emblematic. Birth and *sigi* together stress the life and mortality of man, the fleeting male creation of himself against the continuing chain of life generated by the women. Meaningful existence has to be created by ephemeral beings, in this case men—at least once in their lifetime—playing a role in the origin of life.

ON THE LAST DAY OF THE *nyû yana* in Komakan widows crack the bowls used by their husbands in front of their mortuary blankets. This signifies that the deceased will no longer eat or drink and have departed this world for the realm of the spirits.

INDEX

Page numbers in *italics* refer to captions.

ACKNOWLEDGMENTS *by Walter E.A. van Beek*

I wish to thank the following institutions for assistance and support: Institut des Sciences Humaines in Bamako, Mali; Ministry of Higher Education and Scientific Research of Mali; and Utrecht University, Netherlands. And I thank the Museum for African Art, New York, for permission to use portions of my text on Dogon mask festivals, which they previously published.

ACKNOWLEDGMENTS *by Stephenie Hollyman*

A personal word of thanks goes to my editor, Robert Morton, at Harry N. Abrams Inc. who supported this project from the beginning, and whose keen eye and critical judgment pulled it all together as a whole. Thanks also to Bob McKee of Abrams for his sensitivity, enormous talent, and great sense of design. I am also grateful to Gary Chassman of Verve Editions who served as my agent for this project.

For support, I have to thank Linda Rhoad, now retired from the Council of International Exchange of Scholars, who encouraged me to apply for a Fulbright Fellowship. Without the Fulbright grant I would not have been able to live among the Dogon for such an extended period of time. I want to express my gratitude to Ambassador Sammasekkou of the Consulate of Mali who helped me work out the details of my first trip. Also thanks to Dr. Samuel Sidebe at the National Art Museum in Bamako, Mali, who was my Fulbright sponsor. And thanks to Lester Wunderman, whose Dogon art collection at the Metropolitan Museum of Art inspired me to travel to the Dogon in the first place.

Special thanks to Joe DeLora of Canon, USA, who loaned me some superb Canon lenses for my last two trips, and to Henry Froelich of Mimaya USA for his generous help. Thanks to Jay Colton at *Time* magazine for emotional support, and to Dieter Steiner of *Stern* magazine for his assignments in the United States during the tenure of this extended project. I am also grateful to Michael Rosenbloom of New York Times Television, who trained me to work as a videojournalist. And a note of personal thanks to Steve Cassidy, at CNN International, who always has the right answer when I call for advice.

In the field, special thanks are due to Nouhoum Toumonte, my translator and guide, for my first two trips out of Bandiagara. Nouhoum always pushed me to walk that extra kilometer at the end of a long day. Over six months we visited some fourteen Dogon villages, traveling by foot, donkey cart, and moped. His wide, warm smile kept me trekking along the rugged limestone cliffs through the intense heat, day after day. Also in Bandiagara special thanks to "Le Viele Kansaye," Piero and Lelia Coppa of the Italian Medical Center, and the Bandiagara Dogon Women's Group, of which I was a member.

In Bamako I appreciated the hospitality of Linda Buggelin and her assistant in administering my Fulbright Fellowship. Also thanks to Alexandra Burasch for her hospitality in Bamako. Thanks also to Dramane Cisse of Le Bani Tours who often gave me transport without charge as I returned home to the Pays Dogon from Mopti or Bamako.

In Tireli I would especially like to thank Dogolu Say who opened up his home, his heart, and his village—and adopted me as his daughter. Also sincere appreciation to his son, Atime Say, who as translator, guide, and brother walked by my side during the second half of this project. I also want to express my gratitude to Mamabou Say, who often accompanied me and blessed us with his laughter as we shared gourds of millet beer after days of trekking. Sincere appreciation goes to all the Dogon in their villages who welcomed me and shared their lives.

Particular thanks are due to my co-author, Walter van Beek, for his insightful text and other work on this project.

Finally I want to thank my family and friends for their love and support: my mother, Jean Hollyman; my father, Tom; and my brother Burnes and his wife, Mignette.